# Create

TOOLS

FROM SERIOUSLY

TALENTED PEOPLE

TO UNLEASH YOUR

CREATIVE LIFE

Cover Design: Rikard Rodin
Layout Design: Elina Diaz

Image credits: Summarizing section images designed by Freepik from www.flaticon.com Nikonos underwater camera photo by Morio, Nikon Museum, Tokyo, Japan is licensed under the Creative Commons Attribution-Share Alike 4.0 International license. Public domain NPS Graphics: point of interest, exercise-fitness, stay on trail, trail, trailhead, action figure, bookstore. Converted by User: ZyMOS, via Wikimedia Commons. Jack London photo JLP 537 LA 6 #12346, Jack London papers, The Huntington Library, San Marino, California. Eye—vision Shutterstock 409257079; Beware of Vampires credit Shutterstock 118645969; tea pot Shutterstock 225471844

For permission requests, please contact the publisher at:
Mango Publishing Group
2850 Douglas Road, 2nd Floor
Coral Gables, FL 33134 USA
info@mango.bz

For special orders, quantity sales, course adoptions and corporate sales, please email the publisher at sales@mango.bz. For trade and wholesale sales, please contact Ingram Publisher Services at customer.service@ingramcontent.com or +1.800.509.4887.

Create: Tools from Seriously Talented People to Unleash Your Creative Life

Library of Congress Cataloging
ISBN: (print) 978-1-63353-982-2 (ebook) 978-1-63353-983-9
Library of Congress Control Number: 2019935684
BISAC category code: SEL009000 SELF-HELP / Creativity

Printed in the United States of America

# Create

TOOLS

FROM SERIOUSLY

TALENTED PEOPLE

TO UNLEASH YOUR

CREATIVE LIFE

# MARC SILBER

mango
PUBLISHING

CORAL GABLES

To Bernice Garrett Silber, my mother, who always encouraged me to create and find art in life, and who so wisely and courageously went against the grain and found a learning environment to foster this throughout my whole life. I love you and think of you always...

# PRAISE FOR *CREATE* AND SILBER'S EARLIER WORKS

"I am really excited about Marc's new book *Create*, as he has accomplished something pretty amazing by bringing to light the exact steps of the creative process. This is something far too little is written on, and something that has vastly more power than you'd imagine. He's really made it so easy and so clear for anyone who wants to open artistic joy in any area of their life. As a photographer, musician, designer, educator, and entrepreneur Marc's book really spoke to me. I can't wait to see what people do with the concepts and ideas he shares in its page. He makes it easy to grasp just the right tool to use with his own examples and riveting stories from some extremely talented people. Take it from someone who has been an educator in the arts for decades: if you want a more artistic and fun life, you're holding the book that will do it (plus, you'll love Marc's delightful and engaging writing style). Highly recommended."

—Scott Kelby, bestselling author and educator

"What a marvelously constructed book for *anyone* who ever thought of creating *anything*...and it's not just for the sophisticated artist. Anybody can learn these tools...and they are surprisingly simple, too. It's a very alive read—NOT like a dry walk through the desert looking for some water. There's a drink around every corner here. Refreshingly fresh, it's an action-packed 'how to.' And does it ever deliver!"

—Michael Manoogian, legendary star of logo design

"Put more life into your art. Put more art into your life. Marc Silber's newest book gives practical tools to do both. Make more meaningful, vibrant and impactful art in your chosen art form, or live a more creative, beautiful and purposeful life. Filled with interviews with celebrities, successful artists, entrepreneurs, and people who make their lives into an art, *Create* will give you the insight and inspiration you've been waiting for to kick the creativity in your life into high gear."

—Cathy Weaver, author and educator

"After reading *Create* I was able to articulate what I truly wanted to do with my photography, first to myself, then to others. Marc's insightful narrative, punctuated by his thoughtful interviews with exceptional leaders in their fields, created a safe vantage point from which to envision my best creative life."

—E. Cross, photographer and engineer

"I recently had the privilege of reviewing this book, and all I can say is: Wow! Before I read any non-fiction book, the first thing I do is read the table of contents, and when I saw the table in this book, I immediately thought to myself: 'this isn't a photography how-to.' After a few pages I rediscovered and old friend; my muse. She had fled for quite some time, and I was going through the motions of writing, and when I took photos, well, they were more like snapshots. Thanks to Marc Silber and this well written book, I am learning more about creativity than I thought I was capable of learning—and now am writing better than ever and taking real photographs. Creativity; it's the foundation of art. To live without creativity, is merely existence..."

—James W. Robinson, writer, photographer, creative.

"Once again, with this book, *The Secrets to Creating Amazing Photos*, Marc Silber proves to be a wonderful and worthwhile compendium of photographic knowledge, tips, tricks, survival skills, and historical perspective. This book is a go-to collection of lucid strategies for any photographer who is striving and seeking to up their game in the fast pace endeavor known as digital photography."

—Joe McNally, internationally acclaimed, award-winning photographer

# TABLE OF CONTENTS

This book provides tools to help increase your creativity. *You are an artist* whether you are working in a creative field, or in the art of living itself.

# FOREWORD

Creativity is a word many people associate exclusively with filmmakers, musicians, or artists. Many people even fear the word. They say, "Oh, I'm not creative," and leave it at that. That is a big mistake. By putting up that barrier, they're stifling themselves and staying within their comfort zones.

While it's true that creativity flows easier within some people more than others, everyone has a bit of creativity they use every day. I can't paint or draw like Picasso or Goya, but in my line of business, I have to be creative to find solutions to everyday problems. I have to be creative to work with people with different habits than mine. I need to move the needle forward with people who move as fast as I do and with those who don't. And because not everyone responds the same way, I have to be creative in how I address them. Creativity isn't limited to a few people or professions. Everyone has it, but they don't always realize they're using it.

As a bestselling author, my creativity flows in the stories I tell. The stories of true, tested leaders that get up every day with the purpose of making life better for someone else—whether it's a total stranger, family, friends, or employees. For example, I'm always telling the stories of the hero CEOs I've encountered along the way. People who aren't famous or celebrities, but who use their creative gifts to move the needle forward, people who find creative solutions to problems, and people who genuinely strive to create an environment that encourages creativity.

Marc's book provides practical steps that readers can apply to their daily lives immediately. His easy-to-read, hands-on advice encourages stepping out of one's comfort zone in order to make changes that will lead to a creative outpour, regardless of industry. The good news here is, you don't have to be a rock star like Mick Jagger, sing like Lady Gaga, or have a number of Oscars under your belt to be creative. Unburden yourself from the stigma that creativity isn't for everyone and read this book. You'll realize that you've always been creative and can unleash that power at any given point moving forward.

JEFFREY HAYZLETT
Primetime TV and podcast host, speaker, author, and part-time cowboy

# PREFACE

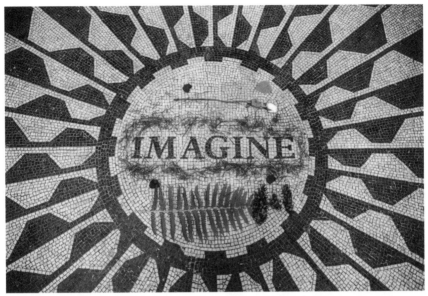

"A MASTER IN THE ART OF LIVING DRAWS NO SHARP DISTINCTION BETWEEN HIS WORK AND HIS PLAY; HIS LABOR AND HIS LEISURE; HIS MIND AND HIS BODY; HIS EDUCATION AND HIS RECREATION. HE HARDLY KNOWS WHICH IS WHICH. HE SIMPLY PURSUES HIS VISION OF EXCELLENCE THROUGH WHATEVER HE IS DOING, AND LEAVES OTHERS TO DETERMINE WHETHER HE IS WORKING OR PLAYING. TO HIMSELF, HE ALWAYS APPEARS TO BE DOING BOTH."

—L.P. JACKS, EDUCATOR

This book will show you ways to transform your life to have a more creative existence—every day. You may already be an artist in some field that you want to broaden your skills in or you may want to add more fun and creativity into your life as whole. In either case, following this book's steps will help you advance toward your goal.

Many people look upon creativity longingly, as something that a few artists and lucky "creatives" get to indulge in. But when it comes to having a creative life, they may feel like a land-locked surfer yearning for those beautiful waves with exhilarating rides.

A common misconception is that only artists and creatives can pursue a creative life. Coupled with this is the notion that just a small portion of one's life could be seen as a creative outlet. For example, playing guitar or singing a few hours a week—but what happens to the other 165 hours in a week?

The truth is that many very successful people view their life as art and incorporate creativity into every aspect of it whether at "work" or "play." Such examples are: an entrepreneur creating a new product or parents creating fun (offline) activities for their kids rather than letting them sink into small-screen obsession. Truthfully, for very creative and happy people, life is an art form; conversely living itself can be an art.

We will be exploring the many ways to add art into your life by reading stories and advice from those who have excelled at doing so. For millennia, humans have passed along wisdom by telling stories. The magic of storytelling is that one doesn't need to hear the precise story that suits their exact needs. By engaging their imagination, the listener or reader fills in his or her own specifics into the story line and thus achieves greater understanding.

In this book, *Create*, I take the same approach that I have with my previous books: I explore common points of creativity from my own experiences, from people I have researched, and those of the seriously talented people I have interviewed. I'll break these down into their components and make each one clear and easy to follow.

If you want to go deeper, I'll give you practical exercises to do in your life. This is where the changes can really occur, so be ready to roll up your sleeves and work/play at transforming your life with them.

The result is a set of tools for you to live a happier and more creative life, which is my goal for you.

Marc Silber
Carmel, California

# HOW TO USE THIS BOOK

"ACTION IS THE FOUNDATIONAL KEY TO ALL SUCCESS."

—PABLO PICASSO

This book is geared toward *action* and not just thinking. I imagine you're reading it because you want to transform your life and take action, which is the key to success, as Picasso said.

## TOOLS FOR CREATIVITY

A tool is defined as "something used as a means of achieving something." (Encarta Dictionary.) In terms of creativity this could be a physical thing, like a paintbrush or a spatula, but it could also encompass non-physical things such as one's ability to communicate as a means to express oneself. We'll be covering both senses when I talk about tools.

"DO NOT WAIT; THE TIME WILL NEVER BE 'JUST RIGHT.'
START WHERE YOU STAND, AND WORK WITH WHATEVER TOOLS
YOU MAY HAVE AT YOUR COMMAND, AND BETTER TOOLS WILL
BE FOUND AS YOU GO ALONG."

—GEORGE HERBERT, POET

I'll be presenting *tools* to you that I have discovered which will lead to new ways of thinking and DOING. You will be familiar with some of them, of course, but please don't make the mistake that a few do and brush them off because "I already know that" which is just another way of saying "I have nothing more to learn"—the biggest trap one can step into. Keep your mind and eyes wide open to learn, especially what may have been staring at you right in the face!

The following are key points that will help you get the most from this book (or "course" as I sometimes refer to it) and help spark a transformation to a more creative life:

## LEAVE ROOM IN YOUR CUP

I have told this story at the start of my workshops:

> Nan-in, a Japanese master, received a university professor who came to inquire about his teachings.
>
> Nan-in served tea. He poured his visitor's cup full, and then kept on pouring.
>
> The professor watched the overflow until he no longer could restrain himself. "It is overfull. No more will go in!"
>
> "Like this cup," Nan-in said, "you are full of your own opinions and speculations. How can I teach you unless you first empty your cup?"

I encourage you to come to this book with an empty cup. If a new idea won't quite flow in, check to see if you need to make a bit more room in your cup.

## TAKE PLEASURE IN THE JOY OF UNDERSTANDING

### "THE NOBLEST PLEASURE IS THE JOY OF UNDERSTANDING."
### —LEONARDO DA VINCI

My parents instilled a deep respect for understanding words and their derivations by encouraging me to use dictionaries. My mom's mantra was to always look up any word you didn't understand as soon as you encountered it; to never try to slip past one, or you wouldn't experience *the joy of understanding*.

In addition to using a good dictionary (I recommend the Oxford Concise which also comes in a very handy smartphone app.) You can also Google "define _____"—but watch out, some of these start simple but soon get more complex. So grab what you need to understand the word and don't dive in the deep end.

## BE FULLY INVOLVED

### "TELL ME AND I FORGET. TEACH ME AND I REMEMBER.
### INVOLVE ME AND I LEARN."
### —BENJAMIN FRANKLIN

Another point I cannot stress enough: get fully involved with what I'm discussing with you as soon as you encounter it. Look at how it applies to you and your life and find real scenarios. For example, when I'm discussing tools for creativity, take a moment to locate yours, so you have solid examples. They might be kitchen knives, or a musical instrument, or wood working tools— whatever they are, connect what I'm discussing with them. This is vital to bring about positive changes.

Part of being involved is setting a schedule to study and work with this book, ideally daily, but at least weekly. Whatever you set, stick to it. Try to get in at least three hours a week which could be a little as twenty-five minutes a day. Not a bad investment to bring on a new creative life.

## TRACK YOUR STRAY THOUGHTS

"KEEP A NOTEBOOK. TRAVEL WITH IT, EAT WITH IT, SLEEP WITH IT.
SLAP INTO IT EVERY STRAY THOUGHT THAT FLUTTERS
UP INTO YOUR BRAIN. CHEAP PAPER IS LESS PERISHABLE
THAN GRAY MATTER, AND LEAD PENCIL MARKINGS ENDURE
LONGER THAN MEMORY."

—JACK LONDON

I love notebooks (they have long been a staple for artists) and I want you to get one and write in it daily. It helps to use it for *visual thinking* to sketch or write down your discoveries, key words you want to remember, diagrams and drawings of how something works, and flashes of inspiration and "stray thoughts." I write my realizations in a notebook daily so that I can keep track of what I'm learning and accomplishing and to face up to areas I need to master.

Your first assignment is this: get a notebook and use it daily while you go through this book. Write in it, draw, explore your ideas, make notes, ask questions, diagram and learn.

## WHAT TO EXPECT AS YOU LEARN

The shape of the book is this: I'll discuss the tools that I want you to be familiar with and give you examples of their use. Interspersed between the chapters are my interviews with a wide variety of creative people telling their stories about how they've transformed their lives. As you'll see, we have a very eclectic mix of artists, Grammy award–winners, a serial entrepreneur who grew up homeless on the streets, the voice of Bart Simpson, and many others who help us round out the book.

At the end of each chapter I'll ask you summarizing questions about what we covered so that you have an opportunity to look at how you can apply these points to your life. I'd like to you feel as though I'm right there helping you become involved and owning what we've covered. Use these moments as a

chance to take the given concept and do something with it: reflect, imagine applications, use it to analyze a given personal or unique situation.

If you cannot easily do so then review that section of the book until you can apply it. But don't treat these as "tests." Rather, use them as an opportunity to really dig in, get involved, and arrive at the "joy of understanding."

Next, I'll give you application steps to put these tools into use. These are designed to help transform your life to a higher level of creativity. And just as in climbing a tall mountain, you'll get to the top one step at a time.

In both the summarizing and application steps, I'll be asking you for excuses, justifications, procrastinations, etc. in order to bring them into the fresh air and peel them off like a snake sheds its skin. Take this opportunity to dig deep and rid yourself of these barriers, so that you can take action, which is the whole point of this book.

To set the tone of the book and your work with it, I don't want you to feel like it's supposed to be a hard or solemn experience. Quite the opposite—you should find yourself being more lighthearted and joyful about life as you progress through the book.

Let's make this climb together and arrive at a whole new view; a whole new way of living as art.

*Be sure to go to SilberStudios.com/Create–Resources for additional resources as you read the book.*

*Since you'll need more space when working with either the Summarizing or Application steps, shift over to your notebook, using as much paper as you need. Make a section of your notebook for these answers. For easy reference, note the page number from this book followed by the Summarizing or Application step you're working on. For example, the next ones are 17-1, 17-2, and so on.*

### Summarizing

1. What's an example of a time you learned about a new tool that improved your creativity?

2. Can you think of a time when you didn't leave "room in your cup"? What were the consequences?

3. How can you be fully involved while going through this book?

4. What are some examples entries you could put in your daily notebook?

5. Why is it important to peel off excuses, justifications, and procrastinations?

**Application**

☐ 1.    Set your schedule: I'll work with this book these days of the week:

_____

for at least _____ minutes.

☐

2. Get your notebook and begin to write in it daily.

Optional: Have some fun and get different colored pens or pencils, stars or stickers. Use these to highlight your entries, to get across the mood you want. Put stars on big flashes or breakthroughs, etc.

☐ 3.    Find a good place to work where you won't be interrupted: set it up with this book, your notebook, pens and dictionary.

☐ 4.    Write three ways you could put off doing this course (get really creative here).

   a.
   b.
   c.

☐ 5.    Write down your goals or areas you most want to improve by using this book.

# PART ONE

---

# THE CYCLE OF CREATIVITY

"EVERY PRODUCTION OF AN ARTIST SHOULD BE THE EXPRESSION OF AN ADVENTURE OF HIS SOUL."

—W. SOMERSET MAUGHAM, AUTHOR

# THE CYCLE OF CREATIVITY AND ITS PARTS

## The Five Stages of Creativity

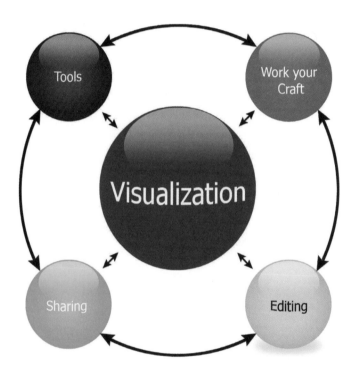

"IT IS THE SUPREME ART OF THE TEACHER TO AWAKEN JOY IN CREATIVE EXPRESSION AND KNOWLEDGE."

–ALBERT EINSTEIN

There is a natural cycle to creativity, as there is to all parts of life. For example, if you want to learn to cook a certain dish, you follow a cycle of first visualizing or getting an idea of how you want your dish to turn out. Then you consult the recipe, and get out your kitchen "tools"—pans, cheese grater, etc. (learning how to use each if needed), then you cook the dish, taste it and add more salt or basil, for example, to make it just right, and then you share it with others.

I'll be covering each of these parts in detail to help you break down the whole subject of creativity into its components for ease of understanding.

## WHAT DOES CREATIVITY MEAN?

Let's begin with the word "creativity" and see how each part of the cycle fits into this definition by Oxford American Dictionary.

> "Relating to or involving the imagination or original ideas, especially in the production of an artistic work." The derivation is from create: "Late Middle English (in the sense *'form out of nothing,'* used of a divine or supernatural being): from Latin *crear—'produced.'* "

Note that when you are exercising your creative abilities you are forming or producing something "out of nothing," which, by this definition, makes you a "divine" being. How true! When we are creating, whether as an art form or in some other aspect of our lives, we are operating in a higher state, which the Middle English originators considered divine or supernatural. But it turns out creativity is a natural ability that you can tap into any time.

Another important part of this definition is to see that when you are being creative, then go into action, you will have *produced* a creative product or result.

Now let's look at the definition of art from the Oxford Living Dictionaries:

> "The expression or application of human creative skill and imagination, typically in a visual form such as painting or sculpture, producing works to be appreciated primarily for their beauty or emotional power." Also: "A skill at doing a specified thing, typically one acquired through practice."

Let's be clear here that "creativity" and "art" apply broadly across all of life not just to "artistic" activities. Don't think of it as being segmented into small slices of your life or day, instead look for the many ways to use your imagination to "form out of nothing" with the end view of having produced a creative result, with emotional power. This could be as simple as planning and throwing a fantastic party, inviting your friends, resulting in sharing a truly memorable and creative evening thus adding art to your life.

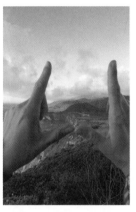

You can see the cycle of creativity begins with your imagination, moves through the steps of producing it, and winds up at the final stage of sharing it with others.

## THE MOST IMPORTANT STEP IN THE CREATIVE PROCESS

We begin at the first and most important part of the creativity cycle: it is what we call *visualization*, the process of forming a mental image of what you are going to create and how you intend it to look as an end result. That's why it is in the center of the cycle (see illustration on page 20). After all, to even pick up tools to create with, you first had to have some *idea* of what you wanted to make, no matter how brief or vague. I will show you how to develop your powerful sense of visualization, which in itself will help you unleash your creativity.

## STRENGTHENING YOUR VISUALIZATION

A big part of visualization is looking at others' work, in whatever form. This is not to *copy* their work, but to be inspired with new ideas from others based on how they were able to create their art. But it's not good enough to look at it and say, "I like this, I don't like that." That won't let you into the inner workings of their craft. Go deeper: if you like it, look at it and see why you like it. Did it have an emotional impact on you, and if so, what was it?

If you don't like it, see if you can dig in and find out why. Maybe there was something distracting about it or it had a technical flaw. Or it simply didn't interest you.

This kind of careful and deep exploration will help you when you create your own work. You're building a kind of visual collection in your mind with which to work, which is vital in developing your ability to visualize.

As an example, my wife Jan and I have been able to find houses that others have overlooked because of design flaws and outdated or missing elements. But where others might turn away, we saw an opportunity to visualize and build exactly what we wanted, rather than paying more for someone else's ideas, which rarely match ours.

For instance, when we were remodeling our home in Carmel, with its tired 1980s kitchen, its poor-quality yellow and blue cabinets, a really bad flow because of a peninsula that jutted out, and topping it off, florescent strip lighting on the wall that made it look like a parking garage, we knew it all had to go! But what to put in their place?

As a starting point, we had a feel for our desired look from our previous house, which we had also rescued from kitchen hell. There we ended up with a compact, warm, and very functional kitchen: cabinets with clean lines, with glass fronts in the doors openly displaying dishes, glasses, and other items. Our open functional design followed what Steve Jobs so clearly articulated: "Design is not just what it looks like and feels like. Design is how it works."

One of the ways the kitchen worked so well is that we had a high-top table and stools at the end of the kitchen, that became the favored spot to eat, no matter how many people crowded around it, being a perfect design that worked and just *felt* right.

We looked through magazines for kitchens we might like or even elements of them and tore out pages, putting them in a folder (I recommend this simple action for visualization.) Then we hit upon the key points that resonated with us and added to those we wanted to maintain from our last house. Because we were able to visualize, it was easy to explain and convey the look to our contractor. He brought in his cabinetmaker who was also able to stay on track with our vision, but he made some important suggestions—getting rid of the peninsula and have an island that allows easy flow around the kitchen. Then, of course, adding stools around it to maintain warm and connected dining, made it all come together. Now we knew we had it.

You can see how our initial vision was sparked by looking at examples, but it developed as we collaborated with others, which I have always found to be a key point of success in any creative activity. But it's vital to collaborate with those who will further your vision, not stop it or alter it away from the core of how you visualized it. (We'll talk about how to choose your people in a later chapter.)

## USE YOUR TOOLS

The next stage is to use your tools of creativity, which could be anything from a chef's knife to a pen and paper—whatever tools you need to bring your vision to life. The key here is to know your tools so well that they don't get in the way of your vision. And a word of caution here: Don't "geek out" with tools. When tools become an end-all and having the latest/most expensive/complex version becomes an obsession, the creative process stops right there. The purpose of tools is to *enable* you to create, not to distract you. I also believe in a minimalist approach to them: Use the fewest and least costly until you have mastered them and add new ones only when a tool really will help you create more effectively.

Let's go back to the kitchen and imagine you were learning to cook in a well-equipped one—which made your head spin with all the appliances, cooking utensils, pans—and on and on!

But say you decided to watch and follow a chef at work who made it look easy and simple. You noticed they also used the same key "tools" over and over, no matter how many dishes they cooked: knives to cut with, pots and pans of different sizes, spatulas and spoons—and they seemed to do all their work with just a few key tools of the same kind. Then it really hit home that it's simple and that you, too, could learn to cook.

## WORK YOUR CRAFT

Now you enter the stage of *working your craft*, which means to apply the skills of creativity using the correct tools to bring about what you had envisioned. The key at this a stage is to get into action and go to work! Don't think about it, don't procrastinate, get to work on your vision. Be ready to side step excuses, i.e. "reasons," and anything other than getting into action! And then, a key point is to continue. You have visualized an end result, so work until you

complete it. Don't let feelings of "it's not good enough" or "I can't do it" stop you. Keep going until you complete what you set out to do. You'll edit or fix it in the next step.

I've always found it better to get my first version out, let it flow. This could be my first draft of a short film, of prose or poetry, or the first product of a business, or any sort of creative activity. I recommend that you take a "go-flow" attitude, meaning let it flow, don't stop the flow by trying to edit as you go. Get *version one* out there in the world!

## EDITING AND REFINING

Then, the next stage we call editing or refining your work, based on how you visualized it. Having produced your art, you now have something you can refine.

When I'm editing a film, my first objective is to put the first draft into a form that tells the story I want to communicate. Most often this comes down to cutting out what doesn't help the story. Less is more in this case, and you'll find that to be true with most artistic creation.

Going back to the collaboration of remodeling the kitchen I mentioned, we were all the way to the stage of getting the work done which meant that the cabinet doors were in place. Now is when we hit this step of editing—something wasn't right but I couldn't quite spot it, they just didn't "feel right" somehow. It was while I was on a walk (and much more later about the power of walks) that I realized the design had strayed off our visualization somewhere. Then it hit me that there were no glass fronts on some of the doors as we had in our previous kitchen and were in a magazine clipping. Somehow this was lost in translation.

By revisiting the original concept with the cabinetmaker and our contractor we arrived back to our vision of how it would look, feel, and *work*. Some of the doors had to be redone in order to fully achieve our original vision. By editing we were able to get back on track. The final outcome was the design we wanted and envisioned.

The go-flow approach in the creative process no matter what art form (yes, even life itself) is very workable when you follow it with this stage of editing and refining.

As you'll hear echoed in my interviews that follow, use editing as a creative tool, not a destructive or self-critical tool. It is there to further what you have visualized, not to turn yourself inward.

## SHARING YOUR WORK

Now we come to the final stage of sharing which means getting your work out to the world. There are so many ways to share what you have created, but the important thing is that you do it!

Don't let your art sit in a drawer, on a hard drive, folded up in a closet, or even in your head. Share it and get it out to the world! By sharing I don't mean that you give it away; sharing includes selling it and getting paid for your creation, which I'm sure you'll agree is tremendously satisfying. In today's world of social media where "likes" are seen as a reward, there's really no better result than sharing your work with someone who has paid you and is truly happy with your product. But "getting paid" isn't just with money, there are many other ways to bring about an interchange for your work with a happy "customer" who may happen to be a friend, co-worker, or family.

Now that we've covered the full cycle of creativity and its parts you can see that your ability to visualize connects with each part of the cycle; your vision is the common thread connecting all steps. Additionally, each part of the cycle interacts with the others in the natural course of creativity.

By understanding each of the stages of the cycle of creativity, you will be in control of the whole process and able to apply these to any part of your life, making art an everyday experience. We'll be taking up each of the stages in detail in the coming chapters, but before we go on, answer these questions.

## Summarizing

1.  What does creativity mean to you?

2.  Describe a time you used your power to visualize and then carried it out.

3.  What are some examples of tools you have used for creativity?

4.  What's an example of a time let your creativity flow when you were working your craft?

5.  List out three excuses you've used for not completing a creative project.

    a.
    b.
    c.

## Application

☐ 1.  What area of your life would you like to bring more creativity to?

☐ 2.  Write down your vision for it.

☐ 3.  What are the tools you'll need to use to bring about your vision?

☐ 4.  What excuses have you used for not getting into action in that area?

☐ 5.  List three steps you will take this week to get into action. (Check off when done.)

    a.
    b.
    c.

☐ 6.  Now look it over and do any editing or refining of that project.

☐ 7.  Share your work with someone you feel comfortable with.

# CREATIVE CONVERSATION WITH CHRIS BURKARD

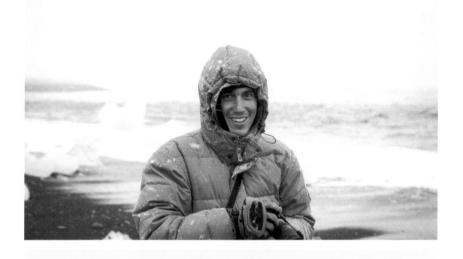

Chris Burkard is an accomplished explorer, photographer, creative director, speaker, and author. His visionary perspective has earned him opportunities to work on global, prominent campaigns with Fortune 500 clients, speak on the TED stage, design product lin es, educate, and publish a growing collection of books. Through social media, Chris strives to share his vision of wild places with millions of people, and to inspire them to explore for themselves. At the age of thirty-two, Burkard has established himself as a global presence and influencer. And he has a managed to navigate his dynamic career while also raising a family.

I've known Chris for ten years. His first book *The California Surf Project* caught my eye because it was so fresh and alive. I then invited him on *Advancing Your Photography,* my YouTube show, and found his artistic advice and his ability to capture moments were spot on. It's no wonder he has over three million followers on Instagram, it seems we can't get enough of him.

*\*\*\**

*When did you first flip the switch to having a fully creative life?*

I made the choice when I was nineteen and I quit my job and quit school to pursue photography. At the time it wasn't really about creativity. It was just more about making a living, doing something that I loved, and I think the concept of embracing some sort of career path that would lead me to interesting places and interesting people and an understanding of the world was really my draw.

I think that inadvertently it led me to a place where creativity kind of reigned supreme. It led me to a place where I could foster creativity; that's always been my biggest takeaway. Creativity is not something you just have all the time, you have to set parameters, you have to create barriers or walls or guidelines for yourself to live with so that you could foster a creative life or foster a creative environment.

That's really the key component. I think for me over time things have become more and more creative or I've been able to operate in a more and more creative capacity because I've done that.

*What were the biggest barriers you had to overcome to make that happen?*

A big one was just mainly dealing with my own self-worth and self-validation. When you submit your work and you never have any type of positive feedback, it can be really challenging. That's a really hard thing to do. I think the first and biggest struggle people deal with is self-worth. You have to come to—"my work is valuable." That's a conclusion you have to come to on your own. And that's a really hard one to just figure out.

*How did you come to that conclusion?*

I didn't. I decided slowly over time, like dew forming: it's super slow, you can't even watch it, there's no turning point. People always ask me, "When did they just click?" And there's no such thing as when things click. If you want to talk about overnight success, it took twelve years of overnight success. The reality is I chose not to think about that. I just put my head down and did my work and there were small successes along the way. There were a lot of failures for the most part. I think that what you find is that even if you do receive great praise from one of your heroes, that's only going to take you so far.

At a certain point, you have to realize that all that validation, all of that earning a paycheck, collecting stamps in your passport—is not going to mean anything to you unless you find a purpose greater than those things, a purpose that creates passion. Passion alone is not creative. Nobody ever said, "I'm passionate about what I do because somebody said so." Or "I'm passionate about what I do because it pays the bills." That's not true. That's totally the opposite.

So I think it's key to understand that at a certain point you have to figure out what you're passionate about and you have to foster that. Usually that requires some introspection and some time for reflection—a spirit quest, whatever you want to call it, to understand what makes you *you* and what drives you. For me it was the ability to share stories with my family, those who sacrificed a lot for me, and my mom. I think I felt really indebted to her for raising me and for other reasons. So I'm just giving you a very simple slice of what drives me. But ultimately that's really what it comes down to.

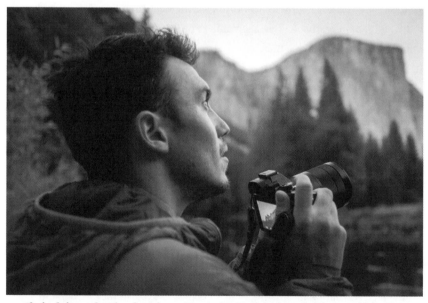

» **Chris doing what he does best, Yosemite National Park. Photo: Eric Johnson**

*What are the successful actions that really make creativity happen for you?*

Having a good routine. Surrounding yourself with positive people or influences. Identifying the positive things in your life and the negative. Fleshing out your mission statement and what it actually means to you.

The key thing is that you don't need to be good at everything and you don't need to tell yourself you're good at everything, or try to convince yourself or other people. Therefore, when you're showing your portfolio or you're sharing your website, don't try to convince people that you can shoot the action *and* landscapes *and* portraits *and everything.* That's not needed. You're hired because you're a specialist and because you're the best at what you do. And really that's what you want to do. You want to hone that skill.

*What advice do you have for someone who wants to put more creativity and art into their life?*

I've always looked at these things as a career path; how do you want to achieve this as a career path? How do you want to do this to build your name and reputation? It's pretty straightforward: surround yourself with things that inspire you. If you don't know what inspires you, go out and try new things.

For thousands of years, we have lived outdoors. It's only been the last couple hundred years that we have been an indoor culture. So deep inside of us, in our most innate self, we are craving to ignite all of our senses. Living indoors shuts off certain parts of your senses. You don't have to live with those senses because you don't have to worry about where your food comes from.

So you need to get to a place where you're using all of those senses. You're finding out what it is you're passionate about and that really requires you to experience new things. I can't express that enough. I think that most of society is a bit too complacent and a bit too looking-for-handouts as opposed to working for one.

*How do you add creativity to your life as a parent?*

When it comes to adding creativity as a parent, you simply have to realize that your goal as a parent is to *foster* creativity. For me at least, it's not really to lead or to instruct or to demonstrate, it's to foster it, because kids are born with it.

You don't need to teach them how to be creative, you don't have to teach them how to be imaginative, you just have to create scenarios where they can do that and let it flourish.

A big part of it is learning how to be hands-off at times and how to create an environment—and nowadays creating that environment might be less screen time and more time creating outdoors, or making your own games or playing theirs. Also when your children do find something that they are passionate about or inspired by, then allowing and supporting that, going all-in with them and letting them really feel the whole thing and experience it. That's a big benefit that we can provide them as well.

# KNOW YOUR PURPOSE FOR CREATING

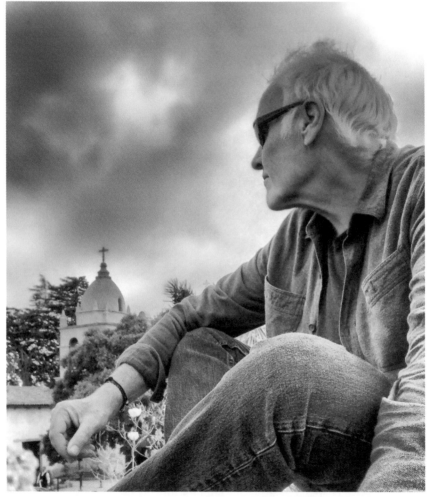

» Selfie (iPhone), Mission San Carlos Borromeo del Río Carmelo, Carmel, CA

"THE PURPOSE OF ART IS WASHING THE DUST OF DAILY LIFE OFF OUR SOULS."

—PABLO PICASSO

Before we take a deeper dive into the cycle of creativity, let's take look at *your purpose* for adding creativity to your life.

First, let's look at the definition of "purpose" from the Oxford American Dictionary:

> "The reason for which something is done or created or for which something exists." It is derived from propose "influenced by Latin *propositus* 'put or set forth' and Old French poser 'to place.' "

When you have a purpose, you are placing or setting forth your objective or reason for doing something. It's as though you're reaching out and placing in front of you where you want to end up.

Think of the difference between getting into a car to just sort of drive around because you're bored, compared to driving to the trailhead of a mountain so you can get out and climb it. Now look at the difference in your purpose for each: no real purpose in the first one, in the second you know exactly where you are going and why. You might ask, "What is the purpose for climbing this mountain?" If you ever have, you'll know the answer instantly: exhilaration coupled with a sense accomplishment that is unmistakable. The bonus is bringing home marvelous stories and photos, adding up to quite a creative package for this purpose.

Having a purpose fires you up; lack of one leaves you lifeless. It's an on-off switch for life. You'll notice those times when you're really motived by a purpose you come more alive and are more creative.

## GETTING SCHOOLED BY LIFE

My high school experience taught me a lifelong lesson about this. In my junior year, I had the opportunity to attend a prep school in Vermont, which was quite a change from the hippy school I had been going to in the mountains above the San Francisco Bay area. Friends of my family with kids my age were moving back to New England to avoid the drug scene that was raging out of control at the time, and they asked my parents if I might want to go along with them.

That summer I had been living up in the hills with friends and enjoying the essence of the California scene: sleeping under the stars among oak trees; long

nights by the campfire and many trips to the Fillmore Auditorium, the iconic music venue in San Francisco that had every big name music group of the day come through its doors, including the Doors.

When my folks asked me to come home for a talk, I was apprehensive what might be in store, given my frequent shenanigans. I was sure it would somehow cut short my Peter Pan existence. But when they asked me if I wanted to go with the other family to attend high school in northern Vermont, I immediately said yes. The charm of New England and the adventure of going to a new part of the country were irresistible.

So, as the summer was ending, I cut my hair and my mom took me to Macys to get outfitted for this new preppy adventure. That was my junior year, which turned out to be the pivotal point of my high school experience. When I arrived, I found the quality of education was far superior to what I had experienced in the free-form school I had been attending.

» **The barn behind our house, Lyndonville, Vermont, Marc Silber**

When the school year ended, I returned to California to attend high school in the fall with over two thousand students. Compared to the prep school with only a few hundred kids, it seemed like an impersonal factory. The school looked and felt like prison to me with its unimaginative cinder block construction, loud class bells, and sterile learning environment. Compounding this was the curriculum for my senior year— essentially what I had just eagerly embraced in Vermont in my junior year. It felt like a massive rehash, and I was getting capital B for bored with trouble on its way from an antsy teenager.

This all added up to a miserable imploding scene for me, and I was ready to do something desperate. I dreamed of the country-wide crisscrossing journeys of Jack Kerouac in *On the Road*, taking my camera and a backpack and heeding Bruce Springsteen's compelling command: "We gotta get out while we're young, 'cause tramps like us, baby we were born to run."

Sizing up my options, I decided the best thing for me was to drop out of high school and hit the road. You can only imagine how my well-educated parents responded to this "bright" idea of mine. After a few "sick days" and a lengthy battle, the verdict came from my dad: "Marc, go back to school!"

I did, but not without a prolonged pout where I spoke as few words to my parents as possible. I could have won an award for my superbrat performance. Finally, after a week of this slow torture, my father said he couldn't go on like this and would I please knock it off and get back to the family too. He was a very hardworking and dedicated MD with a strong family practice. What really reached me about his appeal was when he said it was affecting his ability to care for his patients. That little recognition of a higher purpose than mine pulled me out of my funk.

But going back to the factory-school wasn't any easier nor the outcome any better, so my wheels kept spinning. I was like a junkyard dog with a bone on the other side of the fence asking myself, "How can I get out?"

Somehow, I got the idea to check up on my credits for graduation, and lo and behold, I found that after the first semester of my senior year, which was about to close, I would only need one more social studies class to graduate! And at about the same time one of the teachers there was getting ready to take a few high school students to Mexico to work on a project building a medical dispensary in the very remote Sierra Madre Mountains above Mazatlán.

I spoke with him, and he said I could go along with the other two or three if my parents and the high school were okay with it. Now, here I was going back into the line of fire, but at least this time I actually had a sensible plan to graduate instead of just dropping out. Now my strategy was to convince my parents and the high school principal to allow me use this Mexico trip in lieu of attending the final senior semester

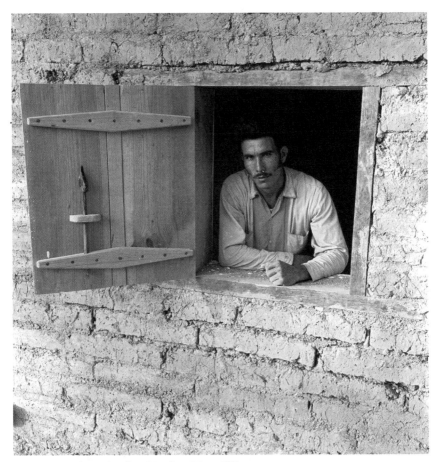

>> **Fausto, Sierra Madre, Mexico, Marc Silber**

## MY GREAT ESCAPE

In one of the best sales jobs of my life, I made an appointment to speak to the
principal of my dreaded school and gave him my pitch, which came out all in
a nervous rush. After I had delivered it, breathless, with no more to say, I sat
back and waited to hear his response. He took a long time, removing his glasses
and cleaning them slowly, as though they were somehow essential to what
he was about to say. My stomach was turning and I felt slightly nauseous; so
much was riding on what was about to be said. In the vacuum of his silence my
thoughts rushed in to fill it: I wondered, what is he thinking over anyway? How
to get this wild-eyed kid back in line? Did this call for some sort of discipline

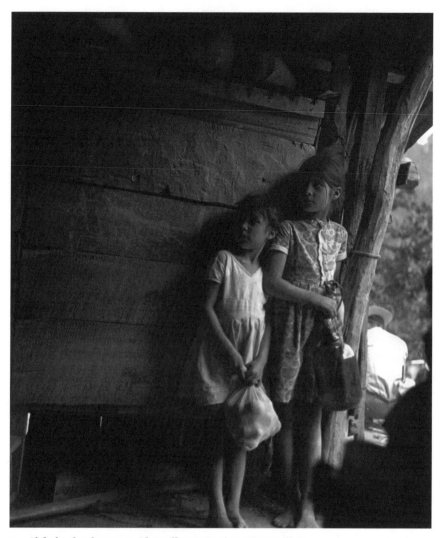

» **Girls in the doorway, El Zopilote, Mexico, Marc Silber**

These were some of my life-lessons from this experience:

1. My protests and urge to flee the misery of high school prison didn't get me out, in fact I was more trapped and cut off than ever.

2. Light began to dawn only when I stopped trying to escape and began to research and really look at my options.

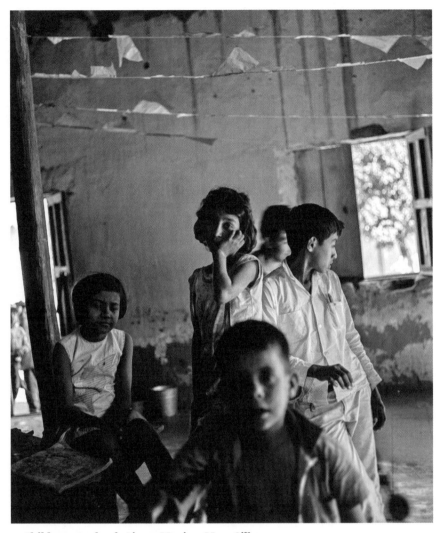

» **Children at school, Ajoya, Mexico, Marc Silber**

3. Tapping into the purpose to help others was what finally opened all the doors; even the principal couldn't say no.

4. I learned that I had to work much, much harder for this taste of freedom. In high school I was loafing along, ninety percent asleep. In Mexico it was raw manual labor from dawn to dusk: cutting trees, making adobe, lifting, carrying, sawing, trying to speak a language that I so sloppily tossed off back in school. But this hard work made me strong mentally, physically, and spiritually.

5.   I was rewarded immensely by capturing some of my best photographic work and finding a new level of creativity.

6.   And finally, I learned problems were solvable, not by running away but by looking for a real solution. I was only able to realize this after I had decided to work on a higher purpose—to help the people of this remote region in Mexico.

If you have any areas where you feel trapped and miserable, where your only road out seems to be to escape (and even that is blocked), where the romance of leaving seems to be calling, I invite you to look to renewed purpose as the solution.

By identifying your purpose and passion for having a more creative life you can open the doors and let the warm breeze of life flow in.

But before I try telling you a lot of BS about how perfect it will be for you from there on out, let me tell you what you already know: it is much harder work and much more challenging. But when you identify and follow your purpose, you know you are alive and will have strength to make it through the challenges that the world throws your way.

 Summarizing

1.   What does the word "purpose" mean to you?

2.   What is an example of when you were being aimless or wandering?

3.   What's an example of a time you were very much focused on your purpose?

4.   Have you had a time of misery and entrapment, where there seemed to be no open doors?

5.   What was your solution?

6.   How could you solve it now?

## Application

☐ 1. Write down a purpose you could have for creativity.

☐ 2. What creative activity or activities do you want to pursue? Write one of them down very specifically.

☐ 3. Write three excuses you've used for not doing it.

    a.

    b.

    c.

☐ 4. Write down three specific actions you can do now to strengthen your purpose in this area.

    a.

    b.

    c.

☐ 5. Now carry them out. How did that feel?

☐ 6. What was the result of this action series?

# CREATIVE CONVERSATION WITH CAMILLE SEAMAN

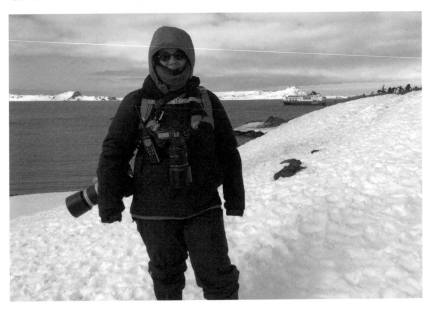

Camille Seaman is a photographer whose work focuses on the fragile environments, extreme weather, and stark beauty of the natural world. Her work has been featured globally in publications, including *National Geographic* and *TIME* and *The New York Times*. She has won many awards, is a Senior TED Fellow as well as a Stanford Knight Fellow.

I was captivated with Camille's work when I interviewed her on my YouTube show but I was also struck by her deep spiritual connection to the world as a Shinnecock Native American, and wanted to find out more.

\*\*\*

*What's been successful in terms of adding creativity to your life?*

That is a hard thing for me to even speak about because I think I am creative by nature. I describe myself to people as a compulsive creative and it means that I have to be doing something fun and I'm always making something. I'm always curious. If I'm not knitting, I'm making furniture or doing beadwork or

photography or film. I don't compartmentalize between not being creative and the rest of my life. And that's why that quote in your preface about mastering the art of living resonated so well with me.

***Are there any common misconceptions that you'd like to dispel in terms of creativity or being an artist?***

Many people approach me and want advice. It seems to me that they think there's a formula like you do A plus B and you will reach C. I never saw life like that. I always understood from a very young age that I am the author of my life. It doesn't have to be done a certain way in order for it to be the right way for me and what works for me may not work for the next person.

And so my advice to people who are interested in furthering their creative career, whether that's in the arts of any kind or just living more fully and authentically, I tell them, "know thy self." To take the time to figure out who they are and what makes them happy and what makes them unhappy. Because when you have those—that self-awareness—it's so much easier to avoid the pitfalls that make you unhappy. For me personally, "unhappy" is being stuck and hobbled. If I'm told that I cannot do something, that's like a death sentence. There is always a way for me to do it.

People thought I was crazy. Even moving to Ireland, everyone was asking, "Why would you do that?" And I said, "Well, why not? I've never done it." I think that as humans we allow ourselves to become so comfortable and so complacent, so set in our routines and on our "rails," and we just accept that they're going in a direction—without trying to author that direction or influence it ourselves with what makes us happy or curious. It's so sad to me that many people I come across have no curiosity; they just want to swallow whatever's fed them and that's enough, I can't imagine that kind of life.

I was very lucky as part of the TED Fellowship, we were mentored by the people at Creative Capital, which is an Andy Warhol foundation. One of the exercises they gave us—it was brutal and powerful—was to sit down and write our obituary. To write what you want to be said about you at the end of your life when you're not even close to it is a very powerful experience.

***What are some of the barriers that you've had to overcome to lead your amazingly creative life?***

I think most of the actual barriers are self-imposed. It's our own thought process and voice that says, *Who are you to think you can do this?* or *Who are you to think that that's available to you?* Again, the first step of knowing yourself and understanding that, when you truly do, you'll know that you are capable of anything and everything. Nothing is impossible except what you tell yourself is impossible. Once you know yourself, that second step is really gaining control of those inner voices, that inner dialogue, because that's the only thing stopping you. People say, "Oh yeah, what about money and bills and responsibilities and practical things?" If you are truly true to yourself, those things will be taken care of.

It's not that it's about money, but it's about that inner voice that says that you are not worthy or you do not deserve, or how dare you think that you have the audacity to demand a living wage or to thrive instead of struggle. It goes back to point one, if you don't know yourself, how can you understand that you are unique in this universe and there is a place for you? I think personally that the whole purpose of our existence is, just like the universe itself, to expand and create and to flourish. I don't think that it's supposed to be as painful, especially in the creative world, as we make it for ourselves.

***What advice do you have for someone who wants to put art and creativity into their whole life?***

I tend to sound extreme on this because I was raised to go big or go home and I don't think that anything done in half measures or half steps is ever going to give you the result, or the feeling that one is seeking. My advice to anyone who wants to live a more creative and fulfilling life that they feel is more purposed and meaningful, inevitably they're going to have to leap. Maybe you don't leap all at once. Maybe baby steps into the pool and you put in your 10,000 hours of painting, drawing, photography, or whatever it is, music, dance, writing. You put those hours in while you're doing other stuff that is giving you something to push against. Because when you're unhappy, that can be fuel to propel you away from that unhappiness.

If you're not ready to leap, then use that unhappiness as a push, like in a swimming pool when you push off the wall. Use that to propel yourself away from that unhappiness. Know that when you get up at six in the morning, because it's the only free time you have to write or practice your violin, that is fuel pushing you away from the unhappiness. And then, one day, hopefully you'll see that you're ready to leap.

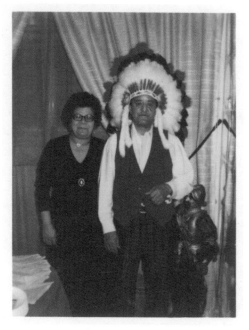

» **Oleada & Lester Seaman Sr., Camille's grandparents**

*As a native American, you told me you view objects that most people consider inanimate as actually living. How does this influence your creativity?*

My grandfather died when I was thirteen, of cancer. Before he died, he called each one of us grandchildren into the room with him. He said this to me, "You are billions of years in the making and there is no one like you. You are born of this time, for this time and you carry the wisdom and strength of your ancestors with you and you can access that at any time. You are not alone. Your job is to figure out how you will serve and when you figure that out, you should do that." He believed all of us lived in service to each other. Even a king, if

they're doing it right, lives in service to their subjects, and our president should be in service to the people and so on.

We are always reminded that we are part of and must remain humble and respectful of all of our relatives, whether it's a cat, dog, bird, fish, tree, plant, or flower. Those are all our relations and when you walk through life seeing everything as your relative, it's much more difficult to do harm and it's much easier to feel connected and inspired, rather than isolated, because connectedness versus isolation already implies a state of mental health.

More and more, I've been speaking with young people, teenagers to university age. And I challenge them immediately and ask, especially to the college kids, "Why are you here? Why did you just decide to stay on the rails and get a university degree?" Many of them haven't ever stopped to ask themselves a question like that. And I always tell them, this is your life, this is your story. You get to write it. Not your parents. They had their chance, don't live or do stuff for them. This is your chance. What do you want to do? I think a lot of older adults who are already on the track and rails don't ever stop to say, "Why am I on these tracks and rails?"

# VISUALIZE WHAT YOU WANT TO CREATE

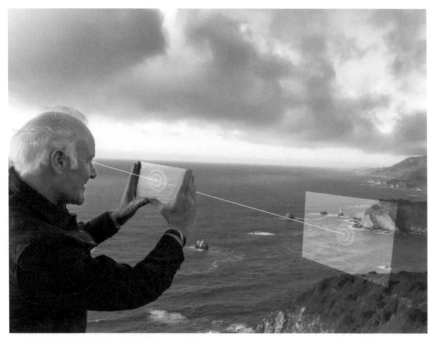

>> I'm visualizing on the rugged Big Sur Coast, CA Photo: Hollie Fleck/ Illustration: Pete Hoffman

"VISUALIZE THIS THING THAT YOU WANT, SEE IT, FEEL IT, BELIEVE IN IT. MAKE YOUR MENTAL BLUEPRINT, AND BEGIN TO BUILD."

—ROBERT COLLIER, AUTHOR

The power of visualization is the secret that artists, entrepreneurs, sports figures, and all creative freethinkers have used for centuries.

As just one example, Brian Wilson of the Beach Boys fully visualized the sound of each instrument used on *Pet Sounds*, his breakthrough album. He first heard in his mind the sounds of a wide range of instruments, many of them had never even been thought to be used before in rock songs. This included such unlikely ones as sleigh bells, a trombone, accordion, ukulele, and even Coca-Cola bottles. With his vision resoundingly clear in his mind, he then went into the studio where he was able to direct musicians to play precisely what he had already heard, like a craftsman following a blueprint.[1]

As an artist, you use your imagination and skill to create work that will communicate effectively what you saw and even felt to your audience. This is inherent in the definition of art by Oxford Dictionary:

> The expression or application of human creative skill and imagination... producing works to be appreciated primarily for their beauty or emotional power.

From this you can see that art applies to any creative skill using imagination. It is much broader than simply thinking of art as painting, drawing, sculpture, music, etc. Let's view art in this wide sense and apply it to any part of life.

A common misconception is that one simply goes forth and works on their craft in the hope of somehow creating art that will be beautiful and have emotional impact. But this would be like a builder with no plans, simply grabbing wood and building materials and putting them in place in the hopes that they will come out fitting well and looking great.

The first and most important step of improving your creativity is learning the skill of "visualization." It's another way of saying, "using your ability to imagine or get a mental view of something."

This term dates back to 1883 and according to the Oxford Dictionary means "the action or fact of visualizing; the power or process of forming a mental picture or vision of something not actually present to the sight; a picture thus formed."

---

1 *The Beach Boys Making Pet Sounds*, and *The Wrecking Crew* documentaries.

It comes from a Latin word meaning "sight" and an earlier word meaning "to see."

Keep in mind visualization doesn't just apply to visual art, as in the case of Wilson's ability to visualize sounds. A dancer does the same with her movements. A gardener with their design, a parent with an outing for their kids, etcetera.

Take a moment—can you remember a time when you visualized something you created before you set out to make it? It could be a birthday party for a friend, or redecorating a room, a presentation at work—any area of creativity. This is creating with definite purpose or intention, rather just letting it happen and hoping you'll get what you want.

## THE KEY TO CREATIVITY

With all of the steps of the creative cycle, why is visualization the central and most important part in the whole series? Because it guides every single step of the process, without which, as we've seen, it would be like trying to travel without a map or plans, or make a movie with no script, or sail a boat without

» **Dorothy True by Alfred Stieglitz, 1919, courtesy of Getty Museum**

charts. In all of these activities, you will end up wandering around and never achieving your goals, which would be wasteful and very frustrating.

I can't emphasize strongly enough that the fastest way to elevate your creativity is to visualize the final result before you work your craft.

## SEE WITH YOUR MIND'S EYE

Alfred Stieglitz (1864–1946) was known as the "father of modern photography" and was one of the

most respected photographers of his day. He emphasized that his process was to see in his "mind's eye" the photograph that he intended to create, in order to convey what he "saw and felt" at that moment. He said, "I have a vision of life, and I try to find equivalents for it in the form of photographs."

Equivalent here means "something that is considered to be equal to or have the same effect, value, or meaning as something else," according to Encarta College Dictionary. It comes from a Latin word meaning "be strong." Thus, when you convey the equivalent of what you saw and felt, it can be very strong for the viewer.

Having a "vision of life," of what you see and feel when you view a particular scene, is what sparks the whole creative process. You are conveying a message including emotions to your audience that they can connect with. This same process applies to writing, music, decorating, or any art form.

## ELECTRIC VISUALIZATION

My first major visualization of a photograph had a rather strange beginning in the eighth grade: Peninsula School, the grade school that I attended from age two to twelve, valued creativity, adventure, and freethinking above all else, which is why I had such a strong beginning in these areas early on. So, by the eighth grade I already considered myself a photographer and brought my camera along on our class trip in May shortly before graduating. As was traditional, the upper classes would take weeklong trips in the fall and spring, often with a specific purpose. This was our spring trip with the goal of finding the extremely rare California Condors, which were nearly extinct by that point.

Our class only had about twenty students which caravanned down the central coast of California in a green VW bus, my teacher's bright red Land Rover, and a tan Ford station wagon. Leaving from the San Francisco Peninsula, we wound our way south on Highway One through the artistic town of Carmel, then past the jagged cliffs on the coastal ribbon of a highway to the bohemian Big Sur, and then continuing south to the small sleepy fishing village of Morro Bay.

Arriving at the campground stiff and pent-up from the drive, to our pre-teen way of thinking, it seemed like the very best thing we could do was to get into a water fight, which many of us engaged in with fervor, resulting in soaked

clothes, but now back in form for adventure. The wet clothes left me chilled and feeling oddly apprehensive.

» **Morro Bay, CA, Marc Silber**

My friend Bob and I took off to search the nearby area of our campground and came across two tall pines that were begging to be climbed. But we also had the wild notion of peeing off the tops when we reached them, each from our own tree: two boys intent on marking their territory like a couple of wolf cubs.

The tree I had chosen had its top cut off, but from my perspective I couldn't see why. I soon discovered as I made haste up the tree: The limbs were lopped off because there were power lines cutting right over the top. But feeling no sense of danger, I secured my spot, shouted over to my friend, "Hey there's power lines over here," and unzipped and let the pee flow forth, arching widely and cascading down like a miniature waterfall. With the lines less than six inches away, I remember thinking as I climbed the rest of the way up, *I'd better be careful when I turn around at the top to climb down.*

Then there was a deafening buzz in my head and a zap of painful electric shock to my left arm as I unwittingly brushed my wet jacket against one of the lines. I was literally blown backwards out of the tree. In slow motion, my limp body bounced down one branch after another, on its descent from the tree. After the horrible shock, my mind and body shut off like a circuit breaker tripping

with an overload. I seemed to watch my body acting like a rag doll dropped from the top, flailing on its way down. From the blankness of mind came only one repeated line, what I was trying to say to my friend, like cartoon thought balloons coming out of my head, "I'm dead...I'm dead...I'm dead!"

Finally, as time stretched like salt-water taffy, having hit eight or ten branches, I collided with the ground, thankfully cushioned by decades of pine needle debris. A pause, and I started to breathe, after what felt like an hour, but was less than twenty seconds. Very stunned, I stood up, oddly first taking notice that my fly was still unzipped. Breathing in I smelled the dreadful stench of burnt flesh. I kept saying, "I'm dead, I'm dead."

Bob must have made haste down his tree and came over to see what had happened. He looked at me and said, "Hey Marc, you're not dead!"

As life came back to my limbs and my mind awakened, my death-thought suddenly inverted like a high diver doing a flip, and I said "Holy hell! I'm alive, I'm alive!"

I stood up, taking stock of my situation, moving my arms and legs to see if anything was broken. Amazingly everything moved, nothing broken, hardly even a scratch. My limp body acted like rubber and simply bounced down the tree limbs like a sack filled with tennis balls.

I felt oddly different, having my first brush with death. Something had changed. I understood the apprehension I had felt earlier, it was looming like a thunderstorm that was now dissipating, the dark clouds breaking up. The horror of this experience was being replaced by the warm glow of realizing I was indeed alive. *I am alive!* I thought.

Going back to our campsite, we both told our teacher what had happened in an overlapping, excited staccato fashion, as though spitting it out quickly would bring him on board faster, which seemed very important—to have an adult learn what had just happened.

Looking very concerned, he asked me to take my jacket off, with its row of neat burn holes up the arm to the shoulder. With my jacket removed, those same holes could be seen on my skin—burned through the flesh. He cleaned the burns and applied ointment and small Band-Aids to the burns, but as there was

nothing else wrong with me, that was the extent of the first aid. I asked him if he thought there was damage to my brain? With a steady look and a kind smile, he reassured me that I looked fine.

Now with that incident over, it was time to move on to the next adventure: as sunset was nearing, our teacher said to load up the cars to head over to the sand dunes nearby. So off we were again in our caravan of Land Rover, VW, and Ford, to the designated dunes.

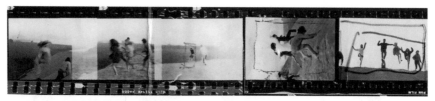

» **Contact sheet of Sand Dune Jumping, Morro Bay, CA**

Arriving, we all jumped out and ran to the top of the sand dunes. Still shaky from the whole very recent experience, I still had the presence of mind to bring my camera. My friends were busy scrambling around hooting and kicking up sand. Then a group found the top and jumped off. I captured a few frames from the side with my beloved Minolta A5 film camera, but that wasn't particularly interesting. The sun was setting behind them, so I went down about twenty-five feet below them on the sand dune. With a flash (a good one this time) I had a vision to capture them in the air from the bottom as they jumped off—with the sun behind, they would be perfectly silhouetted.

Quickly assuming my role, like a director on a movie set, I called out directions:

"Guys, back up over the crest of the sand dune and when I yell 'run!', run as fast as you can together and jump in the air when I yell 'jump!' "

Sensing my purpose, I had their attention instantly, which is no small feat if you've ever tried to focus the attention of a group of twelve-year-olds busy playing. With the group at the ready, I moved into position, focused my camera at the right spot, I set the shutter to 1/125th of a second, aperture f/8.

Following my orders perfectly, they backed up and on my command to run, came charging toward me, like calling "action!" as a director. Then, as they hit the top of the dune I yelled "jump!" and they took off in the air. I

anticipated their motion exactly and was able to capture them in a perfect arc. My visualization was complete and that moment captured forever in this one image, their joy of being alive and free, resonating with my recent feeling of being near death—then suddenly being alive and creating this split second that has lasted a lifetime.

I pressed the shutter at the exact "decisive moment" to capture their graceful motion, a split second later it all fell apart into random motion.

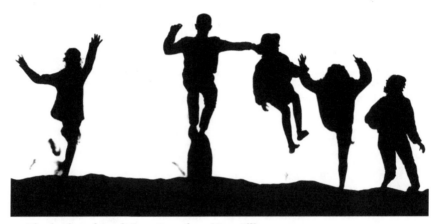

>> **Final print of Sand Dune Jumping, Marc Silber**

Many years later, Caroline, on the far left with her hands in the air, wrote to me about her experience:

> "I was twelve years old, just coming into my adult consciousness, and experiencing one of the happiest years I'd ever known, in the wonderful community that was our class and our school. It was a glorious feeling to jump off the edge of the dune, all together, and that was captured exquisitely by Marc. A month or so later, the photo appeared on the cover of our student-made yearbook, enshrining that moment as an emblem for our class. It became for me a symbol of one of the happiest times of my life.

> "As I look at the photo now, those feelings come back vividly, although with some perspective. Part of the thrill of jumping was that we were together, on our own, and the moment was caught by one of us— creating an expression of our new selves by ourselves, with no adults

involved. The ensuing years have been rewarding in many ways, but rarely as carefree and joyful as that moment. In the right atmosphere, surrounded by the right people, a spirit can soar."

It was strange to move so rapidly from dark to light, but as I found many times later, not totally unusual to find a near-death experience springing into a fully alive and fully aware state.

## LIFE LESSONS FROM THIS EXPERIENCE

1.  Look up before you climb a tree that's cut off at the top. Translated: pay close attention to your environment dude!

2.  No matter how you get there, being fully alive opens the doors to creativity.

3.  Visualize your art.

4.  But then **act** to make it happen.

5.  As a subtext of this—be willing to direct people to bring about your vision: Don't leave it to chance.

6.  Then be fully prepared with your tools so you don't miss the opportunity.

7.  Capture your art at the decisive moment.

## HOW DO YOU STRENGTHEN YOUR VISUALIZATION "MUSCLES"?

I didn't write "learn how to visualize," because you already know how to do it. As it turns out, the ability to visualize is "standard equipment" from our earliest age. In fact, when we are kids it might be its strongest (the previous story as an example), and alas, as we grow older we often hear excuses for not being able to imagine and create as we once did. But the visualization ability of the mind is powerful. It just may need some regular exercise to get back in shape.

Can you remember the wonder you had as a child and the flexibility your imagination had? It's that ability we want to focus on at this stage of creativity. I am so grateful that I made creativity a major part of my life, it has kept me young by causing me to continue to imagine.

# FEED YOUR CREATIVITY: GO TO MUSEUMS

Here's some *Damn Good Advice* from the book of the same title by George Lois, a source of inspiration for me. He is one of the most creative people I know; in fact, he has said, "Creativity can solve almost any problem—the creative act, the defeat of habit by originality, overcomes everything." Among his many accomplishments, he has designed ninety-two covers for *Esquire* magazine, so listen closely to his advice about feeding your creativity:

> "You must continuously feed the inner beast that sparks and inspires.
> I contend that the DNA of talent is stored within the great museums of
> the world. Mysteriously, the history of the art of mankind can inspire
> breakthrough conceptual thinking in any field."

Take George's advice and spend plenty of time looking at art (he does it weekly on Sundays). But when you look, don't just glance and say, "That's great. That's strange," etc. Really look deeply.

Here's the process I suggest: bring your notebook with you to take notes or sketch as you look. If you can't go to a museum, you can do this with books, but don't do it on your computer—you should get as close to the original art as possible.

First, you can select a genre of art that is similar to what you want to create. But you needn't be too selective, it seems any form of creation could be the trigger you need and sometimes the most disparate will be the one that does that.

» **Girl in a Large Hat, Caesar Boëtius van Everdingen, c. 1645–c. 1650, Courtesy of Rijksmuseum, Amsterdam**

Find a work of art that you are particularly drawn to, as I was to the above painting by the artist's use of curvy lines to express the mood of beauty and femininity.[2] Observe closely to find what resonates for you. Take notes of your observations. What can you learn from this art? How did the artist use their canvas or other materials to present their story? What is your attention drawn to? Adjust these questions for the type of art you're observing, listening to, reading, etc. The basic question is: what did the artist communicate to you?

---

2 To learn more about composition and how to express moods, see my book *The Secrets to Creating Amazing Photos: 83 Composition Tools from the Masters.*

## STRENGTHENING YOUR VISUALIZATION IN OTHER AREAS OF LIFE

The same approach that I have outlined of looking at art can be translated to any area of life you would like to add art or style to. For example, if you want to bring more creativity to your work, look for examples that you admire where this has been done. There are magazines such as *FastCompany* that delve into successful ways leaders and entrepreneurs have approached their mission creatively.

The same can be done with sports by studying those who have brought new approaches to their field. Every new advance in a sport was because someone had a new idea and was courageous enough to try it. As in the example of rock climbing, when I first learned, I pounded in Pitons (metal spikes and objects of various sizes to enable the climber to secure their rope to the rock). These had been used for decades in various iterations. But they had a huge drawback: they defaced the rocks: as more and more climbers covered a route, the rock was literally being beaten away.

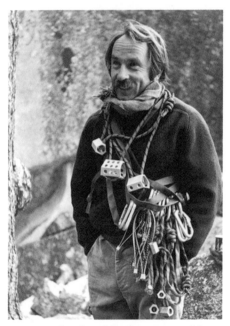

» **Yvon Chouinard by Tom Frost with a rack of chocks**

In the 1960s some British climbers began to use ordinary machine nuts attached to a nylon runner in the place of pitons. Instead of being pounded in and out with hammers, they were placed in cracks by hand with no scaring of the rock. Then in 1972 Yvonne Chouinard began manufacturing them in various sizes (called nuts or chocks) and "clean climbing" became the norm for all climbers. Chouinard went on to found Patagonia, the very creative and extremely successful outdoor clothing and equipment company.

From here we could study the innovations of Patagonia both

in their design of clothing and the way they conduct their business. Just to highlight a few of each: Their products come with a lifetime guarantee, but they take this a step further, by allowing trade-in of your clothing and gear, rather than tossing it out. This innovation was born out of Chouinard's deep commitment to environmental concerns. His mission has guided the company in many ways to fulfill his commitment, including making products that are made to last decades, rather than perpetuating our "disposable economy."[3]

We can trace another aspect of innovation with rock climbing to the growth of indoor climbing gyms. Again, going back to the days when I learned to climb, there was only one educational venue: outdoors, on rocks. While there's no arguing with the sheer beauty of such a place as Yosemite, with the mecca of climbing in the states, there was a need for urban practice. Thus indoor climbing was born as a means to get in shape for the real thing outdoors, but also as a sport for those who might never venture to such exposed high-risk rocks. Instead, they could have a workout in their own city, strengthening and honing their skills.

So, look closely into your area of interest, to find those who have shown creative skill and innovative approaches. You can take this one step further and ask how you can improve what you have found. You may be the next person to make a major breakthrough that changes that area forever.

## TRAIN YOURSELF TO SEE AND VISUALIZE ART

It's good practice to always look for art. Whenever you have a moment, riding on a subway, waiting for a meeting, or out on a walk, try to find art in that environment. Don't just look for the beauty in the world, life has a full array of emotions like the keyboard of a piano. Learn to see and play them all. A big part of strengthening your visualization is looking past your own emotions and barriers to simply look at life head-on.

As an example, for a writer, while riding on a train, you hear a conversation that makes you feel disgust. Going past that, simply listen and take note of how these people are talking, what they are saying, and how they look. This can give

---

3 When I asked his assistant if we could schedule an interview for this book, he replied, "I'm sorry but Yvon's still unavailable, due to his self-imposed retreat from public exposure. At this time his sole interest is in desperate efforts to save the planet from increasing threats to survival."

you a lot of material to work with in communicating this feeling of disgust in a powerful piece of writing.

» **Notebook page of Leonardo da Vinci, Library of Congress**

Leonardo da Vinci gave this important advice for any artist:

> "You should often amuse yourself when you take a walk for recreation, in watching and taking note of the attitudes and actions of men as they talk and dispute, or laugh or come to blows with one another...noting these down with rapid strokes, in a little pocket-book which you ought always to carry with you."

For visual art, it can help to "frame" with your hands making two "Ls" on top of each other or touching your thumbs together and look through them. Simply find images that are interesting to you. Think of it as a workout for your eye. The same drill applies to other art forms: listening for street music, seeing design elements for decorating, observing how parents interact with their children, or how a leader uses creativity to inspire her team.

I often will walk into an environment and just know there is art there, and like a game of hide and seek, will look for it until I find it.

Repeat the above drills—building your mental collection of art, and looking for art.

 Summarizing

1.   What does visualization mean to you?

2.   Give an example of this in your life.

3.   Write an example of a time you were inspired by a work of art and used it to create something of your own.

4.   Name some of the things you would look for and put in your notebook when looking at art.

5.   When looking at life, what can happen if you block out certain emotions, moods, or attitudes?

6.   What are some ways you can train yourself to look for art in any environment?

Application

☐   1.   Write down the genre that you're most interested in seeing at a nearby museum.

☐   2.   Go there with your notebook and carefully observe (taking notes and sketches) of at least three works of art, using the steps on page 57, especially the last point—the communication of the artist.

☐   3.   When you go home, read over your notes and write down what you learned.

☐   4.   Take a walk as da Vinci recommended: look at the attitudes and actions of people. Note your observations.

☐   5.   Review these when you get home and write down what you learned.

☐   6.   Now visualize a piece of art you want to create and keep it simple (a sketch, a paragraph, a meal, a photograph, etc.) Write and/or sketch it in your notebook.

☐   7.   Write down what you learned from this.

# CREATIVE CONVERSATION WITH KEITH CODE

Keith Code has been described by *Rider* magazine as "...arguably the best known and most successful on-track motorcycle instructor in the world." Riders who have been trained either at his schools or by him personally have won upwards of fifty world and national racing championships. He founded the California Superbike School in 1980, the first rider training school to develop a step-by-step rider-training curriculum. His teachings have spread all over the world.

Keith has written three books about riding and racing techniques and produced two feature-length movies covering his books, *A Twist of the Wrist* and *A Twist of the Wrist II*.

Keith Code hits high on the list of the most creative and dynamic people you might ever have the great pleasure of meeting. You'll see in his bio his major accomplishments but there are many more creative ones under the hood, which is why I wanted to sit down with him to have this conversation about what works for him as a creative.

<div align="center">***</div>

**What's been successful for you as a creative person?**

You can't ignore moments of clarity and inspiration. That's the key. Those are the moments that you have to grab and they're fleeting moments. When I do find myself involved with those moments, things open like a book. They're the spark of creation waiting to happen when they come to you. I think everybody must get them now and again. But if they ignore them, then they do so at their own peril. Finding those things and recognizing them—"Wow—that's a good idea! I have an idea, what do I do with it?" Get involved with it and poke around with it, see what happens. That's really what the most successful action is, not ignoring those moments.

You have to be willing to put in the "seat time"—time in the chair. If you're writing something, you've got to be willing to sit down and write when "I think I got an idea on something" happens. In order to create, you have to be able to get it out of your head and put it down someplace on a screen or on paper, or if you have something involved with materials, you have to *do* something with it. You can't find anything out unless you start to manipulate it.

Getting the inspiration is great. It's the thing that pushes you along. But you maintain the momentum of it by the ripple effect of the inspiration: So you had the original inspiration, that was the stone in the pond, and then you go, "Ah! But that means _____, and then that means _____!" That's the ripple effect, it keeps you going "I just worked for two days writing something that I really, really enjoyed. It was illuminating. It was good. It was something that will help my students. And it was a new angle that nobody had ever really taken a look at before. And I nuked it, somehow or another I erased it from my mind!" When you write it down, you put your hat back on and you go and create it. It's better the second time.

That's what I mean by the seat time, put the seat time in whatever it is, the activity or the inspiration, staying in communication with the things that you feel will push you forward in your area of creativity.

### How do you add creativity to other parts of your life?

For me it's the interest level. If something's interesting enough to put in the effort, then it's fulfilling to create in that area. The best things for me are not the things that are pushed on me, but the ones that I feel a close connection to and have some affinity with. Those are the things that are easy. Maybe they're hard jobs, but they're easy to get into. They're easy to get involved in. And at the end of the day, involvement is the key element.

When you find yourself bored and think *Oh it's a job, this is just tough, I gotta work through this.* Then maybe it's time to step back. And write down what are you really passionate about, you know, the passion is the thing that also creates a momentum in just wanting to change or improve things.

### What advice do you have for someone who wants to add creativity to their life?

I teach and write and produce educational material, and have been doing it for over forty years. To stay interested, you have to keep your net out for that butterfly of inspiration that's floating around in your universe, don't ignore it—keep your nose open for the things that really will inspire you.

Everybody should have a muse. Where you find a muse you never know! For me, my muses who created that backdrop of creativity are the people who I wanted to be like. It really is important to have some examples of others who have created, that you admire. That's another important thing, just having some admiration for others who have created sets the bar for you, even if the bar is way, way, way high!

It's really, really important to have some stars in your firmament that you hold in high regard and would be proud to say, "Hey, you know I really enjoy what you do and it's been an inspiration to me. And look what I did."

*Any other advice?*

In my first book, I wrote a passage titled "What It'll Cost." Even though it's written for motorcycle racing, you'll see that you can apply this to any area of life, especially a creative one.

Riding is a game of balancing how much and where you spend attention and, for everybody who's ever read my book—that concept totally sticks. (See the following excerpt.)

Attention is like money and at any given moment, you have an amount of money or attention that you can spend, and how you divide that up is a mark of how successful you're going to be at whatever it is that you're doing. And if you have too much attention spent on unimportant things then important things have tendency to slide. And the other aspect of it is that, even with things that seem automatic, they do tend to cost you something.

» **Keith, cracking the code on What It'll Cost**

## WHAT'LL IT COST? FROM *A TWIST OF THE WRIST* BY KEITH CODE

Attention, and where you spend it while riding a motorcycle, is a key element in how well you will function. **Attention has its limits.** Each person has a certain amount of it, which varies from individual to individual. You have a fixed amount of attention just as you have a fixed amount of money. Let's say you have a ten-dollar-bill's worth of attention. If you spend five dollars of it

on one aspect of riding, you have only five dollars left for all the other aspects. Spend nine and you have only one dollar left, and so on.

When you first began to ride you probably spent nine dollars of your attention on how to let out the clutch without stalling. Now that you've ridden for years and thousands of miles, you probably spend only a nickel or dime on it. Riders tell me that some common movements, like shifting, have become "automatic." It's not true. They are simply spending less attention on it. Riding is like that. The more operations you reduce to the cost of a nickel or dime, the more of your ten dollars' worth of attention is left for the important operations of riding or racing.

You must make hundreds of decisions while riding just one lap of a racetrack or one stretch of road—especially when riding fast. Hundreds! If you understand enough about riding to have correctly decided how to handle twenty-five of those situations, you are probably a fair rider. **The things that you do not understand are the things that will take up the most of your attention.** Whenever a situation arises that you do not understand, your attention will become fixed upon it. You often fear a situation when you cannot predict its outcome, and panic costs nine dollars and ninety-nine cents—you may even become overdrawn. The course of action you have already decided upon to handle a potential panic situation costs much less than this and leaves you plenty of attention to sort out your options.

On the positive side, sorting out the actions of riding beforehand buys you the time and freedom to become creative with the activity of riding, just as having lots of change in your pocket allows you a certain freedom of movement. On the racetrack, that leftover attention allows you to experiment and to improve your riding ability.

*High-performance* riding and racing demand not only that you be able to perform the necessary actions, but also that you be able to observe them. Making accurate observations of your performance is the key to being able to improve them. **If you know what you have done you know what can be changed.** If you did not observe what you were doing, the changes become haphazard and inaccurate. Do you agree?

# THE JOY OF KNOWING AND USING YOUR TOOLS

» An eclectic mix of my tools for a variety of creative activities, Marc Silber

"A GOOD TOOL IMPROVES THE WAY YOU WORK. A GREAT TOOL IMPROVES THE WAY YOU THINK."

—JEFF DUNTEMANN, WRITER

The next stage in the cycle of creativity is the use of your tools to bring about what you have visualized.

Let's look at how the Encarta Dictionary states the definition of tool:

"**Device for doing work;** an object designed to do a particular kind of work…"

"**Means to an end;** something used as a means of achieving something."

This definition fits in perfectly with the creative cycle between having your *vision* and *working your craft,* for which you need the right tools as a means of achieving your ends in your art.

Keep in mind the broad concept of a "tool" and look for ones that apply to your area of creativity or innovation. For example, we've heard about tools a parent might use: The ability to foster creativity as Chis Burkard discussed. He and Marsie (who you'll hear from after chapter 8) both talked about creating scenarios (her photo shoots and Chris' games) as a tool to cultivate creativity with their children.

I had a very workable tool I used to use with my kids when it was time to get up and go out but there was a lack of focus and even a whine of "what should we doooo?" Long before surveys had become *de rigueur* in our modern would, I created a survey and asked each one separately to let them have their own say in the matter. I put all the items that I thought they would like to do and add a few that I was pretty sure they wouldn't, for humor, and so they could resoundingly reject them. Then having asked each, I would announce the two or three items and find magically we had agreement about what to do, where just earlier we had discord. One tip was to combine a healthy activity like a bike ride to the park, with something that was purely fun for them, e.g. eating ice cream when we got there.

It's a good idea to inventory your tools for creativity in your life and in your field of art. It's quite therapeutic to look around these areas and simply list out the tools you have used successfully and constantly. Here are just a few examples:

**Writing**: Your notebook to collect ideas; computer/typewriter/pencil and pens; various tools you use for research—Google, and or your favorite reference librarian; dictionaries and thesauri; reference books; audio recorder for interviews, etc.

**Decorating**: reference books and magazines for the style you want; color wheel to find complementary harmonies; research tools noted earlier, etc.

**Photography**: cameras, lenses, software for processing, reference books, etc.

Many tools cross over for multiple uses such as your reference material, and of course your sense of aesthetics that you developed in the last chapter.

With tools, you have the ability to transform your imagination into reality. Your vision determines the tools you use. This is also interactive: your tools can inspire your vision.

**» Nikonos underwater camera Photo by Morio, Nikon Museum, Tokyo, Japan**

As an example, I once borrowed a teacher's Nikonos underwater camera, which I was incredibly curious about using—a camera you could take underwater many decades before GoPro became the newest thing. Since I had never used it before, I played around with it a bit in the swimming pool. Then amazingly, as if on cue, a large bullfrog came swimming out of the leaf catcher. I visualized getting a shot from under him swimming, then diving with the camera, holding my breath, I captured him. You can see it was a cloudy day through the water with the sky a big gray feathered mass.

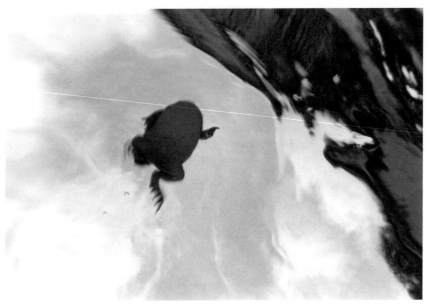

» **Frog in pool, Atherton CA, Marc Silber**

In this case the tool lead to my visualization, which I was then able to craft and capture as I had imagined it. And no, he didn't die a horrible chlorine-poisoned death. After getting the shot, I set him free in the moist ivy where he had been living ever since I let go dozens of small frogs several years earlier.

It's important to know your tools so well that you can use them to work your craft, and so that your use of them doesn't get in the way of your art. In other words, you don't want to be fumbling with controls and miss a decisive moment. In the case of the Nikonos, I used it just enough to get comfortable with it before I captured the frog. And of course I was well grounded in camera use already.

> "THE BEST INVESTMENT IS IN THE TOOLS OF ONE'S OWN TRADE."
> —BENJAMIN FRANKLIN

## THE AESTHETICS OF TOOLS

There's a great sense of joy in having fine tools that you use to create your art with, including living itself. To show you how broadly the term "tool" can span, here are a few examples of some of my most memorable and treasured.

When working in Mexico on the project I wrote about in chapter two, we had a minimal set of hand tools: a few hammers, two hand saws, a large two-man saw to cut planks from felled trees, a few knives, screwdrivers, pliers, a drill, and a few odd drill bits.

 There was one other magical tool called an "*hacha suella*," a small hand adze which is similar to a hatchet, but with the blade perpendicular to the handle instead of parallel to it as a hatchet is. This remarkable tool proved to be the Swiss army knife of hand tools. We used it for hewing, carving and sculpting a variety of pieces of wood needed for building our dispensary. This adze must have been thirty years old, well used but still in very good condition. Its oak handle was polished to a rich sheen from so many years and so many hands clenching it to manipulate wood. I would have loved to have taken it back to California with me, but it belonged to the project. And, alas, I could never find one like it here.

When I returned to California, I used my minimalist attitude toward tools to build a cabin in the Santa Cruz Mountains. But here the effort of construction seemed to defy gravity with its ease since I was used to the challenges of that remote region in Mexico. I took the same approach of using hand tools to their fullest potential to build and sculpt this free-form cabin constructed around oak trees and rocks, tucked into the shade of a hillside. Being my own pack mule, I carried everything up to my cabin on my back from the nearest staging area off the dirt road that wound past an old apple orchard, making its way toward Peter's Creek.

Another handsome set of tools was all my backpacking gear. I fine-tuned this traveling home over many years. My R&D was done over months at a time in the High Sierra, the Rockies, the Sierra Madre, and the Green Mountains of Vermont. Then thrown in the road tests were numerous hitchhiking excursions getting to and from these majestic places.

When you spend that much time with your home on your back, you become quite

» **Backpacks c. 1970**

particular and attached to its contents. I had an intense aesthetic joy at the end of each day when I set up my camp in a Zen-like fashion, with literally all items from my orange Sierra Designs tent, lights, dishes, and utensils perfectly ordered. The feeling of beautiful order was intensified by the golden light as the sun went down hitting my camp, and bouncing in and around my tent, striking shiny surfaces. Instead of being glutted with disposable and anonymous "things" that pass through our lives like crap through a goose, these few cherished items became true friends of mine and I admired their utilitarian beauty immensely.

Cameras, of course, have been tools for me to capture images to tell visual stories. They ranged from my earliest Brownie, to my first manually controlled 35mm, which I adored because I was able to be in full control, having reached the limits of the Brownie. I finally graduated to the top film cameras of the day, which were indeed works of art: The Leica, Rolleiflex, and Hasselblad, the pinnacles in terms of technical and beautiful design.

I repeated this whole process when I moved to digital, beginning with a 3.2 megapixel entry level camera. Once I had proven to myself that I could use it to capture a few striking images, I moved directly to the top Nikon of that time.

I have always taken the same minimalist approach that I have with the tools I've mentioned; enough to get the job done, but no excess. Many people ask me which camera they should use. I answer the same as a chef who is asked which knife to use: the one that gets the job done, that fits well in your hands and that you love using. Try them out until you find that combination.

» **Salvador Dalí's Studio, Port Lligat, Spain, Marc Silber**

Then there is the wealth of non-mechanical tools, such as those for writing to clearly convey your ideas to someone else or of composition to tell your visual story. There are tools of living life as art to create a sense of aesthetics, in everyday living: a sense of style, an ability to communicate easily, an understanding of people, an eye for design to name a few. Each area of life has a set of tools that one should gather just as I gathered the perfect mountain travel kit.

> ### "PEOPLE USE TOOLS TO IMPROVE THEIR LIVES."
> ### —TOM CLANCY, AUTHOR

## EIGHT THINGS TO KNOW ABOUT TOOLS

1. Use tools as enablers to create your art, and your life.

2. Don't get stuck in the "equipment trap," obsessing over always having the latest gear, or geeking out over technical features, but then forgetting about actually using them to create art (yes, that happens all too often).

3. It's best to start with the simplest version of a tool you need and then move up when you've mastered it. You'll learn what features are really needed and when you do move up you'll appreciate it.

4. Get to know your tools as close friends. Where applicable read their manuals or books written by someone who has become familiar with them and who passes along know-how in an easy-to-understand way (not in often confusing manual-speak). You can also look for reliable and simple videos on YouTube, but beware of #2, avoid the too-technical ones!

5. Take care of your tools and they will take care of you. This includes cleaning, maintaining, and putting them into good order.

6. Tools break, but many can be repaired and added back into the race again, if not, get another one. Remember these are your best investments.

7. A good way to see what tool you need is to assess what problem you're running into and then find the tool that solves that problem.

8. Remember people create art, tools by themselves don't.

> "WHAT'S IMPORTANT IS THAT YOU HAVE A FAITH IN PEOPLE, THAT THEY'RE BASICALLY GOOD AND SMART, AND IF YOU GIVE THEM TOOLS, THEY'LL DO WONDERFUL THINGS WITH THEM."
>
> —STEVE JOBS

## ACCESS TO TOOLS

Something I've noticed for years, when you look over any skilled craftsperson, you'll see that their tools are in good order. In fact, it would be enough to see poorly kept tools and equipment to turn around and look for someone else. I've made the mistake of not doing so and regretted it later. It's always best to trust those who value their tools and keep them handy and ready to use.

A big part of creating art in your life is having fast and easy access to your tools. Have you ever missed a great photograph, as the sun was going down, hitting your subject with its sparking rays, then looked to find your camera (where is it?). Then you finally get it, rush to set it up, and there you are with that gorgeous moment gone forever. This could be true of any tool, whether pens and notebooks or brushes, musical instruments, whatever your instruments for creativity are.

You want to be ready to grab them to work your craft at a moment's notice, literally 24/7.

## CREATE YOUR SPACE

Where will you work so you can be focused and not distracted? You'll want to set up your "studio," even if it's a desk and a bookcase, then that's your dedicated workspace. Set it up with your tools on hand, which begins with first deciding what you'll need for crafting your work.

If you're going to write, decide what's best for you. As you know, I use my notebook and clippings to gather ideas and data. But when I write I use a computer. I also have to hand reference books I'll need including a variety of dictionaries, thesaurus, manuals of style, and books that I have gathered for guidance and inspiration.

Warning: computers are very handy but they can be a source of diversion from your task. They call to you like the beautiful sirens who tried to lure Ulysses to his death, and as he did, you have to block out their distractions. At the beginning of each work period, close all other programs on your computer except for writing software and possibly a browser you might need for research. Specifically close mail, texts, and other notifications that pull your attention away from writing—you can live without these for the time you're working. This holds true for any other art form that may involve your computer.

Gather your tools and make sure they are properly placed and in good working order. This includes having supplies to hand, batteries charged, and any other preparatory work.

## "HE LIKES TO KEEP HIS FIRE ENGINE CLEAN, IT'S A CLEAN MACHINE." —LENNON-MCCARTNEY, PENNY LANE

Let's face it, when you're working and producing, things can get pretty messy. Look at a shop that's being well used—all sorts of tools get pulled out, nails, sawdust, screws, the full array. On a film shoot, there can be a wide assortment of stuff around: lights, cables, equipment, makeup, you name it. This goes for any creative activity. But there's a point where the disorder mounts up and gets in your way. So I offer a few important points for keeping tools and your workspace clean and usable.

First is to edit. We'll be covering this in more detail in the next chapter, but as far as tools and your workspace goes, you'll want to edit out anything that isn't needed. I'm also aiming this advice to myself, as I have an inclination to collect things I really don't need in my work area (and elsewhere) in spite of my wife Jan's gentle urgings to edit. Having confessed, I will write what I know I should do in the hopes that this sinks in to me.

Here's the drill: look around your workspace and edit out any "kludge." ("An ill-assorted collection of parts assembled to fulfill a particular purpose," thanks Oxford.) It's a great word. Just hearing it conjures up its meaning—odd stuff that's not needed, like clothes that don't fit or are way out of style. How many rock band T-shirts do you really need anyway?

One way to tell if it's kludge is ask—when was the last time you used it? If it's over a year or two it might be on the most unwanted list. Now this can be sticky for an artist, when you dive back into odds and ends that you might later pull out and use in a project. I've done that with photos, that I'm certainly not going to discard. And much to my sorrow I discarded all my vinyl records when CDs "replaced" them. But these are artifacts. What about everything else?

## SORT YOUR STUFF!

There is a sorting that one must do and decide:

Is this an everyday useful tool that needs front row access? Then find a place near to hand but out of the way of your work, too.

Is it useful but not needed often? This will then live in a bin or on a shelf.

Is it a supply or replacement item but not needed often? This can go on a farther shelf and in a bin.

Is it something you'll want to archive for possible later use, like photos, your writing, various artistic items, (sigh, here's where your vinyl records go if you gave up your turntable too), and other such precious items. Place them in a bin, well-marked, and put it in a closet that you can get to when needed.

You might have a cool collection of tools that you are not going use, but have aesthetic, symbolic or emotional value that you want to make a museum for. Then set up a designed place as I have for older cameras, that I can see but are out of the way of my workspace. When you do this really go for it, and not just as a knickknack shelf (a.k.a., kludge), but elevate these worthy items to their own proper space.

If it doesn't belong to any such category and you really don't know why you're keeping it...but you can't let go of it, put it in a designated "rest home" area like a spot in your garage. Maybe after enough time has passed one day you can quietly let it go!

And finally the stuff that you know you don't need: toss it, recycle it, or give away and congratulate yourself for letting go of it! (More advice to self.)

Now, with the kludge removed, go to work putting it all in order. Jan likes containers to keep the space tidy and orderly. There's a wonderful feeling of neatness and simplicity that comes with having bins, boxes, shelving, drawers, and such where everything lives and stays in its home when not actually in use.

I'm a fan of adjustable wire shelf carts that come in various sizes, where you can adjust shelf heights to your needs. They can also be put on wheels, which can be very handy too. Then on their shelves you can place your containers to hold neatly organized items.

## TIME TO PUT YOUR TOOLS IN ORDER

When you look around your workspace, you may feel overwhelmed at how much you need to organize it. Take it step by step, like implementing a new exercise program, schedule some time for it daily until you've caught up the backlog and then keep things in shape from there on out.

» **Wire racks, cases and bins help bring order**

Jan likes to call "five minutes of clean up!" It's amazing how much you can get done in just those few moments. We'll also set a time period to clean and organize, like thirty minutes in the garage on a Sunday, to keep it in shape.

## EAT FROGS

> "IF IT'S YOUR JOB TO EAT A FROG, IT'S BEST TO DO IT FIRST THING IN THE MORNING. AND IF IT'S YOUR JOB TO EAT TWO FROGS, IT'S BEST TO EAT THE BIGGEST ONE FIRST."
>
> —MARK TWAIN

Frogs are those things you put off doing, that seem the most un-fun but there's a lurking thought telling you it should be done. As Twain said, take it on first

thing, and get it out of the way. Don't want spend time organizing your space? Eat that frog first then get into other stuff that's more fun. It works.

As a final note about tools and your workspace, let's hear more Damned Good Advice from George Lois.

## "MAKE YOUR SURROUNDINGS A METAPHOR FOR WHO YOU ARE"

"I've always invested so much effort in my immediate surroundings because the objects and surfaces and forms that surround me must feel aesthetically right to me. Your working surroundings should not be a presentation to your clients, and your home should not be a presentation to your friends. Surroundings should relate to who you are, what you love, and what you deem important in life.

"In the end, your tools and your surroundings form a team with you as the leader directing them to fulfill your purpose and vision. To that point, use what you've learned here to operate like a great coach and spend time keeping your team tight and in shape."

 Summarizing

1. What are some of your favorite tools you've had (any time in your life)? What made them so?

2. What are three non-mechanical tools that you use?

3. How can you get to know a tool as good friend?

4. How can you streamline your access to tools?

5. How could you make your surroundings a metaphor for who you are?

## Application

☐  1.  Write a list of your tools for creativity:

☐  2.  Highlight your top five:

      a.  Write down one thing you'd like to know more about each.

      b.  Find the answer to each by looking for it in its manual or Googling for it (avoid geeky or overly complicated answers).

☐  3.  Establish your "studio" or workspace:

      a.  If you already have one, look it over and write down three things that need to be improved to have better access to your tools.

      b.  If you don't, then set up a designated space you can call your "studio," even if a desk and bookcase.

☐  4.  Write down three excuses you've had for not having a proper workspace, or not keeping tools in good order or knowing exactly how to use them.

### Bonus Steps

☐  1.  Edit your tools and space: do an initial "de-kluge," removing, items that don't need to be there at all (send them off to where they belong or recycle them, etc.).

☐  2.  Put your tools in order using bins, containers and other organizing devices. Label them as needed.

☐  3.  Look over your space and do any other tweaking to make them "a metaphor for who you are."

☐  4.  Set a schedule daily to spend at least fifteen minutes putting order into your workspace and tools, remember to eat frogs first.

# CREATIVE CONVERSATION WITH DAVID CAMPBELL

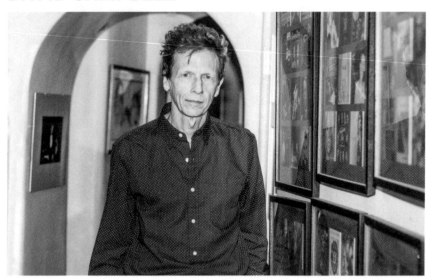

David Campbell has an astonishing career as an arranger, composer, and conductor, having worked on over 425 gold or platinum albums. Remarkably, albums on which he worked on have received fifty Grammys, and his film work has garnered two Oscars for music.

Artists he has worked with include Adele, Justin Timberlake, Michael Jackson, Linkin Park, Beyoncé, Miley Cyrus, Faith Hill, Carole King, Bob Dylan, The Rolling Stones, Metallica, Paul McCartney, Green Day, Radiohead, Dixie Chicks, Ricky Martin, Neil Diamond, Sheryl Crow, various albums by his son Beck and many others.

He has also arranged and orchestrated music for over 80 films including *Annie*, *Foxcatcher*, *August: Osage County*, *Rock of Ages*, *Dreamgirls*, *North Country* and many others.

David has three children, each world-class in their creative abilities and achievements: Beck, Channing, and Alyssa.

I met David when we were both teaching a group of new filmmakers. I was struck by his deep understanding of the creative process in general and by his insightful way of teaching.

<center>***</center>

*David, what have been your main successful actions for putting creativity into your life?*

My most basic concept of creativity is that it has to do with flow; it's not analytical. There are times to be analytical and figure logistics out. But when you're looking for the creative spark on something original, or something that's fresh, or just something that comes from you uniquely, you have to keep the flow going in your outlook.

One thing that could get in the way of that is self-criticism. There's nothing wrong with criticizing your own creations, but you have to do it at a later time. When you're trying to come up with the initial idea, that's the wrong time to then say, "that's lame" or "that doesn't work."

You just keep it flowing. Even if you innately know, "I can do better than that," you just keep going, you keep something going. And then I find usually that the best ideas come right away, because there's a sense of freedom there. You haven't been stopped or stuck by stale ideas or old ideas or "what would so and so think?" or any of that. That can't be part of the creative process because it's just naturally going to work against being creative.

When I sit down to actually create something in my music work, initially it's just to start something. It doesn't have to even be good. I don't care. Just the action of doing it, getting the juices flowing. And then you get yourself into it and you're excited and then of course the good stuff's going to come because that's you. And you're not putting attention on other people or what they might think.

That's really, really vital. Otherwise you get into all these crazy things like when some people start with the idea of "I'm not creative." That's wrong. Take that out of the way because everybody's creative. Look at young children— they're all naturally creative. They get overwhelmed easily by someone's

judgment of what they do, but left on their own they go for it creatively. So everybody has creativity in there somewhere so there's no reason to start with the negative of "I can't do it." You have to just take that off table and proceed to create positively.

**What have been some of the biggest barriers you've had to overcome to get where you are today?**

Earlier on I was curious about this whole idea of being creative. I started out as a musician, not a writer of music. Just interpreting other people's work and that seemed easy enough. Mozart, for instance—I just learned how to play it and listen to my teacher and play nicely and listened to other recordings of how others played it and kind of mimic them. And then after doing it a lot, I started to get my own voice. It was easy to ease into it.

Then when I started coming up with my own ideas from nothing, from just a clean slate, a blank canvas, I had this phenomenon that would happen. I would think, *Now I'm being creative. Oh this is cool.* Then this voice going in myself would say, *Are you gonna be able to keep this up?* So in this case, you're creating something, but you're over here looking at yourself doing it, to see how well you're doing. I had to get rid of that, I actually had to apply what I learned while being a musician, where I learned to play the piece of music so I didn't have to think about what are the notes, or how should you play it. I could just start to play it and feel it. So there's that idea of flow again and I could just create this feeling of "I'm playing it and it's beautiful" and putting my own emotion into it, my own feelings—me. So I started applying that point of view—the flow of ideas—to sitting at a keyboard trying to come up with a whole new idea. That way you flow yourself right into the creative spark.

» **David at the mixing console**

*How does knowing and using your tools fit into your creative process?*

In music it's kind of obvious you have to learn to play something or how to sing, or you have to learn some kind of a mode of performing in order to get the ideas out. It's not that different from learning to talk. We all had to learn to talk and to express ideas. So the more you do that, the more fluid it's going to be. The more you can apply the technique of an area, the easier it is going to be to just keep it flowing. The best solution is learn as much as you can about it or even just learn a little bit, but then do it a lot. By doing the activity, (whatever it is), in huge amounts, you will achieve greater and greater creativity.

*Do you have any favorite tools in any capacity?*

As a composer, for the first half of my career I had to write everything with pencil and paper because computers weren't up to the level of being useful as a writing tool. So I had roughly three decades of doing a tremendous amount of writing music on pencil and paper, which is not unlike a sketchpad for a visual artist or a journal for a writer. It has that tactile feeling and there's a visceral feeling you get when putting it on paper. There's your "hand," your style of putting it there. It's very personalized.

Then, I moved forward to the personal computer age where there are applications that accomplish all the same things that we used to do by hand,

but do them much faster, so that you can get way more work done and delivered and out the door. Everybody expects that speed now. But since I had the background of pencil and paper, somewhere in my mind I'm projecting the tactile experience onto the computer application. For a musician, you really need to have that background of actually picking up an instrument and playing music that moves people. If you can do that, then you can use the computer tool, and you're going to breathe more life into it.

*That brings up the question of how you put creativity into all areas of your life?*

It just boils down to looking for as much beauty, the parts of life that you really like. What do you like about all this stuff around you, the people around you, the situations? What can be beautiful or artful or aesthetic or pleasurable about what's around you? That's putting art into your life, as a constant process every moment of the day. When you run into people who do this on a major level they're usually huge in their area. Their whole life has that: their family, the way they dress, the way they entertain themselves, how they reach out to people, or it relates to the amount of friends they have. This element is always there: "Isn't this beautiful!" or "This is incredible!" Putting a positive spin on things. I've had the good fortune to see some really great examples of that. I aspire to it myself because it just looks like so much fun.

*Let's talk about being a parent: you have some very creative children.*

They are who they are and that's why they're so creative. But my influence is that I realized early on how young children are just naturally very creative, really imaginative, and they spend such a huge part of their day just dreaming stuff up. But the downside of it is typically their confidence about it, they can be a little fragile because they're in their world of creation, their illusions full bore in a dream world, a fantasy world. But the other part of life they're looking for is encouragement since they're little and they're aspiring to be adults in some fashion.

It's fragile, this child creativity, but once you give them a little confidence, they're going to be unstoppable. They'll start to get cocky about how good they are. But it's okay. In that frame of mind, they have a chance to become a really great artist because they don't care about what anybody thinks after a while, which is really the best. As an artist, you come up with the freshest ideas. And

you have the tenacity of "This is what I feel, I'm just going to really put it out, and if nobody likes it at first. I don't care. I'm going to keep doing it." That's what contributes to an artist becoming successful.

With my own children, I tried to be consistent regarding their creativity. For instance, with Beck, anything he's made, I just thought it was great. No judgment or additional comments. I just really appreciated it. Then there was a point when he was around seven or eight, that I had this thought, "Maybe it's time for me to start to show him what I know." I started to do it very lightly. But then right away he'd come back with, "What if you did it this way?" And I looked at it for a second and thought "That was really brilliant. I'm just going to shut up." That has been my mode ever since. Because whatever he came up with on his own, without me filtering it or doing anything to counter it, ended up being a really good idea. I'm still that way now. I've done that with all three of my kids and they're all majorly creative in their areas. They have their own voice.

That's the fragile nature of teaching. The best teachers I had were the ones that always wanted to know "What do you think?" or they'd say, "Here's a little information about this area. Now I want you to just write about what you think." And they'd be genuinely interested in it. Those were the points where I gained huge ground as a creative person. But whenever it was more locked down with an attitude of "This is the way we do it, you have to do this, this, this." With those people, I tried to get out of there as fast as possible because I could feel the creativity being pressed in instead of freely flowing out. You have to be able to learn how to do your craft but it's a delicate matter to teach it so that you don't squelch that original thinker or future innovator.

# CHECKING IN WITH EACH OTHER

>> **Setting the next goal on the Teton trail, Grand Teton National Park, WY, Marc Silber**

I want to keep this discussion as much as possible like a live dialogue that you and I are having. If we were on a long backpacking trip, we'd take breaks where we could talk about how it's going, you could ask questions, and I could find out how you're progressing.

On this type of journey, we'd set goals for ourselves to hit some rewards. Rather than racing ahead and then stopping often to rest, it's actually best to set a comfortable pace and set designated rest times, usually on the hour. Leaving our packs on, but taking the weight off by propping on a rock or tree, we'll grab some water, trail mix, and have a look at the map, to see how far we've come and how far we have yet to go.

Then for the big breaks at lunch and mid-afternoon, we'd stop, take our packs off—whew, such a relief! Often boots would come off too, and if there's a stream—oh man!—nothing like soaking those hot feet in a cool creek or river, while drying your socks in the sun. Food comes out—cheese, rye crisp, salami, mixed nuts, and sometimes even smoked oysters, and also water with fruit crystals. And then, of course, sublime bites of chocolate. A gentle breeze blowing through, the smell of the pines; the pleasure of this simple feast surpasses the finest dining experiences!

While we're resting, we have time to check in on our progress, and with each other: we'd talk about some of the most amazing views and spots we saw. We'd also have a chance to look at any difficulties we're having, maybe fix a sore spot in our boots before it becomes a blister, or fix an uncomfortable pack.

On a really rough day when emotions can get raw from having to push through difficulties or even an interpersonal flare up, this break gives much-needed time to let some "air out of our tires" and chill out before we hit the trail again.

Then with food and some rest, we're feeling better, the map comes out, and we get to see where we've been and where we'll be headed, and set our expectations to make it to the designated camp in time to get set up and catch a jaw-dropping sunset.

So pull out your notebook, grab some trail mix or some cheese and something really refreshing, and let's take a look at how you're doing so far.

### Summarizing

1.  What part of the material we've covered so far has resonated with you the most? Note why it has.

2.  Have you had any realizations about your own creativity?

3.  Have you been using your notebook daily?

4.  Look back over your notebook entries since we started. What did you notice when you did that?

5.  Has anything been uncomfortable (like a "blister") or is there anything that is hurting in any way?

6.  Was there anything that didn't make sense or was confusing? (Let's go back and get it cleared up.)

7.  What needs to be changed the most to hit your goals to add creativity to your life?

8.  Any excuses you've had for not adding creativity to your life?

9.  Where would you like to go from here?

Now let's move onto our next step in the cycle of creativity.

CHAPTER FIVE

# WORKING YOUR CRAFT: BLENDING VISUALIZATION WITH YOUR TOOLS

» Dancer with Chick Corea's Group, Berkley, CA, Marc Silber

"THE GREAT DOESN'T HAPPEN THROUGH IMPULSE ALONE, AND IS A
SUCCESSION OF LITTLE THINGS THAT ARE BROUGHT TOGETHER."

—VINCENT VAN GOGH

Carrying out your vision requires using your tools to work your craft. This is the spark in the whole creative process where you transform your spiritual or mental image and bring it into its physical form. That's why working your craft is a blend of vision and the use of your tools.

Let's examine exactly what is meant by "working your craft."

There's a common misconception that work is hard and no fun. And on the flip side, creating is elevated to some lighter-than-air activity that only applies those lucky folks above the rest of us. Neither of these is true.

First, let's see how these words are defined in the Oxford Dictionary:

> Work: "Be engaged in physical or mental activity in order to achieve a purpose or result…"

You see while work does take effort, its purpose is to achieve a result, which brings us back to your purpose for creating, as we covered in chapter two.

> Craft: "An activity involving skill in making things by hand… Skills involved in carrying out one's work." Its origin is Old English meaning "strength, skill."

From these definitions, you can see that work and craft basically fit together, because this is where you're fulfilling your purpose with your artistic endeavor.

Now, after you visualize then understand how to use your tools, putting them together is vital: You'll want to get into production as an artist as you heard motorcyclist Keith Code underscore. Whatever your craft is, you're going to have a set of guidelines or parameters that you'll want to become familiar with. Because this book is about the artistic process in general, I'm not going to give detailed advice about your chosen area of creativity. (If you're a photographer, a video producer or a visual artist of any kind you can refer to my previous books.)

# FIND RELIABLE SOURCES TO LEARN YOUR CRAFT

With every artistic endeavor, whether painting, music, writing, calligraphy, sculpture, designing your own home (which is an art form), designing your garden, even the way you dress and how you present yourself, you'll find that there are books and videos that could provide valuable information. My only recommendation and warning is to be sure what you are getting is valid, and not someone passing along questionable misinformation. There are several key indicators to help you sift the true from the BS.

## CAN THEY KEEP IT CLEAR AND SIMPLE?

First, what I've already talked about: avoid those who just want to geek out and spew forth a lot of fancy words. This shows they really don't know their subject, to talk about it in simple terms. My experience with any creative person who is really skilled, is that they can easily communicate about it on an everyday level.

It's factually only those people who are trying to *impress* instead of teach, who use these kind of geeky terms. I have found that to be true in all areas of knowledge from art to zoology. For example, a really good surfer or skier can speak to you in simple terms that are easy to understand and follow. So avoid sources of information that seem overly complicated or just plain false.

## DO THEY HAVE GOOD WORK?

Another point: when you're looking for information, look for somebody who has created skilled work in that area. Unfortunately, there are those who have written and made videos about subjects they really have never professionally pursued, kind of like your armchair critic. Avoid those. A good starting point is to look for people whose work you admire. I generally will only gravitate toward someone's books or videos if I've already checked out their work and I love what they're doing. I've also found in conducting hundreds of interviews with artists that those people who have exceptional work tend to be good communicators as well. That's no surprise because what is art, after all, but a form of communication.

##  CREATE A REFERENCE LIBRARY

Compile a collection of books. No matter what you're doing, you should have books on hand in addition to searching on the web or YouTube. When you come across a reference that really resonates with you, make sure you get a copy of it, and keep it close by so you use it often. A few of my trusty companions are various dictionaries (English and technical subjects), *Oxford Writer's Thesaurus*, *The Elements of Style*, a variety of books and manuals on photography and filmmaking, plus a well-stocked library of philosophy.

The points above come under the heading of learning your craft, but now let's talk about actually working your craft.

## GET INTO PRODUCTION!

At this point, the most important point about working your craft is what I'm about to tell you, so please listen well: no amount of thinking, writing notes, listening to or reading books, listening to the other people, or talking about what you are *going to do* will replace actually *working your craft*, which means getting your materials out and starting to do it.

The way you learn is by performing those functions. I was able to learn a variety of art forms because I was fortunate in going to a school that valued creativity above anything else. We were encouraged at every turn to write, draw, make films, photograph, paint, weave, work in clay, etc. On one hand, that hurt a bit because I had some big gaps in other aspects of my education, which I had to fill later. But on the very positive side, it taught me to just get out and produce some art.

» **Jack London at his outside writing desk, c. 1916, courtesy The Huntington Library, San Marino, California**

As an example, if your goal is to write, the most important thing is that you get in the seat ("seat time" as Keith Code calls it) and write every day. Jack London would write one thousand five hundred words every morning. He'd sit down at a workspace, often outside, with his reference books and then before he went out for the day, he would write his quota of words.

Set your target and whatever it is, if you're writing, decorating your house, painting or playing music, set yourself a daily goal to do a certain amount of work every single day. Only *after* his one thousand five hundred words would Jack go off to his next activity: working on his ranch, or as he was an adventuresome soul, he loved to get out and see life at large. He and his wife Charmian often went traveling: they'd go off on an adventure, whatever it was, you knew it was going be fun! But it also gave him material for his writing.

# BE A 24/7 CREATIVITY MACHINE

I want to turn you into a 24/7 creativity machine. Yes, I mean that! If you're not actually sitting down and working on your craft, you're gathering material your entire day; twenty-four hours a day can be used for material that you're gathering for your art. By getting into that mindset, you will transform your life immediately. It doesn't matter if you're going through a painful or an uncomfortable experience, or if you're dreading something. I want you to look at it as a way to gather material. Be willing to take in what's happening whether it's emotional or a mental conflict that you're going through.

Don't just focus on yourself. Use the advice from Leonardo da Vinci (page 60) and look at the "attitudes and actions" of other people in those circumstances. Look at them when they're arguing or displaying any other kind of emotion. Notice if they're comfortable, at ease or they're nervous. Look at them; see what they're doing with her hands, with their feet, with their facial gestures. No matter what kind of art form you're pursuing, you're going to use this material. You'll find it has a powerful side benefit: when you're looking deeply like this, it keeps you from getting drawn into the drama itself.

But 24/7, really? Yes, keep your notebook handy, you might wake up in the middle of the night, totally inspired. Keith Richards lead guitarist/songwriter of the Rolling Stones tells a story about how he would have a tape recorder next to his bed because sometimes he'd come up with a little guitar riff or lyrics and he didn't want it to float away in the middle of the night. That's how he wrote "Satisfaction," which was probably a signature song for the Stones.

The story goes, he woke up in the middle of the night and came up with the guitar riff, played it into the tape recorder and then mumbled the lyric, "I can't get no satisfaction." He woke up the next day, listened to it, and went *wow, I really love this stuff.*[4] So the takeaway here is to capture those fleeting thoughts that you have in the middle of the night. Keep your notebook next to your bed or use a voice memo on your smartphone. Don't let those moments slip by. Look for them and, who knows, it could change your life.

---

4 *Life*, Keith Richards

» **Seventh grader painting a mural, Peninsula School, Menlo Park, CA, Marc Silber**

## LEARN FROM KIDS

There's something we can learn from children about art in our culture: kids get to have so much fun painting, drawing, dancing, laughing, playing music, etc. They get exposed to many different art forms as part of their education and as part of their life. Who says that should change as you get older? If it worked as a child to grow mentally and spiritually, wouldn't it make sense to continue on that same trajectory and keep evolving as a creative being? I believe so, and that's really the key message here: whatever level of creativity you feel you have achieved, go to the next level, or even ten times that level.

## BUST THROUGH THE HYPNOTIC TRANCE

Could it be that our culture has been hypnotized into a belief that, as children, we have this surge of creativity and then gradually, as we enter high school and certainly by college, most of that is pretty well damped down? Then we're basically getting fitted for a harness for what might be considered a kind of drudgery and work. We hope to get a little bit of time where we could do something fun. That's unfortunately the picture that many people have bought into. I'm assuming you haven't or you wouldn't be here.

Let's break through the hypnotic trance, or evil spell. Why not have that same creative spark, interest and urge the kids have? They're not thinking about what they're doing, they are into action with art, and outstanding teachers and parents encourage and foster their interest. If they're going to paint, they're finger painting or later with brushes, and then learning techniques. The key is that every day they go to art class and they make artistic work; that's what we need now.

Let's break through that hypnotic trance that says only kids get to do this and adults are sort of stuck in harness like some old mule. The best way to do that is to make sure you're working your craft every day. No excuses.

## GETTING IN THE ZONE

A big part of working your craft is what I call "getting in the zone." By that I mean you can't try to mix in your artistic creation with other distractions. For example, on vacation, walking around talking and shopping with family or friends is not the best time to capture photographs of the surroundings. You need to have your mind open and focused on discovering interesting images. If you're trying to mix that while talking, looking for street signs, trying to decide what to eat that day, it's unlikely you're going come back with remarkable photos.

When you get in the zone, there's something that clicks in place. It's a feeling of being fully aware and tuned in as an artist, not as a tourist or a detached nonobserver. I noticed this early in my career as a photographer: I was closely observing my surroundings and capturing what could make a creative photograph, rather than being removed and just pressing the shutter and getting "snapshots." There's a definite point where you start to find and *see art*. It's about finding those artistic moments, flashes, bits whatever we want to call them: images or sound bytes, elements for a book or a poem, or inspiration for your home or business.

Getting in the zone applies to any art form and to life itself. Being fully aware of the present surrounding opens doors to moments of inspiration. They exist around us all the time but might zoom by unnoticed unless your open your mind, fully aware and focused. It's when you're seeing things in a very intensified way and looking for those artistic bits, those moments, those images, the sounds, etc. From talking to many other artists, those moments happen only when they're in the zone.

## UP YOUR CHANCES FOR MAGIC

Having said that, there are exceptions to being in the zone, and that's when you want to be prepared in any case. "Chance favors the prepared mind," as Louis Pasteur said. For example, you might chance upon a remarkable opportunity or

inspiration for your art. If you're prepared with your tools, you can capture the moment quickly. Magic can spring forth at any moment.

» **Hermanus, Western Cape, South Africa, Marc Silber**

The photograph above is an example of this, taken while I was traveling with friends on the Western Cape of South Africa. It was getting late and we were stressing about where we were going to stay that night and some of us even a bit cranky—when were we going to eat?! Then chance opened its door to this jaw-dropping sunset. I knew I had to get it and shouted over the internal discussion, "Stop the car!" My friend swerved over and I jumped out with my camera, and because I was prepared, I captured the shot. But with traffic on the opposite side to my instincts, I was almost run over in the process. I pulled back just in time to avoid a serious mauling by a speeding auto. In the end I triumphed by being prepared to work my craft.

I want you to think in terms of those moments when you can work your craft undistracted, with focused attention and the purpose of coming away with an artistic creation.

## STAY ON THE TRAIL

 Let's talk for a minute about saying on your creative path. Now, if you're in full bloom as an artist, as a creative, with nothing holding you back, you might skip over this section. But I'm guessing if you're reading this book, there's some room to grow to the next level.

There are some reasons for forgetting about creativity or putting it on the back burner. We'll talk about a big one, avoiding vampires, in a later chapter. But here's the abbreviated version: It's possible that you ran into somebody who was hypercritical of your work. By critical I mean they gave negative destructive criticism, not constructive, spot-on critique, which is quite different. A proper critique actually has a definite purpose, designed to help the artist. It's best done by pointing out the key aspect to improve while at the same time recognizing something positive in the work. Vampires use criticism to shoot somebody down; they have no life of their own, so they suck it out of other people. Have you ever run into one?

Another reason why you could have abandoned your craft is you might have gotten busy with other things; life went in a different direction. That's what happened to me. You already know I grew up in a creative, artistic environment and for many good reasons, my life took a turn in a different direction; it was satisfying and fulfilling, but in a very different direction.

About sixteen years ago I made a major decision to get back to having a highly creative life. At that time my career path followed the road of building a successful management consultant company in Silicon Valley. Initially, there was a lot of new excitement and I enjoyed what I did. Later, I longed to get back to my artistic pursuits, which for me was photography.

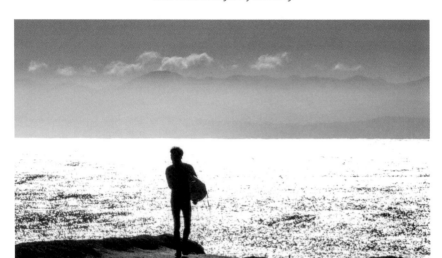

» **Surfer getting ready to jump off Steamer Lane, Santa Cruz, CA, Marc Silber**

"TO DO SOMETHING, SAY SOMETHING, SEE SOMETHING, BEFORE ANYBODY ELSE—THESE ARE THE THINGS THAT CONFER A PLEASURE COMPARED WITH OTHER PLEASURES ARE TAME AND COMMONPLACE, OTHER ECSTASIES CHEAP AND TRIVIAL. LIFETIMES OF ECSTASY CROWDED INTO A SINGLE MOMENT."

—FROM *THE INNOCENTS ABROAD* BY MARK TWAIN

After pondering and assessing options, I decided to sell my consulting practice to my partners and change back to being a full time photographer. The only hiccup was I hadn't done much in the way of photography for years. As I said, you have to find those times when you're focused and in the zone. *My excuse* was, with all the other things in my life, I simply hadn't put myself in that position often. So here I was with no excuses. I stripped everything away and began a career with a finite period of time to get back to work as an artist.

I had a runway to help because of the sale of my business, allowing a transition rather than jumping in immediately and living a starving artist's life. Through the necessity of supporting a family, with hard work and good fortune, I was able to avoid sleeping on a couch, eating ramen and peanut butter. Yet, every day I'd wake up and staring me in the face was the reality that I needed to work

my craft, and get paid. And more fundamentally, I needed to get up to speed as a modern photographer.

Previously, I was trained in classical photography, in the dark room with film cameras. When I re-entered the scene, digital photography was riding in like cowboys into a saloon. It was fast becoming a viable alternative to film. My turning point was when my son Bear took a box of my old prints and scanned them into a montage, saying, "Dad, these are incredible!" That was the jumpstart I needed. It occurred to me, if he could bring about the realization that I should dive into this, why don't I reinvent myself and learn digital photography? That's exactly what did over the next several years.

I jumped in with the intention of making this a viable career. With a new portfolio, and reaching out, I created shows where I sold my work. I pitched magazine work and got the assignments. I did other kinds of photographic work, portraiture and areas that I really hadn't done much of before. I was happy to jump into this because I found that no matter what I did, I was working and learning something that I could carry over to the rest of my photographic career.

It was frightening jumping off from my previous business that ran smoothly. I knew exactly how to steer it down the road and make it work; how to adjust all the knobs and levers to make it create income for the family. And now I was going back to something, no—going forward to photography in the modern era. Would I be able to come out at the end of this, with a sound business? That was unknown.

Sometimes you have to make those leaps and trust yourself enough to know that you can do it and moreover you *should* do it. As for working my craft, I created a situation where I *had* to learn daily, but more importantly, I had to get out make it work.

I wrestled with many questions: Sell my work, how do I do that? How do I improve on techniques that I really was unfamiliar with? Those are things that were driving me forward. At the end of the day I did succeed, which was fulfilling as an artist who had strayed off the path to come back again and find that yes, I could do it. I could get in the zone, I could capture those moments and share my work though sales.

# ROUNDUP OF WORKING YOUR CRAFT

No matter how you intend to work your craft, professional or not, or simply for the love of adding art to your life, the magic of creativity only begins when you work your craft. It is the outward manifestation of fulfilling your artistic purpose.

Find reliable sources to learn your craft, stay away from those who make it too complex or don't create great work themselves.

The most important step to take daily is to get into production with your skills and produce the art that you have set your goals toward. Set a minimum daily target for your work and make it happen. This will put fire in your life and sparks in your eyes.

Set up a 24/7 creativity machine where you are constantly gathering material that you use to build with. Open your heart, look at life and take in whatever is there, no matter the emotion, conflict, or discomfort. Use this, as da Vinci said, to see the attitudes and actions of people as part of your creative library. Even record your flashes in the middle of the night.

Pull yourself out of any evil spell that says as we get older we forget how to create and have fun with it. Allow yourself the pleasure of getting in the zone often.

And, finally, always follow your passion, even if it leads to a frightening new start. Don't be disappointed years from now by what you didn't do.

 Summarizing

1. Write down a time you were in the zone with your artwork. What was that like?

2. List out three excuses you've had for not getting into production.

   a.
   b.
   c.

3. Can you remember a time when you were a kid and you were in a high state of creative activity? What was that like?

4. Did anything come along that hindered it? A career change, feeling like it's something you can't do anymore, or worse, some vampire bit into you and sucked your blood?

5. How can you be a 24/7 creativity machine?

6. How could someone make a big leap into a creative life?

## Application

☐ 1. Look back to page 18 where you set a goal for how much time you were going to work each week. I want you to reassess that and ideally at least double it.

☐ 2. Take up your artistic pursuit, whatever it is. Go out immediately, get into production, and get in the zone. Spend at least thirty minutes working your craft and come back and write in your notebook what you experienced.

☐ 3. Some hard questions:

    a. Who told you your art wasn't good enough or it was a waste of time?

    b. Who discouraged you from creativity?

    c. Have you bought into any hypnotic patterns or ideas about losing your creativity?

☐ 4. Look at your goals again, as an artist, do you need to refine them?

☐ 5. Since we've come this far, what would you like to create on an immediate basis that aligns with your goal?

☐ 6. Spend at least twenty minutes working toward that goal and do this every day for a week now. What did you experience?

# CREATIVE CONVERSATION WITH MARK ISHAM

Mark Isham is an electronic music innovator, jazz artist, and prolific film composer. He has earned countless accolades including: Grammy and Emmy awards, and Oscar and Golden Globe nominations.

His collaborators include many of the most respected names in film and music—Robert Redford, Tom Cruise, Brian De Palma, Frank Darabont, John Ridley, Jodi Foster, Robert Altman, Sting, Wil.I.Am, Sydney Lumet, and Mick Jagger.

Some of his most memorable scores for award-winning features include the Oscar-winning *Crash* and *A River Runs Through It,* along

Create

with Golden Globe winning *Bobby,* and *The Black Dahlia.* For *The Black Dahlia,* Isham was awarded "Best Score" by the International Film Music Critics Association.

As Robert Redford said, "Mark is a man who really lives his craft. One of the most attractive features about Mark is that he knows how to keep the music subtle, but still support the drama. Mark does that so beautifully."

I've known Mark for three decades and have watched him rocket to being a major force in the music industry and in Hollywood. I've seen how he adds creativity to his very dynamic life and so wanted to include this conversion with him.

\*\*\*

*What have been your successful actions for putting creativity into your life?*

I put creativity into my life because it was sort of there all the time. It was just an instinctual thing I did. I didn't want to sit around. I wanted to sit at the piano and bang out some stuff. I wanted to pick up the horn and play it better. I wanted to have a band. There're all these drives that I wanted to pursue to be creative.

The part two of that is when you decide to be a professional and you decide you need to be creative on a predictable, high quality level so that you can exchange that as a product, that changes the game. If it's a hobby of being creative in your life, you can always just say, "Well, I don't need to do that right now." But if you've got a deadline that's going to help pay the rent the next day, then the game has changed. It's a different game.

Now, having said that, I don't know if the successful actions are that much different: If you're a composer, you compose. Even if it's just a hobby, you do the thing that you want to do. You engage in the creative act itself. You don't sit around and talk about composing. You don't necessarily sit around and read about composing. You actually sit down at whatever it is that is your vehicle, whether it's a pencil and paper or a keyboard or a Dictaphone that you sing

into. Whatever the mechanical act entails for the thing that you do that you're creative with. You actually just sit down and do it, and this of course becomes exceedingly necessary if you're a professional—you can't not do it.

You can have all the psychological impediments and all the blocks, if you will, and demons in your head telling you that, "Oh, I can't do it. I'm terrible." Whatever it is, whatever the negative side of all of this crops up, you have to just make that fundamental decision to do the action of that creative act. And that's the simplicity of it.

I added to that as I became a professional, it ended up being three P's: if you talk about the doing, you're **producing** the product of your creativity. Then you **promote** the fact that you do it. You tell people about it, you play it for people, you show it to people, you give it to people, you let them know that you are doing this and this is what you do and this is the quality of it. And this is the thing it does, and this is how they can enjoy it, and this is how they could have it.

You promote it and then ultimately you can't let any negative influence allow you to stop doing these two things. So the third P for me is **persist**. Basically you just go back and forth between the first two: you produce and promote, you produce and promote, you produce and promote. I really think that's the simplicity of it. Even if it's a hobby that you want to improve or if it's paying for your kids' education.

*Are there any common misconceptions about being a creative or creativity that you'd like to dispel?*

One that I run into occasionally—the idea that an artist has to be crazy to be great, that there's a certain amount of neurosis and psychotic behavior and God knows what, that these demons have to be sort of allowed to take over for the art to be truly great. I think that's a load of BS. I find in the music business that there's a lot of leniency given to this point of view. And I just disagree with it.

*What have been the biggest barriers that you had to overcome in order to have your creative life?*

I've mentioned the negative side, the voices that say that "You can't do that." "You're no good," that it's "too hard." I say this knowing that it's a reality for

most people I've met. I don't know if I've ever met anybody who doesn't have something along this line that they come up against in some form or another. And it certainly leads to all sorts of strange solutions.

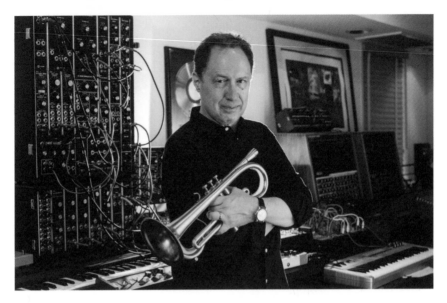

I was a jazz musician. Historically jazz musician turns to alcohol and drugs to combat a lot of this stuff. Fortunately, I became aware that it was a crutch and that these negative things weren't necessary, and my art would be doing better if I actually confronted them head on and rid myself of them, rather than to try to nurture them and feel that they were necessary, or just try to block them out through chemical means.

So that was certainly a challenge at one point when I was much younger. Fortunately, I had a lot of willpower and a fair degree of understanding of this separation and the actual true negative side to all this stuff. And, I was able to push through a lot of that.

These thoughts of, "I'm not good enough," "I'm going to fail," will always occur. I think they occur in anybody who's trying to create something that's never been there before. You know, the blank page, trying to put something into a universe, to create some beauty, to create an impact of beauty and emotion in people. It takes some toughness to push through the ideas from others that do float around, that things like that shouldn't be done.

So for me it's pushing through that and just recognizing it has nothing to do with my intention, has nothing to do with my purpose, has nothing to do with my goals. It's all just crap that's floating around and I can intellectually understand that and therefore I can actually move through it.

*How about adding creativity to other parts of your life?*

I find that creativity is an interesting word. It implies it's the pathway from just doing something and creating something artistic, and there's something else it implies. Because anything can be done—any activity, any making of anything, any creating, any sort of effect anywhere—it can actually be achieved through the eyes of "do it the best you can." Do the best you can and do it to create an effect upon others. And that's where creativity enters everyday life. Just doing it is a creative act, a part of one's mission and the way one follows through, putting one's intentions into the universe.

*Any advice you'd want to pass along for somebody who would like to add art and creativity into their whole life?*

When I spent a lot of time looking at various different definitions of the word art, one that I found was by L. Ron Hubbard that I found very useful. There's also one by John Cocteau that I loved, too, I just read a number of different philosophers, artists, and about what they think art is, and what others think art is, and it's tied up with words like creativity, communication, beauty, and aesthetics. The more one understands those things and how to apply them in their life, the closer you are. Then I think it's not that hard to be creative in one's life, because it's a natural inclination in most people to experience those things and to bring them into one's life.

# EDITING AND REFINING YOUR WORK

"THE PROCESS OF EDITING IS WHAT I ENJOY MOST—PUTTING THE PIECES TOGETHER AND MAKING SENSE OUT OF THEM."

—CHRISTIAN MARCLAY, ARTIST

The next stage of the creative cycle is editing and refining your work.

There is a pendulum swing that leads to two common misconceptions about editing. At one extreme you just let your work flow and never touch it again. On the other, I've seen people never complete their work because it always needs "one more edit."

The truth lives somewhere in the middle, where you let you work flow smoothly and at the appropriate stage you switch hats and edit to refine it. By working in this sequence you allow your work to flow, not stopping or hindering yourself before you go to the next stage.

## VARIATIONS OF EDITING

There are several distinct variations or phases of editing, we'll take up each to see how they apply in the creative process. It will help to look at each of these even if you're working in a different medium. You'll see examples that you can apply to yours. Remember to keep room in your cup (see page 13) as we explore a variety of examples of editing in various forms. Even though these scenarios are widely different you'll see the common threads they share. We'll even be talking about editing your life, a very interesting concept.

The first is editing of writing, which is correcting grammar, usage of words, style, and basically putting things into a form where they'll flow easily and communicate well to the reader.

» **Keep notes, no matter what form of editing**

The next variation of editing is to eliminate in order to clarify. Sometimes you need to add to your work, or modify it in order to clarify and refine it. For example, you might have written a beautiful paragraph, that you're totally in love with. But then when you read it over, you realize it just doesn't help the story, or help the reader understand what you're talking about. So you get rid of it or you park it away somewhere, like the advice I gave for sorting your stuff. Or you might need to add a sentence to finish your thought.

Film editing also goes through this process initially. Let's say you've shot an hour of an interview with an amazing guest. There are some really spot-on

parts, but also bits where the guest rambled here and there, off-topic. You want to cut those diversions because they just don't make a tight and meaningful story, going off in different directions. But those "beyond the interview bits" may well serve a purpose elsewhere. This is why we practice *non-destructive* editing. We never know where that random bit may somehow fit later on. (You can see an example of this with Camille Seaman's interview where I used a part that didn't fit her main interview, but fit later on page 143.)

## REMOVE WHAT GETS IN THE WAY

When I'm interviewing someone, I'm editing in my head, thinking, "That's a good sound bite right there." "That's awesome." "That's perfect." "But here he's going off the point" or "This is contradicting what was said earlier, so that part I might not use." This helps me conduct a successful interview because I can tell when I have enough content since I know what I'm going to look through or listen to in the editing process. You see, a lot of editing does come down to cutting out, especially something that really will not aid the visual or written story or painting or whatever it is you're producing.

In visual composition for instance, if you feel something doesn't belong, take it out. Generally, *less is more* with composition. Look at photographs or paintings that resonate with you and you'll find the artists removed things that distracted from the main subject, or from where they wanted to put the viewer's eye, as I covered in my book on composition. The same is true for many other art forms: eliminating those things that don't add to what you're trying to bring about when the viewer experiences your work.

## ALIGN THE PARTS FOR SMOOTH FLOW

In film there's another phase of editing, which is getting everything aligned for a smooth flow. When cutting from one scene to another, where you cut can make a terrific difference. You've likely experienced a film that seems jarring or the timing is off when the cuts are not smooth. Smoothing these out can be a thrill by going back and forth until getting that exact moment to cut and go to the next frame or scene.

Does this apply to other forms of art? Yes, it is the point of timing. Certainly in written work it applies, and in other art it applies as well. Timing in the

performing arts is essential: in music, dance, theater, comedy, poetry, etc. A creative gardener knows when to plant what in order to display what they have envisioned for their garden.

Timing definitely applies to adding creativity to your life. Let's say you're throwing a dinner party and want to engage your guests. Jan likes to bring them together to play "Two Truths and a Lie" where each person has to guess which one of the three statements by each guest is true or false. The person with the highest score wins. Timing this early in the evening breaks the ice, opening everyone up to each other. In terms of editing it into the party, it's knowing when to end and go onto the next "scene" and sit down and begin the meal.

## PHYSICAL EDITING

In still photography, you're dealing with a single frame, so editing tends to be focused on: where do you want to capture this moment? Later you edit in your digital darkroom by cropping and processing your images. As to cropping, I am old school and I'd rather see people "crop with their feet" which means moving your whole body with the camera in and out. For example, you might visualize an image with a person leaning against a tree, but from where you're standing the person is much too small. So you "crop" by moving forward to bring them tighter (closer) into the frame. Too many newer photographers are relying on the digital process to take care of these things. It can make a big difference when you physically move. That's editing right on the spot.

Some things cannot be edited in post-production, and so there are certain changes that need to made at the time of production. For example, editing can apply to how you approach lighting. Let's say there's a big streak of sunlight going across your subject's face. Don't try to fix that later because you're not going to be able to if it's over-exposed. So editing in this case would mean you move the person or you put up a filter, which softens the light, or use some kind of a barrier that blocks the light. This is a form of editing in the physical sense.

# BE READY TO MOVE THINGS!

Whenever you're creating, be ready to edit your "set." Arnold Newman, the iconic portrait photographer, famously said, "Photography is 1 percent talent and 99 percent moving furniture." He was joking of course, but the truth is, when I'm on set and we're trying to place people and objects in a way that enhances the still or film shot, there's a lot of furniture moving: a couch, a chair, a lamp, moving things out of the way, or moving things closer into the shot or farther away. Don't be shy to edit right on the spot. You're doing it because you're basically setting things up to capture what you visualized in the best possible way.

You may call me out here, by saying, "That's editing while you're working your craft." What you're really doing in these cases is arranging your work to *eliminate* editing later on, or to *avoid problems* you can't fix later.

With still photography and film, you have another aspect of editing, which is how you process images. This is what you're going to do in terms of adjusting contrast and the many other digital controls that help to tell or enhance your visual story. The same is true with audio editing. Again, try to eliminate the work in audio editing by taking steps to record cleanly and clearly. Don't try to record something in a noisy environment that will be difficult to fix later. This idea of "we can fix it in post" is a nice fantasy, but frankly it's not always true. For example, you can't fix a motorcycle going through your recording, it's impossible, and if it were possible, it would take more time than you would want to spend on it.

Just as with moving furniture, find a better place where you're not exposed to motorcycles, airplanes flying overhead or lawn mowers. I have had to send an assistant out to tell a gardener next door with a leaf blower to say, "Here's twenty dollars, please take a break, have a coffee and come back twenty minutes." Don't be timid about editing what's happening on the scene to pull off the creation of your work.

## LET YOUR WORK FLOW

When writing I urged you earlier to let it go—flow. Write it, and then come back and edit it. Jack Kerouac, the celebrated writer of the '50s Beat era was known for sitting down at a typewriter with a long roll of paper fed into it and typing practically non-stop without bothering with punctuation or grammatical changes.[5] He just pounded out the story; his editor was left with the task of breaking these long, long, long blocks of text up into paragraphs, fixing punctuation, and grammar. It worked for him. Whatever style of writing you adopt, the most important thing that I urge is not to let editing interfere with your flow as a writer or an artist. They are two separate stages.

It's important when you're editing to take a look at it from standpoint of the reader. When you're writing, you're just thinking about the story or what you're trying to put down on paper. When you're editing now you're going over it to fix those things don't really make sense or get in the way from the reader's standpoint. You're switching your hats.

## WALK THROUGH AND TAKE NOTES

You'll want to edit once you've set up for an important event, whether it's a dinner party or your first gallery show, or any special occasion. For example, with a dinner, you're going to prepare the food, get everything set up, open the wine, and arrange everything the way you want it to be presented.

Once you've got it all set up, go to the editing phase: walk out of the room, then walk back in as though you're a guest or the client and look at everything. See what *they* see. I would advise my consulting clients to do this because they often don't see the way things look to the customer. It seems so *normal* to them that they forget the stack of magazines in their reception area is pretty unsightly and

>> **Check with a small level**

---

5 Jack Kerouac's Famous Scroll, *'On the Road'* Again NPR, *All Things Considered.*

it is an advertisement that they not paying enough attention to
their environment.

I recommended clients do this drill, as you can in your house, school, your
own apartment, studio, car, wherever. Once a week, take out a little notepad
and walk through your space as though you are a client or somebody coming
to see it for the first time. Write down whatever grabs your attention. "Oh,
that plant needs watering or it needs to be thrown out." "Oh, that light bulb
in that fixture is a little off-color from the other one—it's a little blue, the
other ones are a little warmer." Don't try to fix everything as you go. Just keep
your notepad going and you'll find by the end of this exercise there are things
that you're going to edit. This is an important drill that you should do on a
regular basis.

Let's return to the dinner party. I see you've set up everything. Now, step back,
go to your front door, and do a walk-through of your living space as though
you're a guest. See what they would see, take notes of each point that needs
attention. For example, the photographs or the paintings are a little off balance.
I like to take small level with me and put it on top of picture frames and adjust
them to be perfectly level. There's nothing cornier than beautiful art on the
walls that's all slightly off-kilter. It's like you were getting dressed and you hit
the wrong buttons, making your shirt go askew, not a cool look.

Fix every one of those points until you've got it the way you want. And
remember, somebody coming to your house or your apartment, gets an
impression as they first arrive, so go back as far as you need to from your entry
to your driveway. Even out on the street, if a neighbor has a recycle bin left
tipped in front of your house, fix it.

Edit your surrounds. If it's there to be improved, when you fix it, you're going
to make a better impression and you're going to feel better about yourself. Look
around, even your car; maybe it has a bunch of kludge, things that don't belong
there. Every time we fill up the car with gas/electricity, Jan has a routine of
emptying the trash and neatening up. When you get home get rid of the kludge.
These enhance the aesthetics of your life.

# EDITING A BODY OF WORK

Another definition of editing is to arrange your work in a certain sequence. For example, in editing a film you're putting clips together in a sequence that makes sense and those in turn fit together into the whole film. We can take this same methodology and apply it to other forms of art, and to life itself.

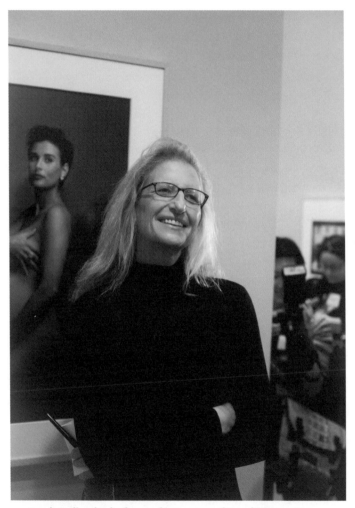

» **Annie Leibovitz in front of her cover of Demi Moore, San Francisco, CA, Marc Silber**

There's editing a body of work into an aesthetic and cohesive whole. I had the opportunity of walking through Annie Liebowitz's exhibit in San Francisco, with a throng of people on a press tour. We were old pals from our alma mater,

the San Francisco Art Institute. After graduating, she went on to become famous for her iconic celebrity portraits for *The Rolling Stone* and *Vanity Fair.* When the heavy traffic tour ended, as if it had been arranged, the crowd disappeared, leaving just the two of us walking through and discussing her exhibit. Pausing, she turned to me and asked me about my work. I told her I was in the process of putting together an exhibit of my photos from my high school experience in Mexico—giving a short version of the story I told you. Dressed in black, like a Jedi Knight of photography, she let a moment go by and said, "You know it really is essential to have somebody else edit your work." Because her body of work has been so well curated in her books and exhibits, this one sentence had a profound effect on me.

Editing? She didn't mean editing in Photoshop, adjusting the digital controls? Although that could be helpful, I like to do that myself, being in control of the whole process. In this case, she was talking about which photographs were going to be included in the exhibit, in which order and how they were going to be arranged together. Have someone else edit them. The light bulb went off: get help from a trained and trusted eye to select images and organize them into a cohesive whole.

Now switch to another scene later as I was preparing for the exhibit, the gallery owner and curator came to my studio where I showed him the prints that I wanted to include. Like a hunter, he sensed there was work hidden that he might be able to flush from the bushes. He asked, "What else have you got? Do you have contact sheets from Mexico I can look at?" Contact sheets are tiny prints made by lying negatives flat on a piece of photographic paper. When printed you view them to decide which to enlarge (see page 53 for an example). So I pulled them out and like a search and discovery mission we went through them together peering at each with a magnifying glass. He indicated the ones he wanted to display with a red grease pencil. What was interesting about this process were the many photographs I had passed over, not paying attention to them until he "discovered" them.

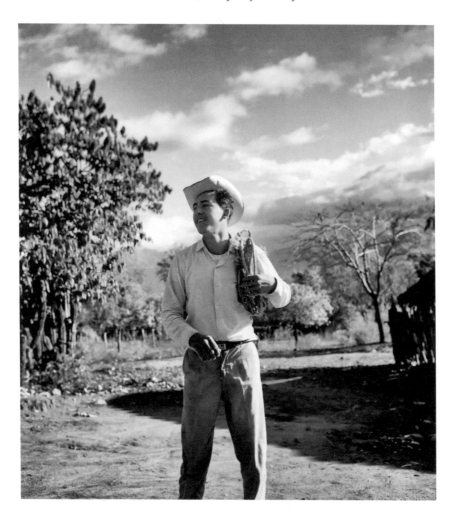

The one you see above became one of my favorite photographs, though I had never printed it before because I was editing my own work. Now I see it as an important image from Mexico of a simple time gone by; it could have been our Old West from the late 1800s.

>> **The *San Francisco Chronicle* covered the exhibit**

Before the show went live I visited the gallery to sign the prints. I was struck with a wave emotion at how well he had curated the images into a cohesive story, like frames of a film joined smoothly together. Attendees at the show said they felt immersed in a culture they would not otherwise have seen. This was my goal as a storyteller.

This is what Annie meant with her sage words of having somebody else edit your work. Find someone you trust, who has a good eye to help you find what's going to be most appropriate to put in that body of work. Whether it's an exhibit or a book or whatever it is you're creating. They should help you determine what really fits well.

This definition of editing applies to all areas of art: to a collection of poems, drawings, paintings; to a group of musical pieces or a dance performance. And of course, to design, interior decorating, and landscaping. And possibly most importantly, to yourself as art: how you dress and present yourself. In each of these cases it can help to have guidance from a skilled editor.

> "YOUR LIFE IS YOUR STORY. WRITE WELL. EDIT OFTEN."
>
> —SUSAN STATHAM, ARTIST, AUTHOR

## EDIT YOUR LIFE

Let's step back from this physical editing process, taking a look at how you operate as an artist—body, mind, and spirit. Are there negative areas you're banging into that you need to edit out of your life? You've heard mention in many of the creative conversations about how negative voices can hold one back. How about emotions? Do you get angry, frustrated, tired or sad, or do you want to give up, and get discouraged? Such things need to be edited out of your life because they're getting in the way of your creative process. Exactly how you do that is beyond the scope of this book, but reach out to me and I'll give

you a recommendation of a book that helped me tremendously to rid myself of negativity.

A tool you can use right now is to take a look at your purpose as an artist and see if there are barriers getting in the way of that purpose. You could have a physical arrangement of your studio that needs fixing. Or a toxic relationship that's bubbling over and giving you headaches, or distractions. Or maybe something needs to be fixed about your own attitude. Just note those down in your notebook that they need editing. The first step is clearly to see for yourself what needs editing. Then write down a few changes you could make to improve each. For example, if you're trying to write in a distracting environment, take your laptop to the library. Your attitude sucks? Listen to the advice from artist Camille Seaman and fix it!

## BE WILLING TO MAKE CHANGES

In building and designing there has to be the editing and refining process because sometimes plans get thrown off or something gets lost in translation. You need to have the humility to say, "This doesn't look the way I wanted it to." "I need to change the color, it's off, or the placement of those objects is off, or I need to reshoot this whole thing because I just don't like the way it looks or this whole paragraph just doesn't make sense. I'm going to fix it or get rid of it."

Another aspect of making changes is letting go of something you've fallen in love with in your work. For example, in editing film, one of the toughest moments is when you have this beautiful clip, maybe you're doing an interview where the subject is explaining something or they're telling a story and it's just fabulous, you I love it! The only problem is when watching it again, it doesn't make any sense in terms of the message of the film. Maybe you'd get lucky and could pull it out and repurpose it in some kind of a social media byte; but in any case, it's got to go.

## NON-DESTRUCTIVE EDITING

One rule we follow when we're editing film, (you can carry this over to the different media you're working in), is don't do destructive editing. By that I mean if you are working with a version of what you're creating, for example a

story, before you make any major changes, create a new version. It's really easy to save these digital versions on your computer. Later you can clean them up if you want. Whenever I'm going to make any kind of major change I'll create a new version. Let's say I'm working with version three of a project and I'm going to go back through it again. I make a version four, then I close version three, to get it out of the way so I don't accidently edit it. Therefore, whatever I do with version four doesn't matter, if I decide later that version three was actually better. I haven't lost my work. If you don't do that, you're going to be sorry and upset with yourself. Simply keep making new versions.

The same holds true with other writing or digital creativity. Start with your draft and add –v1 at the end of it. With each new version add –v2, –v3, etc. Just save a new version, then make the changes you need, but possibly later you'll remember about that one paragraph, "That was pretty good, I could use it over here." You haven't lost it, you just have to go back to version three, pluck that paragraph out and stick it where you want it to go. Hence, this is nondestructive editing.

Applying this to non-digital areas, the best approach to non-destructive editing is to use tools such as white boards, sketchpads, markers, etc. before you commit to changes. For example, once Jan and I were puzzled over how to best cut tiles to accommodate a floor drain for a shower with a complex slope. We huddled with the contractors and the guys who were actually going to cut and place the tiles and came to decision about how it could be done most efficiently. The tile guys listened, but looked like they might have a better idea. A few minutes later, they showed us their cutting plan by drawing lines on the tiles. Yep, they had much more efficient way of doing it. Thankfully, they used a non-destructive approach with lines instead of cuts.

And, for your own life, "don't burn bridges" is analogous to non-destructive editing: don't make destructive "edits" that you may regret afterward. You've seen people who later come back to a relationship and try to smooth over harsh "edits"—I've certainly had to. A better approach might be to hit *pause* and size up any major changes before they are committed to. You can even diagram or draw out your options, or talk it over with a trusted confidant looking at the best way to approach the situation before committing to a course of action.

## EDITING IN PROMOTION

I find that with very short pieces, I follow David Ogilvy's advice, an early Mad Man of Madison Avenue. He confessed that he was a better editor than a writer. He wrote a draft, and then worked through a series of edits until he ended up with the exact words he wanted. Because his writing tended to be very terse and tight, it was just a paragraph or two. Like a stonemason building a perfect arch, each word was precisely fitted in place through his editing process. So it had to be closely edited to prune any extraneous words. It was going to be used in a magazine ad, with nothing unnecessary, only what would tell the story. He had a maxim, "The more you tell, the more you sell." Tell your story. But if you run on and on, it's not going to sell. In this case, edit it to tell your story. We'll get into this more in the next chapter "Sharing Your Work."

Editing is part of the creative cycle, when you approach it this way, as an artistic function, you will find great joy in the process.

 Summarizing

1.  Can you remember a time you worked your craft and edited later?

2.  Can you remember a time when you used editing to carry out your initial visualization?

3.  How could someone else help to edit your work or body of work?

4.  Give an example of what can you do at the time you're crafting your work to edit out distractions or problems.

5.  List out three excuses you've had for not editing your work, your workspace, or even your life as an artist?

    a.
    b.
    c.

 Application

☐ 1.  Take your notepad and walk through one part of your environment, whether it's your work environment, home or your studio, and take notes of those things that need to be edited.

☐ 2. Fix at least five of them. If it's going to take you longer than 20 minutes, carry this out through the course of this next week.

☐ 3. Who do you trust to help you edit your work? Remember, you're not looking for someone who is going to be *critical*. You're looking for somebody to *help* you find what should or shouldn't be in a collection.

☐ 4. Meet with this person either remotely or in person have them look over your work and help you edit it. As an example: someone could help you edit your Instagram feed. One way of doing that is just looking for those posts that really didn't get much response or didn't resonate. Also, the ones that don't feel worthy of putting under your name.

☐ 5. Or you could do this with a box of photographs or drawings you laid out on a table or a collection short of stories that you've written.

☐ 6. Whatever it is, get that other person to help you edit. Carry that out and write your observations about working with them in your notebook.

☐ 7. Write down any areas that come to mind that you realize you need to edit, whether it's physical, emotional, mental or spiritual. This is where you get to look at areas you want to improve or root out any bad habits. The first step is to write them down. There's no limit to this step. Write down as many as you can think of.

☐ 8. Using highlighter, mark five of those items that you consider the most crucial.

☐ 9. Using another color pen, write down next to each highlighted a *non-destructive* editing action that you can take to improve that area.

For example, I know that I need to clean up my studio, to edit and de-kludge. I'll highlight that and then in another color pen, I'll write down that I will spend ten to fifteen minutes each day de-kludging my studio. That's an editing action I can do right away. I don't have to go out and buy anything, just fix it!

Do that with all five. There is no need to get complicated about it nor do any destructive editing. For example, if you don't like your emotions, please don't put down use of a harmful drug to "fix" that condition. That's destructive editing. Instead, find something productive. Take long walks, or take a short walk anytime you feel depressed and look at what's going on around you— that's constructive editing.

# CREATIVE CONVERSATION WITH CHRIS MACASKILL

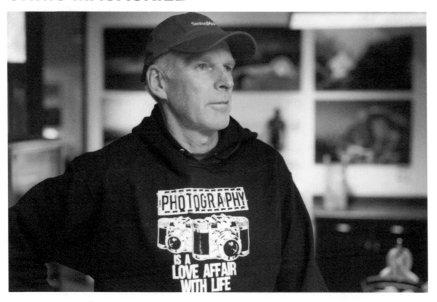

Chris has a remarkable record of success on his a very creative career path: In 1991 he produced an award-winning PBS documentary; then he went to work for Steve Jobs as his evangelist at NeXt (Jobs' 1985 startup purchased by Apple in 1997). Then as CEO of Fatbrain: from the family garage to $100 million in four years and public on the NSADAQ. Fatbrain was later acquired by Barnes & Noble. In 2002, he cofounded and was CEO of SmugMug, the best photo sharing site hands down (they acquired Flickr, their Goliath) and currently he is the co-founder/CEO of Cake.co, a new platform for having targeted conversations around your interests.

I've known and admired Chris for years as gentle soul with big accomplishments. He has a remarkable story of essentially editing his life: from a homeless "street urchin" to earning a Master's in Geophysics at Stanford (4.0) then working closely with Steve Jobs for years and thence to becoming a Silicon Valley serial entrepreneur.

<p style="text-align:center">\*\*\*</p>

*You once told me this briefly, but can you talk about what it was like being homeless as child?*

I was born to a mom who was struck by adult schizophrenia after she got a master's from Cornell and had a successful career in cancer research. We ended up, like so many schizophrenics, living on the streets. You wouldn't think it could happen to a child, but it happened to me in the '60s.

Mom's dream for me was to go to a great graduate school like she did, and I somehow made my way to Stanford with the help of amazing, loving adults. And then I got to live my dream life in Silicon Valley working for Steve Jobs and then bootstrapping SmugMug with my family, for the love of photography.

*When did the spark of creativity really become the central point in your life?*

I think it came from living with my mentally ill mom, probably second through fifth grade, on the streets of Oakland. It felt like an eternity. I honestly don't remember caring if I lived or died. You can't have any self-esteem when you're living on the street.

I thought I was probably committing a serious crime by not going to school. My mom wouldn't let me go because she was afraid I would be kidnapped. In my elementary school brain, I was worried about the police coming to take me to San Quentin for life. I watched schizophrenia overtake my mom and thought that it was the cruelest disease imaginable.

I thought then that I was the unluckiest boy in the world and that it was totally unfair. People looked at me like this dirty little street urchin who shoplifted and didn't go to school, or so I imagined. I didn't realize that in places like India some kids work the trash dumps, nor did I know about kids who had cancer.

In sixth grade my dad took custody of me and I moved to an all-white, upper middle class neighborhood. Even though I'm white, I didn't know any white kids at the time. I was terribly far behind in school. It was years into high school when I finally figured out how to get decent grades, a girlfriend, and a job. I learned to ski. It was then that I started to see how wonderful life could be. I believed that I appreciated it more than anyone else because none of the other kids realized how hard life could be, how lucky we were. They had school buses, moms to drive them around, no truant officers to put them in San

Quentin. Their moms were not mentally ill. We could get on a bus on Saturday morning, ride to Squaw Valley to ski all day, and come home at night. Life was actually amazing, something I didn't appreciate before. It's like putting a really good meal in front of somebody who hasn't eaten for a long time; you're going to enjoy it more than the person who gets a meal like that three times a day.

At that time I thought—and it's never left me—we should all take advantage of every second life gives because it could end in the very next second. For not that many of us, it's really great. If we have an opportunity to make it great, if we aren't living on the streets of Oakland like I did, we owe it to ourselves to make the most of it.

» **Chris and his wife—"badass" shoot by Renee Robyn**

*What barriers did you have to overcome to let that creativity blossom?*

Self-confidence. We call it *imposter syndrome* now. When you're homeless, you have no self-respect. People didn't know what to do when they saw a dirty little kid living on the banks of a creek bed or under a freeway overpass with a mom who had obvious mental problems. They would glance and quickly look away. Some kind women would sometimes stop, kneel down to our level and talk to me, but I was afraid of talking to them.

There were some social workers and I remember Catholic priests and nuns who seemed like angels sent from heaven. They would give you hugs no matter how badly you smelled and how dirty you were. I see Pope Francis do that. We could go to their soup kitchen on Thanksgiving and Christmas. They didn't judge like everyone else did or ask questions that scared mom and me. I would give anything to go back in time and thank them.

Coming from that to my first day in school in Orinda, where all the kids were white, well dressed, and educated was humiliating. After school hours in Oakland, I played baseball in the streets with my friends and I was pretty decent, which is all it took to be accepted. Suddenly I had to walk into a sixth grade classroom wearing strange clothes that my new stepmother had picked out, and the kids were doing arithmetic times tables. What? I had never heard of such a thing.

For a couple days I was completely lost, too afraid to tell my teacher, Mrs. Gibbons. She eventually called on me to come to the board and diagram a sentence. What does that even mean? I took the chalk and in front of the class I drew a box around the sentence. Everyone erupted in laughter. I don't know how Mrs. Gibbons reacted, but I remember running out of the class, down the creek to a cement drainage tunnel, and hid there all day. That's what I always did in Oakland; I just ran and hid.

I hoped that my dad, who was a former heavyweight boxer with a deep voice that scared me, didn't know I wasn't in class that day. I didn't know what to do for the next day because as far as I was concerned, I would never go back. It was too humiliating. Unfortunately, the principal had called him, and my dad, being a disciplinarian, took out his belt. That was a thing back then. I fantasized about running away to Montana and living in the woods.

It was a very long journey from having zero confidence to having enough to apply to college and start a company.

***In terms of being creative, what are the main successful actions that have worked for you?***

My type of creativity is entrepreneurship, so my heroes in life are people like Steve Jobs, Jeff Bezos, and Elon Musk. It's pretty incredible that I ended up

working for Steve and he told us something important: you can tell a lot about a person by the heroes that they keep. He admired Nike for having athletes as their heroes. So when Steve returned to Apple, he made their new ads all about his heroes. And you could tell a lot about Steve by seeing who they were.

Steve, Elon, and Jeff are not easy to work for. What makes people do it is they have a bold, clear vision. And they are missionaries, not mercenaries. Yes, they got rich, but that wasn't their purpose in life. Their purpose was to do something great that they loved.

I cringed when Steve was asked to give the commencement address at Stanford. He hadn't graduated. Would he even take it seriously? But he gave one of the most popular commencement speeches ever with a very simple message: in order to do great work, you have to love what you do. So your mission in life is to find what you love. And that is what has worked best for me. I love photography, so I started a company to let me live my life among photographers.

**What advice do you have for people who want to be more creative, wherever that creative spark is?**

My advice is to dare to be different. Among investors, they look for patterns, but I think the pattern for the best companies is they don't fit the pattern. Apple is its own company with its own culture that goes its own way, and so does Google, Amazon, Netflix, Spanx, and Starbucks.

It's the same with photographers. The best ones often stand out with their own style that doesn't look like anyone else's. If you look at the people in Steve's Think Different campaign, they all thought differently.

# SHARING YOUR WORK

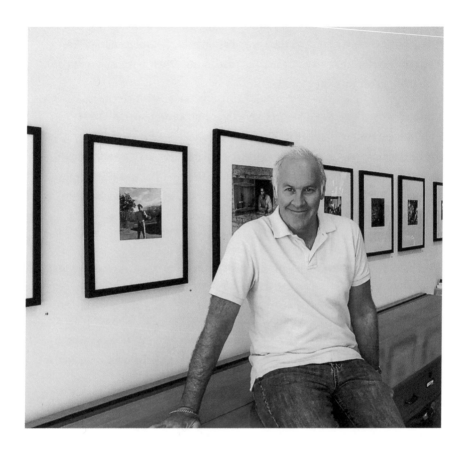

**"THE PURPOSE OF ART IS WASHING
THE DUST OF DAILY LIFE OFF OUR SOULS."
—PABLO PICASSO**

"Washing the dust off" is best done when you pass along your vision and the emotion that you have captured in your art.

Now that we've come this far, the final stage in the cycle of creativity is getting your work out into the world. I use the word "sharing" in the broad sense of getting your work out to others, including employing social media, selling your work, being part of exhibits or concerts, being printed in magazines and books, etc.

We'll also look at how you can engage others in your use of creativity in life itself. The same idea holds true when you want to share your art and creativity with others. For example, you've heard from photographer Chris Burkard about how he fosters creativity with his children. You've also heard from others I interviewed about how they have added creativity into their lives that they naturally shared with others.

Let's backup for a minute. Why do you need to share your work? Are you going to be satisfied creating things that remain in your computer or in a drawer or tucked away somewhere? I know the answer, since I've already gone that route and found a great deal of joy in bringing out old projects that I had created many years ago, dusting them off and letting others see them.

» **A negative and final print of chairs, Peninsula School, Menlo Park, CA**
**Marc Silber**

Growing up as a photographer I captured all my images on rolls of film. When I developed them, they then became "negatives" meaning the lights and darks reverse (see above, left). Then, printing them, they reverse again, resulting in positive images on photographic paper. When I entered the digital world of photography, I had thousands of these negatives, which remained for the most part unseen. I had only scanned a very tiny fraction digitally and most of them were lying in a state of rest, like sleeping memories hidden away, forgotten almost.

One of the first things that I did then was to purchase the highest quality negative scanner on the market. I reasoned that if I were going to go to the trouble of scanning my negatives, I wanted them to be the highest quality possible. There was a learning curve to the precise process of scanning. Once I worked it out and got into the rhythm of the process, I fed negatives into the scanner like it was a hungry beast. I literally went through my entire collection looking at old prints and contact sheets, and picked out the top of many hundred images that I had photographed over the course of decades.

I was able to use these scans in many different ways. Living in Silicon Valley in the early 2000s, the internet was a familiar tool so I initially began by sharing them on the website that my sons Ian and Bear created for me. That in itself was heartwarming because I immediately had a way to easily show my work. Once the website was completed, I e-mailed a link around to everyone I knew. This was back in early 2005 when it wasn't commonplace, long before Instagram and Facebook made sharing easy. I sent the link to friends and family, many of whom didn't know that I had a past as an advanced photographer. I received back wonderful feedback that I saved. As a note, keep every one of your kudos, they're going to come in handy.

Having a website was a major entry point for getting my work out into the world and blowing the cover off the hidden state of my photographs. Although I had printed from the negatives themselves, it became possible to get very high quality prints made digitally. Using Photoshop also opened the door to corrections that needed to be made such as getting rid of dust spots or scratches, or making enhancements. So I cleaned up that initial collection of images that I had brought back to life.

## YOUR WORK AND YOUR LIFE

As a creative, when your work goes to sleep and lies dormant and forgotten, a part of you does too. Creativity is such a powerful component of our lives, that having that drive in a deep slumber affects your whole existence. I found there was a thick mixture of emotions as I brought my work out of dusty hiding places and back into the light: a joy of putting order and life back into it, but also a sense of sorrow for having lost it along the way.

Reentering the world of photography, I followed the points that I'm going to advise you to do to get your work shared. I can't emphasize enough how important it is to get your work out into the world and, where possible, to sell it. This is contrary to the misconception one of my early art teachers gave me: that you should never sell your work. What rubbish that is. Artists love and need to sell their work. In fact, there's no higher compliment than somebody buying your creations.

We get so spoiled on social media by a thumbs up or a comment. That's fine, but the ultimate engagement is somebody's purchasing your work because it means they truly love it. You've probably noticed that there are different ways that money "feels" depending on its source. The most joyful money I've experienced is from selling my work, to have truly created this income source.

## YOUR VISION OF YOURSELF AS AN ARTIST

Let's start with your vision of yourself as an artist. Remember, visualization encompasses the entire creative process. It is the wind underneath your wings. No matter what you're doing, it will keep you aloft. It will keep you pointed in the direction of your goals.

Where do you want to go as an artist or as a person with a creative life? In short, what is your vision of yourself? We're going to be doing a specific exercise at the end of the chapter, but I want you to start really looking at that. Where do you see your artistic and creative purpose taking you? Are you going

to be using it in a business to become a more creative entrepreneur or do you see yourself using it to design your home, or your appearance? I know you have a goal to work in some art form, whether it is writing, pen and ink drawing, watercolor painting, music, dance, or another performing art, designing a garden, photography, video, or any other artistic expression.

All of these are areas where you can produce as an artist. There is no such thing as somebody who is not creative. If you haven't discovered or rediscovered your own creativity yet, I want you to know it's there, and in more ways than you may realize. There's some corner of your life that you have already put your hands into, but withdrawn from and tried to close the door to. But the door is never completely shut. A ray of light shines through the crack, no matter how weakly, and you can find it by seeing yourself as an artist.

Let's examine what the possibilities are in terms of you being a creative person. In visualizing yourself as a creative, the steps you will take are: listing out all the creative areas that interest you and then honing it down to one or two in particular to begin with. Find that area that you're already the farthest along with; not the hardest, most difficult, or most challenging. That's not the way to start.

» **Backpackers at Riffelberg Chapel, Matterhorn, Zermatt Switzerland, Marc Silber**

# THE ART OF WALKING

When I taught mountaineering, we didn't begin the first day by climbing a steep mountain requiring ropes, anchors, and ice axes. That came much later. The very first day we taught people the *art* of walking. You may think everybody knows how to walk, but it turns out most don't, not when traveling long distances with a heavy pack, at high elevations.

The technique and art of walking properly on a long hike or expedition is to find a comfortable pace that you can hold for some extended period of time, like an hour at a time. Don't go in wild fits and starts where you kind of rush ahead, stop, pant, pant, pant, lean against a tree, or take your pack off and then go back and run ahead again. That is not proper walking; you will get totally exhausted doing that.

There's a rhythm, there's a beauty and an aesthetic to hiking properly. It allows you to spend the least amount of effort thinking about how uncomfortable you are, or how heavy the pack is, and introverted into drudgery. Let's avoid that and instead put the maximum amount of attention on what you're there for: enjoying the experience of the mountains and the wonder of nature. You can experience such an inspirational surge! When you take a walk enveloped by nature, you are in the ultimate creation museum, with an abundance of inspiration there.

So, we began with teaching people to walk, just as you have to teach people to breathe. But doesn't everybody know how to breathe? Yes, they breathe shallowly and randomly, but when you follow the pace that I'm talking about, your breathing falls in line with it. You replenish your oxygen. You don't run out because you're not doing this back and forth randomness.

This is a fitting analogy for a creative: you're on a long journey and need to find the rhythm and pace that will sustain it, allowing you to look around and enjoy your whole blessed experience.

# FIND YOUR FOCUS

Let's begin with you and the closest area to achieving your goals as an artist. What is that? We'll start there. In my case, I had several possibilities but chose photography as the closest area to professional accomplishment.

Next, I'd like you to take the word visualization and apply it to yourself. How do you envision yourself as an artist? What style or category of creativity do you want to be known for? That is your main genre. It could be a certain type of artwork, music, writing or drawing. Or it could be your creativity in life as a chef or gardener, or how you bring creativity to your business or to your children's life.

We need to find your genre and niche you're going to focus on. As you heard Chris Burkard say, don't try to be everything to everybody, that's an easy way to fail. You'll find that every great artist, even though they may span many different genres in their work, is fundamentally known for only one genre. Annie Leibovitz is known for being a celebrity photographer. She takes many other kinds of photographs, but what she is known for is being the photographer for *Rolling Stone* magazine, or *Vanity Fair*, often capturing celebrities. Ansel Adams is known for stunning landscapes even though he also captured portraiture, but you don't think of him as a portrait photographer.

The Beatles. They covered all sorts of genres in their music, from heavy rock to light folk music, but they are known as a "great little pop band," as Paul McCartney called the group. Pablo Picasso: study his work and you'll see many different periods: the blue then the rose periods, cubism, and surrealism, but what you know him for is the genre he invented for himself—the ultimate achievement for an artist.

Discover your own. I make the point in my book, *Advancing Your Photography* that you should zero in on the genre that you want to become fabulous at and take a deep dive into it by finding out everything you can about that genre, other artists in that genre, what it is that you love about it, and what your expression is within it. This applies to your life as art: how do you want to express it?

Now we're developing your vision of you and your life, which comes to the next point, which is branding.

> "A BRAND IS A SINGULAR IDEA OR CONCEPT THAT
> YOU OWN INSIDE THE MIND OF A PROSPECT."
>
> —AL REIS, AUTHOR

## CREATE YOUR BRAND

The mind can be a crowded place with all the information we're bombarded with daily. To establish a brand you have to "own" a position in the mind. Then others can easily grasp who and what you are. That's what great artists have done, and you should too.

Branding is a function of what others see or think of when they think of you. Your brand is what *differentiates* you from others. What do you think of when you see "Starbucks"? You think of their green logo, but you also think of coffee, even though they've branched out into all sorts of other things. It's still about coffee, isn't it? What do you think of when you hear "Nike"? Nike, the swoosh, "Just do it." They encompass many different sports, but it's that attitude. That's what they branded themselves with. Now take your vision and work it into *your brand.* This is true whether or not you plan to be a professional artist and sell your work, or want to create an artistic life. You still should take these steps to properly brand yourself so that others can see in a split second who you are and what you represent.

This is where you're going to fill in some blanks. I am a _____ (poet, musician, writer, photographer, chef, creative entrepreneur...) and my genre is _____ (jazz, non-fiction portraits, Asian-fusion, app-creator...)

## YOUR MISSION AS AN ARTIST

What is your mission as an artist? At Google, they use three word mission statements. Write down, my mission is to _____. You don't need to limit yourself to just three, but keep it simple.

» **Salvador Dali's studio, Port Lligat Spain, Marc Silber**

My mission statement for photography education is "advancing your photography," three words. "Advancing" means that you're constantly moving forward from whatever level you are on. "Your" because it's not about everybody else's; it's about *your* photography. Advancing your photography is my mission statement. What is your mission statement with your art? Whatever that is, write it down even if it is simply "Draw the most elegant birds in my region." Or it could be "Make a viable living as an artist." That was part of my original mission statement that drove me on through the whole transformation process I told you about.

In life, you might have the mission of "fostering creativity with my children" or "providing an aesthetically-pleasing environment for the family." From my dedication and the stories I've told you can see that my mom used both. While other kids were served meat loaf and mashed potatoes, she seemed to always be preparing multinational dishes, many she picked up from her volunteer work at the Stanford International center. The same was true of brining a variety of cultures to our home, by often inviting foreign students to stay with us for a few weeks. She was deeply loved by many for her warm and creative hospitality, which became her very recognizable brand.

And now let's take a breather, set your pack down, and visualize where it is you want to go. What's your goal? Earlier I asked you about your goal, and now you're probably going to refine it. Let's take a clear look at where you want to go as an artist.

At this point we have arrived at a fork in the trail, with two options:

**Trail 1:** You intend to produce art in some genre that you'd like to get out to the world, selling it, showing it, or presenting it to others in some way. Simply keep traveling straight ahead and read on.

 **Trail 2:** You want to add art and creativity to your life but don't plan to show or sell or promote on social media, etc. You can pick up this trail on page 146. (You can always come back and take Trail 1 later.)

## DEVELOP YOUR VOICE

This is all about developing your voice, your unique thumbprint on your art form. One of the things that you should create to get your work out there is your artist's bio. No matter how brief, you have a biography as an artist that needs to be written. If it started thirty years ago when you were in grade school, fine. Put your biography together; it can be a few paragraphs. You'll couple it with your artist statement, basically encapsulating what we've just gone over: what you aspire to be as an artist and what your goals are.

It's important from here forward that you present your work as professionally as possible on any channels that you use. You're building your brand, and you want it to stand out both artistically and technically. I know budget can be a concern, but go for the highest quality you can achieve. And of course there are many social media channels that cost nothing. Aim for presenting your work professionally with high quality.

## WAYS TO GET YOUR WORK OUT THERE

No doubt you're already using social media for your personal life, but step up your game so that you're presenting your artistic work professionally. This includes a clear statement of your brand, your logo (which you can get made inexpensively), and your head shot for your avatar (your picture in social media). To establish your brand, you need to keep it simple and be consistent. If you change things around often, you'll lose your branding focus.

Each major brand we discussed established their brand with an outward image, logo, and their story and stuck with it. Even when they added more and more to

what they produced, as these brands have done, they still own the core position in your mind.

"But Marc," you say, "I just want to get good at my art and show my work to my family and friends. I'm not planning on being a pro." My answer is, to quote a British statesman, "Whatever is worth doing at all is worth doing well." You've come this far to improve your craft, now let's take that next step to present your work professionally to others. You will certainly be repaid for your hard work by helping others experience your art.

## SOCIAL MEDIA

If you're a visual artist, definitely put your work out on social media. My favorite is Instagram. You can use it for almost any kind of visual art or photographs. You also can take pictures of your paintings or drawings and post them there. You can put up to 60-second snippets of film if you're making one. If you're a writer and you're writing poetry, you could put sections of your work perhaps with a photograph or graphic and your text.

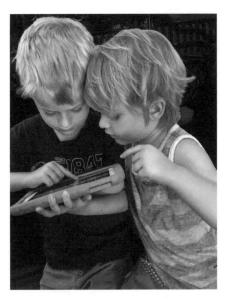

» **Brothers getting their work out there, Marc Silber**

Make use of all social media platforms that work for your genre. If you're so inclined, put a YouTube channel together to show videos of your work or even of yourself vlogging (a blog where the postings are videos) about your art.

Definitely set up a website which is the hub for your brand. You'll post your bio and artist statement, and show your work. It will also link to your social media and have a contact form so people can reach you. I use WordPress, but there are many easy to set up websites. Find the one you're comfortable with or better yet find someone you know who can help you set up yours and maintain it, as my boys did for me many years ago.

## CREATE A DATABASE

Something you're going to want to start immediately is creating a database of people who are interested in you and interested in your work. This is very important because you'll want to send newsletters to them on a regular basis and other announcements, and of course use it to sell your work. There are many email marketing platforms that will make this easy and you can add a form to sign up for your newsletter to your website. But also remember when you meet people offline, make sure you have a registration book that includes their email address. This is incredibly valuable and you'll want to get that started right away.

## SHOWING YOUR WORK

My mantra for this stage is: get your work out there! Get it seen by others and see how they respond. This gives you needed feedback as an artist. Any art form is a means of communication, and it needs to be two-way. The way to receive responses to your work is to show it as widely as possible.

A recommendation from Chase Jarvis, who is both an incredibly accomplished photographer and the CEO of CreativeLive (which provides online classes in a variety of creative fields), is to create a portfolio containing ten of your best work. Why ten? It's a good round number to represent your work. As you elevate your skills, switch out your top ten, even if it's a re-edit of your earlier work. It's a great first assignment to get together or newly make your portfolio and then keep constantly raising the bar for your top ten. And put them in a professional portfolio case, which you can buy online. You'll need this for other steps of showing your work.

For other types of artists, this translates to having a collection or repertoire that showcases your best work. This could be your top written works, or songs, or even recipes as a chef. The idea is to gather a collection that you feel best represents you and your work. Then keep updating it as your elevate your skills.

## DISPLAY YOUR WORK

» **Blue door of Church in Ajoya, Mexico, Marc Silber**

Another important aspect of sharing your work is to make sure that it is displayed in your home, in your studio or your office. It's a vital point that you are showing your own work where others can easily see it. Of course, that starts right there in your own immediate environment. If you're a visual artist, a photographer, painter, or any kind of artist, the best thing to do is to display your work that you really love; either the originals or get prints made, and make sure you frame and hang and them very tastefully. That's another part of showing your art—the frame itself. That gives a completed, dressed up look to them, like putting on a tie and a coat, and it will finish off your work handsomely.

Display your work well: hang it linearly so that people as they walk by can see it at eye level. Make sure that the lighting is flattering, that it isn't in a dark corner, that you have good illumination, but that it's also not bouncing off the glass, with reflections.

Translating this for non-visual art: look for ways to showcase your work. For example, I was at an opening of an Ansel Adams exhibit in Big Sur, CA. The program included a local poet/singer who sang a fitting selection to a very receptive audience. Another example is a garden club that took a photography workshop series from me, to be better able to photograph their wonderfully aesthetically pleasing creations to share with others the many ways I've mentioned.

# GET YOUR WORK OUT THERE

Getting your work out there includes having live shows or live events. There are many different venues where visual artists can show their work, at coffee houses, libraries, schools, businesses. They're always looking for art to display. Google in your area to find some of these venues and simply contact the person who acts as the curator. Often it would be an office manager or someone managing a store, library, coffee house, etc.

Tell them about who you are (use your bio and artist statement). Make an appointment to take your portfolio that we discussed and show them your work with the intention of booking a show. One tip is, don't interrupt them as they are looking over your portfolio. Let them get familiar with your work. Of course, answer any questions, but let them get involved. Don't talk to them while they're actually trying to take in your work. Let them experience it.

This same approach applies to written work, where you can find venues such as coffee houses or other settings where you could present your work to a live audience. I know that can be scary, but it's really important to put yourself out there to experience an audience. This is all part of that creative cycle of sharing.

The plus side is that you'll be strengthened by the experience of what it's like to get in front of other people. Let them take in your work, whether it's a visual presentation or a verbal presentation or music, or virtually any kind of art form. Google in your area to find venues for your type of art. There are some websites that can help you find venues for your genre.

> Go to SilberStudios.com/Create-Resources for help finding venues and for detailed steps to take to book shows.

# BE YOUR OWN CHIEF MARKETING OFFICER (CMO)

An important part of sharing your work is being your own Chief Marketing Officer (CMO). Every brand has one: that person who has the responsibility of making it well known, resulting in people purchasing their products. You are your best CMO. Embrace that job. Don't buy into the false idea that you shouldn't self-promote, that idea is going to cause you to fail. I want you to succeed. You're wearing a different hat when you're the CMO. You're

representing the artist (who happens to also be you). What you want to do is look at your brand, who you are, who you visualized yourself to be, and look at the ways that you can get your brand well known and people purchasing your products. That's the job of the CMO.

If you have somebody who can help you with that, all the better, perhaps a spouse, a good friend, or another family member. In any case, you're going to want to work closely with them to make sure that they are representing you and getting your name and your work out there.

It's important to know that you are marketing your work *and yourself*. Think of the great artists who have become popular in their lifetime, (which eliminates Van Gogh and others) and you'll see that each of them created an image, a "brand," that was a key part of promoting their work. As you read though the creative conversations, you'll clearly see the brands that each of these remarkable people have built. We all instantly recognize Nancy Cartwright as the voice of Homer Simpson for example. The same for each of them.

## PERSONAL CONTACT

Always go for personal contact as much as you can, knowing that you are marketing yourself and your work. This applies to all aspects of showing your work and selling it.

Just as you create your art, you create your own opportunities: Look for ways to pitch your work in your area. Is there a local magazine? Go see the editor and pitch them on an idea for publishing your work. Think of an idea that interests you, such as creating a photo essay about your area, with landscape shots of unusual images that people might not be expecting.

No matter how you go about it, get your work shared in a professional manner and continue to look for new ways to get it out there.

## MAKE CARDS AND HAND THEM OUT

Be sure to make cards that stand out and represent you well and always have them with you to hand out. Remember to put them in your wallet and in various pockets. I've been caught too many times with people asking me for a card and have run out!

» **Create the front of your card that stands out**

Camille Seaman whose creative conversation we heard, also gave this advice:[6]

> One of the things that happened in my life that was significant as a
> photographer: I didn't feel secure or confident to call myself such until
> I had business cards printed that said Camille Seaman Photographer.
> When people would ask what I do, I practiced with my friends so I
> felt comfortable and safe handing out those cards and saying "I'm a
> photographer" and it took practice for a while.
>
> But practicing in a safe environment with my friends and family, handing
> out cards, "I am a photographer," helped that inner voice, that inner
> conversation to say "yes I am" and "yes I deserve it" and "yes, I'm
> worthy." Now I hand them out and they go, "Of course—a photographer."
> Or they say, "You know, oh my God, I would love one of your cards. I love
> your work," like they know me before I even have to pull out my card.

» **A medieval baker with his apprentice. The Bodleian Library, Oxford**

## APPRENTICE WITH AN ARTIST

When you get to a point when you are considering going pro, the best advice I can give you is to find a good working artist (in your genre and whose work you admire) in your area and reach out to them about apprenticing with them. Getting real-time studio experience

---

6 This is an example of an extra bit from her main interview that I was able to use here, per page 110.

is the very best way to learn the trade. Many of my past apprentices have gone on to establish their own successful careers.

What I recommend is to look online until you find somebody that does the kind of work that you aspire to and contact them. Your sincere request is probably going to be met with "let's meet and talk." Tell them about yourself, and what interests you in their work, and that you would like to learn from them and ask them if they offer apprenticeships.

And when you do apprentice, my best advice is, is do whatever tasks come your way because as an artist you have to do all these things anyway even the non-glamorous and mundane ones. For example, let's say you have the assignment of straightening up the studio. Apply what we went over about organizing and getting rid of disorder and kludge. As an artist, you would be doing it yourself, so don't hesitate or hold the idea that something is beneath you. In building your own studio, you're going to do anything that needs to be done.

Your most important action at this stage is getting your work out. Find the venues where you can show your work. Use all the existing channels of social media, getting your website up and building your own newsletter list. Make it easy for people to find you and get your work out there.

 Summarizing

1. How can you visualize yourself as an artist?

2. How can you focus on one genre at least to begin with?

3. How would you describe your "brand"?

4. Name three excuses have you have had for not sharing your work.

   a.
   b.
   c.

5. What are three ways to share your work?

## Application

- [ ] 1. Write down your vision as an artist.

- [ ] 2. Where do you see your artistic and creative purpose taking you?

- [ ] 3. Write out creative areas that interest you.

- [ ] 4. Highlight the creative area you are closest to achieving your goals in as an artist.

- [ ] 5. Write down a statement of your brand and how it's different than others.

- [ ] 6. Write down your three-word mission.

### Bonus Steps

- [ ] 1. Write a short bio (it only need be a few paragraphs).

- [ ] 2. Write your artist's statement, which is basically your vision as an artist. Including: What is your purpose? What is important to you? And a bit about your art. This is separate from your bio because your bio is about you, the artist statement is about your art.

- [ ] 3. Put together your portfolio of ten or your collection/repertoire that showcases your best works.

- [ ] 4. Google to find venues for your genre, and write down a list of at least three opportunities that you could have as an artist to get your work out there.

- [ ] 5. Contact at least one. Make an appointment or call them directly to show your work.

- [ ] 6. See at least one of those contacts and show them your portfolio of ten and ask for a show.

- [ ] 7. Write in your notebook your experience while doing this.

# ⚙ TRAIL 2—YOU WANT TO ADD CREATIVITY TO YOUR LIFE BUT DON'T PLAN TO SELL OR PROMOTE

I'm going to offer a few ways that you can share your creativity; obviously a complete list could fill many volumes. I'll offer some examples and let you add your specifics to it in the application section following.

## SHARING CREATIVITY WITH CHILDREN

» **Working on a creative scenario, Marc Silber**

Take the suggestions from Chris Burkard on page 32 to foster creativity with your children. Create scenarios with them as both he and Marsie recommended on page 168. These could be photo shoots as she suggested or creating games with them.

The game of research was always popular with my kids: I'd give them a list of things to discover (mostly outdoors) and have them go off and explore each one. I would compile their list by walking around and finding things that I knew they could find. For example, I could see a birds nest off the porch and put "find a bird's nest" on the list. Some were easy like find out like how many windows there are downstairs. Some harder, find three different types of insects.

I'd give a list of about ten items to find that they could work on together and when complete come back and tell me their discoveries. This simple game fulfilled many purposes: It took kids who might be otherwise bored and propelled them into action with a purpose. It also got them offline and accustomed to looking at things in the real world. And it taught them the value of doing their own research.

Use David Campbell's suggestion on page 85—give them some information or show them a creative technique and then ask them, "What do you think?" and be genuinely interested in what they say.

Give them a job: When my kids hit their teens I always gave them jobs at my companies. These were real, not pretend jobs. And they were mostly in creative areas like working on web design, video editing, marketing, and organizational skills. I found that like David Campbell, I would give them a bit of information and material to study and just get out of their way and let their creativity flourish. The results? One is the CEO of a major innovative publishing house, another is the COO of a very successful startup, another is a designer at Instagram and our youngest partnered with Aaron Kyro in his wildly successful YouTube channel (page 182).

## PARTIES SHOWCASE AND SHARE YOUR CREATIVITY

You've heard me talk about the creative value of parties. My wife and I have always considered them an art form in themselves. The key is in the planning—beginning with your visualization. Like all things in life, parties follow a pattern with a beginning where your guests arrive and get to hang out and chat; then you might have the game of two truths and a lie; then move on to fabulous food, wine, and conversation; and finally move on to music and dancing or just more hanging out, perhaps outside on a deck.

We've also used parties as a goal for completing house projects, or for displaying new art or newly discovered music.

Throwing creative parties or events follows the same creative steps I've gone over. Begin by visualizing: for example, by looking in magazines and cutting out what ideas resonate. Or getting ideas from movies or books. Our non-profit put on a series of parties for fundraising, and to make it fun there was always a theme, which some took as an opportunity to let their creativity shine. For example, one of these events was put on at an aviation museum. The theme was "Top Gun" and all attending dressed in appropriate aviator attire. One couple even rode in on racing motorcycles as the character "Maverick" did in the movie. In this case you have a great mix of creativity with giving back, which has certainly been successful for community fundraising.

Our children's school had a wonderful way of encouraging many of the actions I've suggested in this chapter. Each year they put on an art show showcasing the children's work. They were always held at a fabulous venue like a winery overlooking the shimmering lights of Silicon Valley. The kids displayed and

sold their art, dressing up for the occasion. This gave them an opportunity to share their work and sell it to the community. It was quite an honor for them, to be identified as paid working artists. Many of them went on to have very successful creative careers.

## DECORATING YOUR HOME OR WORKSPACE

» **Clouds over Big Sur photo in the guest room**

I've given you examples of how Jan and I have created our home and studio. This again began with our visualization, from finding examples to planning and collaborating. You can see this example in one of my photos, mounted so that it floats off the wall, with contrasting lines in the pillows below it. When you consider how much time we spend in these spaces, it makes sense they receive the bulk of your creative horsepower.

## YOU ARE THE ARTIST OF YOUR ENTIRE LIFE

The most embracive and important area of creativity is that of the whole: a life well lived. You heard David Campbell talk about this on page 84—those rare people that infuse art into all areas of their life. This is one of my goals for you: to be the captain of your artistic ship of life and take your creativity to a whole new level!

## GETTING MORE IDEAS FOR ADDING CREATIVITY TO YOUR LIFE

Use the tools we've gone over, but also gather your own ideas and put them in your notebook. You should find plenty of inspiration from my creative conversations, to spark your imagination. We'll be shaking this loose in a minute in the application steps.

### 🖌 Summarizing

1. How can you visualize yourself as a creative person putting art into your life?

2. Who is an example of an artist you admire and what they are known for?

3. How could you define and differentiate your brand?

4. Name three excuses you've have you had for not sharing your creativity.

    a.
    b.
    c.

5. Name three ways to share your creativity.

    a.
    b.
    c.

### 💃 Application

☐ 1. Write down your vision as an artist in life.

☐ 2. Write down your short mission statement.

☐ 3. Where do you see your artistic and creative purpose taking you?

☐ 4. Write out all the creative areas that interest you.

☐ 5. Highlight the one where you are closest to achieving your goals in as an artist.

☐ 6. Write down all the ways you can think of to share that creative area.

☐ 7. Write in your notebook your experiences while doing this

# CREATIVE CONVERSATION WITH JOANNA VARGAS

Joanna Vargas is a celebrity beauty guru and entrepreneur. By way of illustration, at a recent Golden Globe Awards she was prepping many of the nominees for their appearance on the red carpet.

Her nature-meets-technology approach has made her one of the most sought out estheticians and experts in the beauty industry today.

Bringing her background in photography and women's studies into the beauty industry, Joanna navigated her way through her early days at a top celebrity dermatologist's office. Then she made the leap of opening her own salon with her husband. She tells us about the adversity she had to overcome to achieve her phenomenal success. As an entrepreneur she was inspired to apply her creative philosophy to make her practice evolve and expand to both coasts—all while raising a family.

I've known Joanna for some years and have been impressed with her passion for beauty coupled with a fierce entrepreneurial spirit. I wanted to include her story of breaking out into a highly creative life against all odds.

\*\*\*

*What have been your main successful actions for bringing creativity into your life?*

I made it a priority. The last time I worked for somebody, I was very successful, earning money, and as far as my career goes, it was probably the pinnacle. It was the best place in the world at that time to work, but I just didn't feel happy. I was making money, I was valued, I was being listened to, but I just felt empty on the inside. And I realized it was because I wasn't able to create enough. In that capacity, that wasn't what my job was. And I understood that. I went to my boss and told her that I wanted to do more and help her create more. But that wasn't something that she wanted to do or didn't want it for me.

That happens in life. And so I realized that I was either facing a life of doing actions that I didn't have any feeling behind, just for a paycheck and to be keeping the status quo, or I needed to make a big change in order to pursue personal happiness for myself.

So my husband and I started our own business. The big thrust of that was to be able to create, from the bottom up, everything that I wanted a client to experience when they came to see me. So I went from zero creativity to 100 percent creativity. And it was really knowing myself and knowing what the missing piece of the puzzle was for me. You have to create in every aspect of your life.

I have to create in my marriage in order for us to be happy with each other. You have to realize that creating is actually the most important thing for anybody, and it's not that you have to be an artist or have to have a predisposition for it. I wish I could paint and draw as well as I create in other areas, but you don't have to have some inner talent that somebody validates. You have to listen to yourself and know that it's an important aspect in order to do it.

So, the main successful action was keeping my own counsel. When we wanted to start this company, most of our friends told us not to do it, that I was secure.

I was successful already. So why did I want to rock the boat? And at the end of the day you have to consider that if you're truly happy, you will be successful. And if you're creating something that's worth communicating about, then it's going to be valued by other people. And that's certainly what happened with me.

***Are there any common misconceptions that you'd like to dispel about creativity, or being a creative?***

The most common misconception is that there are certain people that have a predisposition for it. I personally feel that anybody could be creative and very successfully creative if they opened themselves to the possibility of that. My mom was a very good visual artist, so it's not like growing up I had someone telling me, "Oh, you're so good." I didn't win trophies. I didn't get brought up with the mindset that I was such an amazing creative talent. It was kind of the opposite: I didn't have the talent that she had. So the main thing is not thinking that you can't do it or that you have to have some sort of DNA for it. I think that it lies within anybody to create in any aspect of their lives. They just have to consider that to be possible and then it just opens up a whole world.

***Were there any hardships or emotional barriers that you had to overcome in order to move from the working life that you described to having the kind of creative life that you have now?***

I had all of our best friends telling us we would fail. I had just had a baby. I had just gotten married and it did seem crazy to quit a job where you're making over $100,000 a year to do something where you don't know what's going to happen. My husband Caesar and I didn't have money set aside. We put everything on credit cards. So the day that we opened the salon we were in debt a good hundred grand on credit cards that we couldn't pay unless I made something happen. So I had to really dig deep to figure out what was going to be successful in terms of services, design, and the experience that the client has.

It was life or death in a way, if I didn't figure it out, the three of us were going to be in the streets with everybody saying they told us so. And it was not an overnight success; we had three very rough years with some months charging groceries on our credit cards, juggling money from one credit card to another;

it was very dramatic. It's not like we could take a vacation, I had to work seven days a week. I missed a lot of things that I wanted to be around my son for, but I was doing it for something. I think the biggest barrier is at the end of the day, you have to face yourself in the mirror.

You have to stop listening to everybody else around you. I had to face myself when I came home at night, did I do the best job at this? Could I have done anything better? And there was a lot riding on it. So I think keeping your own counsel is really important and knowing that you're living your life. If I had gone to you, Marc and asked you for your opinion, it would have been *your* opinion about my life, but *I'm the one who* has to live it. So I had to keep myself honest and know when I'm coming up short, and force myself be like, "Okay, I didn't do that very well, but I'm going to fix this," and really face a lot of my own fears. And when I did that, I could look myself in the mirror at the end of the day.

» **Joanna creating word of mouth with excellence**

*What advice do you have for getting your work out into the world?*

At the end of the day, I really focused on making the person in front of me happy and fully communicating with that person. I get questions from people like, "How did you get celebrities or how did you become successful?" And really the only success that I could imagine is if I made the person in front of me happy enough to tell another person. You build a business that way, or

you build your universe that way. That was my intention every time. I would make someone so happy and focus on being in the moment so much that they would just go out and tell other people and that's how we built the business ultimately. Focusing on what you're doing, then doing it excellently so much that the word has to get out, it can't be contained.

***What advice do you have for adding creativity or art into one's life?***

You have to set goals for yourself. And if you don't have a goal for the day or the week or the year, you're going to wake up one day and find that you're in the middle of your life and you don't know how you got there. You've got to put some thought into how you want to be. Even if you start out by saying, "I wish my life were like this", so that's your goal. Who do you want to have around you when you're achieving that goal? And what do you want to be doing as everyday actions in your job? And then you can start to put in steps toward that goal. But if you're not thinking with goals then everything kind of seems sort of grim.

There're so many ways that life can be creative. And I think people get stuck in a rut sometimes where they feel like they don't put any thought into it. They're just going to work and then they're coming home and they're not really thinking with it. But life can be sort of endlessly happy if you're looking for things to up the ante for yourself And I think when we're children, nobody talks to anybody about how to get the most out of your life. You go to school, go to college, then get a job, and then you work the job and get married and she's supposed to have kids and you're just doing everything sort of that you're supposed to do.

But the real fun of life is really making it fun every day. And I don't know that people realize that you can have that. It is looking for little ways that you can make it better for yourself or bigger ways to make it better for yourself. I have taught myself how to ice skate so that Ruby could ice skate with me because that's what she really wanted to do. And it's become fun and it's an activity. And Cesar began finding different things that we could do together that wasn't eating and drinking, or just being at work, things that could be really fun—the next thing that we can do that will really blow people away.

# LET'S CHECK IN

Before we go onto the next phase, let's check back in to make sure you've got your basics in up to this point.

## CHECK THESE OFF

☐     a.    Writing in your notebook every day. If not, do so from here on.

☐     b.    Working on some creative action every day. If not, make it a habit.

☐     c.    Taking a walk every day. Any kind of walk outside, perhaps at a park. Don't walk in the mall. Outside is best where you're looking at trees, people, rocks, and things. Do you live in a city? There's always a park somewhere. If not, walk down the street and look around.

☐     d.    Put better order into to your workspace.

☐     e.    How are you doing now?

# OVERCOMING BARRIERS TO A CREATIVE LIFE

"PEOPLE ARE ALWAYS BLAMING THEIR CIRCUMSTANCES
FOR WHAT THEY ARE. I DON'T BELIEVE IN CIRCUMSTANCES. THE
PEOPLE WHO GET ON IN THIS WORLD ARE THE PEOPLE WHO GET
UP AND LOOK FOR THE CIRCUMSTANCES THEY WANT, AND IF THEY
CAN'T FIND THEM, MAKE THEM."

— GEORGE BERNARD SHAW, MRS. WARREN'S PROFESSION

# MAKE TIME TO CREATE

» **Clock, Musée d'Orsay, Paris, Marc Silber**

"IT'S NOT ABOUT 'HAVING' TIME. IT'S ABOUT MAKING TIME. IF IT
MATTERS, YOU WILL MAKE TIME."

—UNKNOWN

The number one excuse for not following a creative goal is "I just don't have time" so we might as well tackle this head on and look at remedies for this malady.

Time, like anything else, is something you have to place. If you think about it, what's the difference between allotting time to create and allocating a space for your art to work in, like we talked about earlier?

How do we decide what to do with our time? First, there are several big chunks of your day that are already taken up. One is by work and the other is sleeping. They consume about two thirds of your day right there, if not more. And then you have other tasks that you need to tend to: meals, family, taking care of your personal items, and all the other parts of our life. With all these demands, how do you carve out your creative time?

When you dig in to your schedule, you can still find a number of hours left over. The question is, how are you going to spend that time and by "spend," I want you to look at it like a budget, as though you're investing money. What would you do if you had an excess of say, a quarter of your budget to spend? That's actually not a bad chunk, especially when you allocate it so that you get a good return on your investment.

There are so many sticky things that will absorb your time: the staggering number of hours that people watch TV, go online, and do other things that really show absolutely no return on their investment, or rather have a negative return. Similar to how you feel after eating junk food, instead of a really nutritious meal.

## HARD STATS ON SCREEN TIME

According to the *New York Times*, "On average, American adults are watching five hours and four minutes of television per day."

According to ComScore the average American adult spends two hours and fifty-one minutes on their smartphone every day.

The average American spends twenty-four hours a week online, per *MIT Technology Review*.

Even allowing for overlap of these numbers you can see that an enormous chunk of time is gobbled up by gazing into one screen or another, somewhere between three to five hours per day, or twenty-one to thirty-five hours per week!

Before we leave this, here's the contrasting sad news: Americans read an average of 16.8 minutes a day, according to CNS News—hold the phone, what?! That's only 5 percent of the time spent watching TV. Is that a wakeup call? We'll be working on remedying this in a moment.

Look at your budget of time per day: you have 1,440 minutes to spend. Like a couple who are saving for a trip, you have to cut out the waste, and stash away what you've managed to salvage if you're gonna see Maui, the Yucatan, Reykjavik, or wherever your lusting for. Instead of saving money you are saving "creative currency."

By simply eliminating the minuses, we can actually work out your budget and make this a mathematical proposition. So in the application steps we're actually going to do the math on your time budget. This isn't so much time management; it's really just to prove and to put in concrete that you do have time for creative priorities in your life. Obviously, you're going to budget what you have as your primary interests, so the first step in recovering or regaining time is to elevate the priority for your creative time.

## A SAMPLE TIME BUDGET

One way to dispel the myth that you don't have enough time to invest in your creative activities is to do a time budget. I'm not even suggesting that you attempt to follow it to the minute, but use it as a guide to get ballpark figures for how you use your time and what you actually have left over.

Let's say this is how your weekly time budget works out hourly:

| Task | Daily | Weekly |
|------|-------|--------|
| Sleeping | 8 | 56 |
| Total work time | 6.42 (7 day average) | 45 |
| Shopping, eating and cooking | 2 | 14 |
| Exercising and taking care of yourself | 1.5 | 10.5 |
| Family and friends | 2.14 | 15 |
| Chores | .85 | 6 |
| Misc. (those things you might do only weekly, monthly, or even a few times a year) | .28 | 2 |
| Total budget | 21.19 | 148.5 |
| Remaining | 2.81 | 19.5 |

This gives you a minimum of 19:30 hours *dedicated* creative time weekly or 2:49 hours a day.

## OPTIMIZE YOUR LIFE FOR CREATIVITY

But you can even squeeze more out of this by *optimizing* your time to include "creative loading" by using time to observe, that we'll talk about more, reading and other ways to add to your creative currency. Also note that the tasks above include plenty of room to add creativity: cooking, being with friends and family, even exercise can be an art form. The goal would be to add creativity to all parts of life as we'll see in a later chapter.

## CHANGE OF ATTITUDE

» **Off-screen play, Peninsula School, Menlo Park CA, Marc Silber**

This is a major change of attitude for most people. We talked about how, as kids, we had budgeted a fair amount of time for creative activities. What happened? Why did that all seem to evaporate as we grew up? We succumbed to an evil spell and fell into an hypnotic trance. But there is a red pill that will get us out of this matrix, and that is limiting or removing the time spent on TV and social media or surfing the web.

Now, don't get me wrong, I watch TV, primarily movies that become part of my visual library collection, which for me is similar to going to museums to look at art. I try to budget my time when watching TV toward learning about somebody's craft, moviemaking, screenwriting, or really observing how the actors are performing or the whole overall message. So even there, I'm really trying to take away what I can utilize and I recommend you do that, too. Use your notebook to jot your observations.

The internet is an incomparable tool for doing research. Back in the day we had to go to the library and bug the reference librarian over and over again to find what we needed. I still do that by the way, because there are many times I need a book for research; but the internet often serves that function well. The point is, use it with a creative purpose in mind, and don't get caught up in the BS that tends to swirl around screens with click bait that can distract you, which is just a mammoth waste of time. You want to cut those areas out, thinking about

it in terms of spending money. If you could recover a quarter of your monthly budget, you'd be pretty damn happy.

> "THE KEY IS NOT TO PRIORITIZE WHAT'S ON YOUR SCHEDULE, BUT TO SCHEDULE YOUR PRIORITIES."
>
> —STEPHEN COVEY, AUTHOR

## SCHEDULE YOUR PRIORITIES

Priorities play a huge part in shaping a schedule. The first step is to raise your priority right now to include your creative time, every day. We talked about a 24/7 creativity machine and I gave you some examples. Try to look at your life that way no matter what you're doing. For example, if you're at work or you're doing something that just seems like a non-creative activity, use it as an opportunity to learn. Let's say you're stuck in a really boring meeting. Use that as an opportunity to look at people as Leonardo da Vinci said, look at their expressions and how they respond to each other. What is their body language? How do they sit? What are they looking at? What are they doing? That's actually material that can be utilized in numerous ways in writing and drawing, acting and dancing. The more familiar you are with how people act and respond in different situations, the better you are going to be able to represent them in your own work.

By observing at those moments what might have been lost by "zoning out" (slipping into an eyes-open-unconscious) you're adding a plus to your budget. You'll find these opportunities all around: in the checkout line, on a subway, or waiting at a stoplight.

Another very important point, that we touched on in earlier chapters is creating a schedule and sticking to it daily. It's important not have a random creative schedule. Set times that you and others know that you will be dedicating time to your craft. Most artists and writers, as with the example of Jack London, established their creative time and never let anything interfere with it. Treat your time with the respect it deserves and protect it from encroachment, as you would monetary savings for a trip to an exotic land you've been dreaming about.

## THE VALUE OF READING

A huge component of creativity is reading books daily, ideally away from screens. Reading will stoke your fire and strengthen your ability to visualize, since the process of reading engages your imagination, rather than having prepackaged pictures fed to us.

In Stephen King's book *On Writing,* he gave this advice for writers which is applicable for any creative:

> "Reading is the creative center of a writer's life. I take a book with me everywhere I go, and find there are all sorts of opportunities to dip in. The trick is to teach yourself to read in small sips as well as in long swallows. Waiting rooms were made for books—of course! But so are theater lobbies before the show, long and boring checkout lines, and everyone's favorite, the john. You can even read while you're driving, thanks to the audiobook revolution."

>> **Woman reading, Rembrandt van Rijn, after 1634, courtesy Rijksmuseum**

This is excellent advice and will help you fuel your passion and salvage otherwise wasted time. Consider just the time you're driving or on a train on a long commute, you can re-invest it by reading rather than throwing it away on talk radio or web surfing. Your time spent reading is another way of banking creative currency.

I suggest that you add to your tool kit a cordless warm light reading lamp to use if your bedmate is sleeping. It's also handy when traveling on planes and other places where you need soft light to read by.

And as a note, King mentions his own schedule is very set: he writes two thousand words a day, but gives the new writer a break with a daily quota of only half of that:

"Your schedule—in at about the same time every day, out when your thousand words are on paper or disk—exists in order to habituate yourself, to make yourself ready to dream just as you make yourself ready to sleep by going to bed at roughly the same time each night and following the same ritual as you go."

## BEAT FATIGUE

Another big excuse for not following your passion, is being too tired, a cousin to lack of time. Let's say you've been at work, you've been commuting, you're burned out, dog-tired, what do you do? That's the time where many people just simply veg out in front of a screen (bye-bye).

How can you recover from fatigue and burnout? Personally, I find there's nothing more invigorating than a walk or practicing sports, which you just have to push yourself to get up and do—we'll cover this in the next chapter. You're tired, but, that's what you need to do to overcome it—push yourself through it and get into some activity, not go the other direction and grab a beer and veg out even more.

Another remedy is to put yourself into your creative activity. This is reviving because you're actually fulfilling your purpose. Find something that you can do. I'm fortunate in that my day gets filled with many aspects of creativity, either writing, working on my photography, editing a film, or interacting in some way. Even marketing is a creative activity. So try and budget and put as much time back into your day as you can for your creative activities.

 Summarizing

1.  List three excuses for not having time to create.

    a.

    b.

    c.

2.  How can you best invest your time (as you would money)?

3.  Where can you eliminate "minuses" in your schedule to salvage time?

4.  List three examples you've seen of the hypnotic "evil spell" of losing time for creativity.

    a.

    b.

    c.

5.  How can you schedule your priorities instead of prioritizing your schedule?

6.  What are ways you can remedy fatigue?

Application

☐ 1.  List out your weekly time budget per day and week.

| Task | Daily | Weekly |
|---|---|---|
| Sleeping | | X7 = |
| Total work time | | X5 = |
| Shopping, eating and cooking | | X7 = |
| Exercising and taking care of yourself | | X7 = |
| Family and friends | | X7 = |
| Chores | | X7 = |
| Misc. (those things you might do only weekly or monthly or even a few times a year) | | X7 = |
| Total budget | | |
| Remaining | | |

☐ 2. This gives your minimum dedicated creative time weekly.

☐ 3. Fill in your basic weekly schedule. Black for items that don't change, yellow for variable, and green for your creative times.

☐ 4. Draw a weekly calendar like this: (or go to SilberStudios.com/Create-Resources to print your Create-Calendar.)

| Monday | Tuesday | Wednesday | Thursday | Friday | Saturday | Sunday |
|--------|---------|-----------|----------|--------|----------|--------|
|        |         |           |          |        |          |        |
|        |         |           |          |        |          |        |
|        |         |           |          |        |          |        |
|        |         |           |          |        |          |        |

☐ 5. Post this in your "studio" where you and others can refer to it.

☐ 6. Mark in blue times where you can read: A dedicated time each day, as well as times you can listen to audio books, or other "sips" as Stephen King suggested.

☐ 7. In your notebook, keep a daily log of your time for at least two days and see how close you come to your schedule.

☐ 8. Find at least five times in the coming week where you're able to optimize your schedule. E.g. turning a potentially boring situations into an observational experiences. Write notes of each in your notebook.

☐ 9. What is your overall conclusion about your schedule now?

# CREATIVE CONVERSATION WITH MARSIE SWEETLAND

Marsie Sweetland is a mother, photographer, and executive in the technology industry. With over two decades of experience in tech, she has worked through multiple boom and bust cycles of the internet economy. She was among the first one hundred employees at Equinix, which today has annual sales of $5 billion and over seven thousand employees. She has been an avid photographer since childhood, focusing on family, children, and infrared photography. She enjoys traveling internationally, snowboarding, and spending time with her family.

\*\*\*

*How do you add creativity to your life as a parent?*

Since childhood, photography has been one of my very favorite outlets for creativity. As a parent, I love taking photos of our children—both at home and with a more formal photo shoot type setting. I will actually schedule "photo shoots" with my kids. They have been doing this with me since birth and have become quite accustomed to this special request. When we do a photo shoot together, it adds a lot of fun to a trip to the pumpkin patch, a vacation in Hawaii, or a day at the park.

I view photography with kids in two different ways: first, what I call "snapshot documentation." These are photos that document what we did and what we saw together. I have many terabytes of photos of this nature. I love having a scrolling photographic timeline, showing everything we do together as a family.

This is totally different (in my eyes) to taking a professional series of photos that are suitable quality to be framed. When I'm in "photo-shoot mode," I let the kids know and they go along with the game. It's quite fun.

When they were younger, my photoshoots were 75 percent herding cats, 25 percent photography. But now, as they are older, they have really joined into the creation and help me find locations, ask questions about lighting, and want to know if I've gotten "the shot."

Our family tends to have repeat places where we go on vacations and outings each year. For example, we always go to Aspen over winter break to visit my family. The kids get a week of grandparent and ski time. We'll take the normal snapshots of skiing and whatnot, but sometimes I'll take them to a ranch or a beautiful stretch along the road where I may see a photo shoot opportunity. Or, if I see one of those magical moments where the setting and lighting all match up, I'll just pull over and say, "Hey can I to do a photo shoot of you?" and we'll get out and do a quick shoot.

Both of our kids are now starting to enjoy photography themselves. They have their own cameras, or sometimes they may see a shot and ask to borrow my camera. It tends to be a bit of a two-way create between my husband, and myself and the kids. And that adds a really neat element, that came just on its

own. For years they were always the subject; then they wanted to get behind the camera. So now it's a really special family create that's starting. I love that.

**Are there any common misconceptions about creativity, especially as a working mom that you'd like to dispel?**

I think a common misconception might be that you need to be a professional before you start doing photoshoots, or that you need to focus your career on photography in order to consider yourself a professional. I have a very busy, professional career in the tech industry. I'm frequently asked how I find the time to be a working mom and also take photos. The truth is I just make the moments and I think if I ever looked at myself and said, "Okay, now I'm going to be a professional photographer," I never would have done it. The key is finding something, whether it's photography or anything creative, and incorporating it into your life with little bits of time. Just do it and work with what small amounts of time you may have.

**What are the biggest barriers that you've had to overcome in order to have a more creative life?**

Sometimes I can get so busy and so buried with work that the last thing on my mind is photography. One successful strategy I've done over the years to continually improve my skillset is to donate photoshoots to various charities and organizations. I have donated them to our church's annual fundraiser, I've donated backstage photoshoots to my daughter's ballet studio during Nutcracker season, and I also donate a photo shoot to our children's school auction each year.

» **Marsie Sweetland: her daughter in the *Nutcracker Suite***

This ends up being doubly gratifying, because the proceeds that are raised goes to a charitable cause, and I use the opportunity to improve myself as a photographer.

My biggest jump as a photographer is always after I prep for and deliver a photo shoot for another family. I move up every time I do those. And when I see the improved work and have the thought, *Wow, these are definitely better than last year*, that's inspirational in itself.

*Any final advice, especially for parents, to add creativity into their lives?*

I would suggest you just start. Don't worry about how good your work is. Just start and improve as you go because with any artwork there's a gradient scale of quality and it's like the saying, "It's the journey, not the destination." I would encourage parents to enjoy the journey of taking photos and improving along the way. It's very fun to learn new techniques and watch your improvement over time.

I would also suggest, with moms especially, to recognize the difference between taking photos that document activities and an actual photo shoot. Find time for one. Choose a day at the park or on a vacation and carve out some time for

photos. Talk to your kids about it and let them know what you're trying to do. Ask for their help. Kids love to help and if they know that they are helping you learn a new skill, they may be more willing to pose and smile than you'd think.

At first you may need to keep it short—five minutes or so. But gradually you can take photos for longer durations as their stamina for following instructions builds. If the photos don't turn out as good as you were hoping, there's always another day for another photo shoot. You can use your family as a learning ground to get to know your camera and to try out some new techniques. By continuing to learn about photography and then taking the time to practice your skills with your family, you'll not only enjoy the creative process, but you'll have some fantastic photos of your children—taken by you!

# TAKE LONG WALKS AND ADVENTURES

» Hikers, Jungfrau Region, Switzerland, Marc Silber

"THE OBJECT OF WALKING IS TO RELAX THE MIND...
DIVERT YOUR ATTENTION BY THE OBJECTS SURROUNDING
YOU. WALKING IS THE BEST POSSIBLE EXERCISE. HABITUATE
YOURSELF TO WALK VERY FAR."

—THOMAS JEFFERSON

For the length of human history, walking has been in many creatives' toolbox right on the top shelf. There's a tremendous value to walks and you'll find that many great artists have recharged their batteries frequently by getting out and taking walks.

Steve Jobs was known for taking long walks when meeting with people. Instead of sitting in an office or in a boardroom he took people outside where they would walk and talk sometimes for hours. His biographer Walter Isaacson, wrote, "Taking a long walk was his preferred way to have a serious conversation." Walking was a key part of his creative process, and is another example of how he broke away from corporate conventions. In this case he drew from a deep well that has been used for millennia.

Other notables in history made walking a central component of their daily routine, for example, Aristotle reportedly taught students while walking or strolling around Lyceum, his school in Athens.

Beethoven remarked about how he visualized, "You ask me where I get my ideas. That I cannot tell you with certainty. They come unsummoned, directly, indirectly—I could seize them with my hands—out in the open air, in the woods, while walking, in the silence of the nights, at dawn, excited by moods which are translated by the poet into words, by me into tones that sound and roar and storm about me till I have set them down in notes."

Philosopher Soren Kierkegaard wrote about the curative power of walking, "Above all, do not lose your desire to walk. Every day, I walk myself into a state of well-being and walk away from every illness. I have walked myself into my best thoughts, and I know of no thought so burdensome that one cannot walk away from it. But by sitting still, and the more one sits still, the closer one comes to feeling ill. Thus if one just keeps on walking, everything will be all right."

When following Jefferson's advice it's up to you to decide exactly what "very far" means. For me, it's usually an hour or more. I don't necessarily do that every day. Some days I take short walks of a mile or so, but I definitely get out every day with Shyla, my ever-faithful Golden Retriever. She actually drives me out, barking if I don't take her on a walk, urging me on by yapping until I do. This simple daily ritual is excellent for getting away from electronics, all the

noise, the phone calls, and the undone things that have stacked up. It's your time to experience renewed joy by putting attention into life.

We've touched upon this already with da Vinci's quote about walking with your notepad and deeply looking at what other people are doing and how they appear. When you walk through a town, you certainly should do the same. If you have access to a park nearby, there's going to be plenty of people. Look at them and observe how are they acting? Get out of your own head and look at them. That's also a most restorative action.

Since childhood I've loved hiking in the mountains. On the extreme end of the scale, in my teens as a mountaineering student and later an instructor, we would go out for thirty-day expeditions. These very long journeys are incredibly therapeutic. Once you've gone for more than a few days, all the hypnotic traps of our modern civilization tend to dissolve. The longer you're out, the more they disappear. It's the same on a sailing voyage, when you get away from land with all the encumbrances of our civilization. There's a freedom that goes along with it.

If you have an opportunity to take a multi-day hiking trip, I highly recommend it. They can be done in a number of ways: You can backpack, which is the traditional way of carrying everything needed yourself. Or you can do a more luxury route: there are many places where you can hike from hut to hut, only carrying your day gear. You can research options to find what's more appealing.

My growth as an artist was catalyzed by getting out into nature frequently. When I was on my high school excursion to Mexico, we had a break halfway through the trip when the teacher running the program had to return to Mazatlán to pick up supplies. He left me and the only other student at that time behind. Because I was accustomed to long solo hikes, I decided to walk up the Rio Verde. This was very a remote part of Mexico in the Sierra Madre mountains with absolutely no connection to outside civilization: no radio, no electricity, no cars, no link to the modern world. This made my short expedition extraordinary. It was like time-traveling back a few hundred years and observing what people did when they lived on a river that served as the hub of activity for their entire existence.

» **Friends on the path near the Rio Verde, Mexico, Marc Silber**

Making this eighty-mile trek even more of a challenge, I decided to fast (yep, no food at all) for the entire five-day walk. Why? because I was self-conscious about my weight and wanted to shed pounds in a hurry. Also, it was the '60s and we did such extreme things. So I took no food and I only drank tea and water. The first day I was famished, it was beyond difficult. I felt hollow, gnawingly hungry and empty. Surprisingly, by the second day my appetite disappeared and I actually had quite a bit of energy.

The people on the river would invite me in to their thatched huts, "*Ven aqui, ven aqui, a comer!*" ("Come in, come in, let's eat!") I had to explain to them that I wasn't eating and I couldn't come up with a sensible way of explaining it. Why would anybody turn down food in this needy environment? People were

primarily eating tortillas, rice and beans, an occasional chicken or possibly goat meat on rare occasions. Grasping, I said that the doctor told me I shouldn't eat. They were somewhat satisfied, but probably secretly thought this gringo kid might be slightly tilted. They invited me in anyway, I drank tea while they ate their sparse meals.

» **Boy on his horse, Rio Verde, Mexico, Marc Silber**

I sparked my creativity on this long walk, capturing an extensive series of meaningful photographs. This journey was a massive decompression since I'd already been in the remote environment of the Sierra Madre for several weeks and then pulling away even farther, casting off my last moorings to civilization. Going deeper another eighty miles marked a shift in my direction, shaking off what little of society I had been clinging to. By the time I came back to our tiny

"village" (a solitary hut) I had nourished myself creatively with dozens of rolls of exposed film of the people in this remote region.

## INVEST IN A DAILY WALK

You may not be ready for such an extreme adventure, but as an artist you should find your own level and work on lengthening it as you can. Let's look at some more compelling reasons why you should make sure every single day you get out for a while.

Hippocrates stated, "Walking is man's best medicine." Wise advice; you'll find it is true that a walk seems to cure all sorts of complaints. But its effects run much deeper than purely physical.

More than 2,400 years after his advice, a 2014 study was conducted at Stanford University entitled, "Give Your Ideas Some Legs: The Positive Effect of Walking on Creative Thinking." Their research found that "Walking opens up the free flow of ideas, and it is a simple and robust solution to the goals of increasing creativity and increasing physical activity."

They went on to say, "Walking has a large effect on creativity. Most of the participants benefited from walking compared with sitting, and the average increase in creative output was around 60 percent." Consider such an increase from the simple action of walking. Imagine if you could increase anything in your life to that extent with such a straightforward activity as putting one foot in front of the other.[7]

What a package of creative and physical benefits. Make sure walking is a key component in your daily toolkit and work it into your schedule (it fits into your exercise slot giving bonus points). You can use walking as a daily proactive tool and also keep it in reserve when you get stuck on a project and simply need to reset. Follow Thomas Jefferson's advice to take your mind off your woes and problems and simply "...divert your attention by the objects surrounding you."

## TIPS TO HELP YOU MAXIMIZE YOUR WALKING BENEFITS

1. Get off your phone and electronics. If you use your walk as another time to stay plugged in, you'll diminish gains.

---

7 Marily Oppezzo and Daniel L. Schwartz

2.  On the other hand, bring a notebook to draw or jot your thoughts. By all means bring a camera (but if a phone, ignore all other apps).

3.  Take Jefferson's advice and put your attention on the objects surrounding you, looking outward, not in.

4.  To increase connection to the outside world, I prefer to wear sunglasses as little as possible.

5.  Use walks for meeting with others to spark creativity.

6.  Plan longer walks, but walk daily even if shorter.

7.  Make sure you're comfortable and prepared for changing weather. I wear a hat and carry a small sling bag, with a light windbreaker inside, a small flashlight and a few other items.

8.  Keep a regular walking routine so it doesn't get shoved off your schedule.

9.  Find a comfortable pace—I tend to push myself.

10. As you'll often be covering the same route, you'll get to know people on it, be open to talking with them, but don't get too sidetracked.

11. Walk in parks or quiet streets whenever possible. Don't let your walk time be disrupted; stay away from cars and street noise as much as possible.

12. Take a walk as a remedy when you get stuck or need to reset.

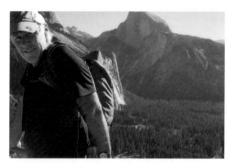

>> **On one of my countless hikes in Yosemite National Park, CA. Photo: Jan Silber**

## SPORTS FUEL YOUR CREATIVITY

In addition to walks, sports are important for increasing creativity. When you're busy creating, and in the zone, you need to balance that by getting into a demanding physical activity, which is why sports are so vital to bring that about.

I've always gravitated to non-traditional sports. When other kids' heroes might have been Babe Ruth, Pelé, or Jonny Unitas, mine were mountaineers: John Muir, for his sheer love of the mountains, Edmund Hillary for being the first Occidental to summit Everest, and Gaston Rébuffat the all-around simply cool French Alpinist.

I wrote a report on Muir in the fifth grade. He was known as the "father of the national parks" in the US, who influenced park creation globally. He traveled in the mountains for months at a time, in all seasons, carrying no more than a hatchet and bag of bread. These trips inspired him to write beautiful prose and poetry. One of my favorites, that so gracefully encapsulates his powerful mission, ultimately winning us our National Parks:

> "Keep close to Nature's heart...and break clear away, once in a while, and climb a mountain or spend a week in the woods. Wash your spirit clean."

His message resonated deeply with me; in my teens I began to rock climb and take serious mountaineering trips as I've told you. These acted as a catalyst for my photography, music, and writing. On one of my many long solo hikes I perfected my blues harmonica playing by practicing on breaks and at the end of the day. When it came to sharing, my most memorable "concert" was in the Wind River Range of Wyoming playing to the setting sun and glancing over to see tears streaming down from my fellow co-ed mountaineering student. The biggest reward for any artist is their audience experiencing such an emotional impact.

During my junior year of high school, while living in Vermont, I took up cross-country skiing. This is another example of how sports ignited my creativity. All winter that year I daily skied a 10K course through the trees after school and often twice over the weekends. I vividly remember my senses heightening through this vigorous exercise, coupled with an increased sense of aesthetics, again inspiring my photography, writing, and music.

Later my snow sports evolved to downhill skiing and then to snowboarding, with the same results.

In my forties I discovered surfing and passionately charged into it. I'd get in the water two or three times a week often pre-dawn in order to (barely) make it to work on time. Surfing is both a sport and an art.

» **I'm catching a bit of air, Bear Valley, CA**

You're catching beautiful wave forms, like flowing glass. They capture sunlight, turning it into nature's most beautiful light show, as it bursts through the spray rising off a wave. While you're waiting for the next set of waves, there's endless opportunity to observe the enchantment of sea life, such as dolphins. They are best surfers in the world, whose mixture of grace and playfulness is a sheer joy to experience. My favorites are the otters, playing in the water like puppies. I often paddle as close as I can to their display of amusement as they dive and dine on crabs, munching a limb at a time, much to the crab's dismay.

The feelings I experienced after these sports were heightened perception and refueled creativity, in spite of physical fatigue, I felt washed spiritually as Muir said, and soaring aesthetically.

My advice is to be sure to balance your time spent working and creating with your favorite sports. You will reap the rewards of well-invested time.

### Summarizing

1. Can you remember a time you benefited from a walk? Jot it down.

2. Why do you think taking walks improves creativity?

3. What are some ways you can improve your benefits from walking?

4. Why do you think it is important to give your attention to natural objects as you walk?

5. Write about some times that sports helped you as an artist.

### Application

☐ 1. Add your walk time to the schedule you created in chapter eight, use a favorite color pen.

☐ 2. Stay on a schedule to take your daily walks, no matter what.

☐ 3. On your next walk observe what happens with your free flow of ideas.

☐ 4. List at least three realizations you've had while walking.

☐ 5. Take a walk as a remedy when you're feeling foggy or down. Note the results.

☐ 6. Work into your weekly schedule your favorite sports or exercise.

# CREATIVE CONVERSATION WITH
# AARON KYRO

Aaron is a massively successful YouTube producer with over 3.6 million
subscribers and nearly one billion views on his "Braille" skateboarding
channel; one of the top channels on YouTube in any category and
certainly in sports. As an entrepreneur he has leveraged his brand to
"Braille University"(paid tutorials), merchandise, and workshops. His
success has brought him to give back much of his time and generously
contribute to humanitarian causes.

I've witnessed Aaron's meteoric rise from humble beginnings seven years ago
to stardom today. Some time ago, my son Lance joined him as a producer,
becoming a YouTube star in his own right.

Since he is a very creative person, I wanted to get an inside look at Aaron's process and inspirations.

<p style="text-align:center">\*\*\*</p>

**What have been your main successful actions for bringing creativity into your life?**

I try to find inspiration in things that are a little bit out of the everyday, mundane, set way that people do things, or set system that people have. A lot of people are in this sort of mindset, that's the way it is and it's not going to change.

I'll watch movies. In the field of skateboarding I will watch a compilation of tricks that a person did and I specifically will watch people that are doing things that nobody else is doing or they're using spots in a way that nobody else is using them. If everybody skates a certain way, this person is skating it a totally different way or everybody skates at the top and they're grinding the middle.

It's about breaking out of that mundane—every day you wake up in the morning, go to work, go home, feed the dog, whatever it is. I'll also watch science fiction movies or whatever, that will just be like totally out there. I'll find inspiration in the weirdest places sometimes. And that'll make me think, *You know, I really should launch that new website that's going to get all those people involved.*

**Besides movies, what other things trigger that sort of inspiration?**

I'll watch other people do things. For example, yesterday there was this guy who came to my skate park and at the age of six years old, his legs were run over by a train. So he has legs only from his knees up and that's it. But he rides a skateboard and he pushes with his hands and he can do incredible things. It's

things like that that make me see that anything can be done. Whatever idea a person might have had that they squashed, it gets you out of that. If he can do that trick with no legs, somebody can do something incredible. Or you can achieve whatever dream you have.

I think that people are naturally creative. And then what happens is they squash those ideas because of the mentality of "Oh, I could never do that" and then it gets squashed, whether it was by them or somebody else or even being part of the everyday mundane world.

**Are there any common misconceptions about being creative that you'd like to dispel?**

People think if you're creative that you're different, you're weird, which means you're not going to have friends or that your idea is not going to be successful. A big one is that you're not going to make any money. I think that's a major one in terms of business and the world because people look at who's making money now. So, then that gives people the idea, "Oh, there's no money in being creative or being an artist."

The truth is you do make money being creative and likely more money than you would ever make otherwise.

**What have been the biggest barriers you had to overcome in order to live a really creative life?**

I worked as a valet before I quit my job and went full time into YouTube. A lot of people were telling me this was a terrible idea. "You're going to fail." "It's not going to work out." "Nobody makes money at that." When people say that and you already have enough uncertainties about it yourself, you think, *I don't know.* Especially when you're young, you're just getting out of high school or college and you have to pick a career path, that is a key time period in anyone's life where they have no idea. If they could look into the future and know either scenario: "One day I'm gonna do creative YouTube stuff and be very successful in every kind of way," or "Going this way I'm going to just work the Monday to Friday nine to five job and sort of end up hating my life." It would be easy, but you can't, you can't look at the future like that.

For me, it was going up against all of those barriers of people saying that and then being able to push through. It's not that it's less work, it's probably a lot more work actually. But I think the key thing is that it's work that you like.

**What do you think about sports fueling creativity?**

I think that it absolutely does because every now and then there's a person in sports that is above and beyond other people. Wayne Gretzky was one of those people. How a goalie blocks a shot in hockey is they look at where the guy's eyes are directed. So if the guy's eyes are looking toward the left of the net, the goalie will begin to go to the left and then the shot will go there and he'll block it. Wayne Gretzky had this ability to look in a different direction and then shoot the puck into the net.

Those are the things that are the most inspiring. Other people seeing that say, "That guy was thinking way out of the box. He didn't do the same thing that everybody else did and he was above and beyond the rest of his peers." So then they get the idea, "Maybe I could do that too." I think sports, even if even if it's a team sport with a lot of rules, you'll see the guy who understands the rules but then goes beyond an understanding of those rules to be creative within the rules and win. And he's a *great*.

**How about as far as adding creativity into other parts of your life, for example, as a husband or entrepreneur. How does creativity enter those areas?**

Being an entrepreneur, you have to be able to look at some economy or some sort of exchange between your business and people and you have to be thinking way outside of the box. It goes back to watching movies or sort of daydreaming, getting out of the regular everyday mundane workday world that allows you to do that.

Or with your wife. If every Friday night we go out to dinner, maybe one Friday night you might have to sort of surprise her, "Well, we're going somewhere. It's a bit of a surprise," and then you get there and you're hiking across the Golden Gate Bridge. But if you tell her you are going hiking across the bridge she might say, "You go alone."

**Is there any final advice you want to leave readers with for bringing creativity into their lives?**

Try to think back when you were a kid and hopefully when you had some creativity. But sometimes when you're older, you have to really dig it out of yourself. You have to really pry and ask your younger self a lot of questions. But if you think of what you wanted to be when you were five or six years old when you hadn't gotten into the mundane workday world, whatever it was, try to get back into that mindset for a little part of your day each day. Whatever you need to do, then do that.

# FIND AND PUT ART INTO YOUR LIFE

» Window art, Santa Pau, Spain, Marc Silber

"THE ARTIST IS A RECEPTACLE FOR EMOTIONS THAT COME FROM ALL OVER THE PLACE: FROM THE SKY, FROM THE EARTH, FROM A SCRAP OF PAPER, FROM A PASSING SHAPE, FROM A SPIDER'S WEB."

—PABLO PICASSO

Art needs to be *put* or *placed* in your life. It won't just fall out of the sky, or grow on of tree. You need to plant it and nurture it with the right ingredients to cultivate your dreams.

Sadly, many people put up with a life that lacks creativity because they've either forgotten how it feels to freely create as an artist, or they've bought into the misconception that one should hypnotically shoulder their heavy burden daily, be glad to do so, and maybe at best "whistle while you work."

In order to put art into your life, you must first consider yourself an artist, and an artist is first of all someone who is very observant of the world around them, as Picasso pointed out in the epigraph above.

As a teen, I remember being deeply impressed by photojournalist David Douglas Duncan's marvelous book, *The Private World of Pablo Picasso*, "Dedicated to the freest spirit—and the most disciplined—I have ever known." The book is an inside and intimate look at the artist. It opens with a photo of the photographer's and artist's first meeting. We see Duncan's first photo of Picasso grinning in his bathtub, happily scrubbing his back. They went on to develop a long friendship, with Duncan capturing over 25,000 photographs of Picasso.

My biggest takeaway from the book was how Picasso discovered art in life all around him, transforming it from his vision into his own work. As one example, there is a cinematic frame-by-frame sequence of Picasso at his dining table eating fish and then delicately nibbling the final scraps of meat off the remaining skeleton. The series continues, revealing him having a flash of inspiration so strong it seems to spark right off the page. Pablo heads to his ceramics studio and makes a clay representation of the fish on his plate, impressing the fish skeleton into the clay, forming two filets. Finally painting the plate, then placing the clay-fish on the plate's rim. We then see him pause to contemplate his newest work of art.

This series speaks volumes of what inspired this extraordinary artist. Where the rest of us would be thinking about how to discard the remains of the fish so that it didn't stink up the whole house, here Picasso was inspired to his next moment of creation, with the inquisitiveness and energy of a child.

From this we learn a key lesson: first be receptive to finding art in our life, at any moment. As Picasso said, "From the sky, from the earth, from a scrap of paper..." or even fish bones.

» **Look for art everywhere. Glacier Point, Yosemite Park, CA (smoke in air from forest fire), Marc Silber**

This comes down to looking very directly to find art and then putting it into your life. In workshops the first thing I teach is to look deeply to find images. You can develop this skill with practice, by tuning in even more intently to find a compelling image, one that everyone else may have just walked by, totally unnoticed.

No matter what kind of artist you are I recommend doing this drill regularly.

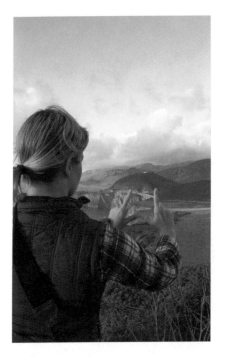

## TRAIN YOUR EYE TO SEE

It's good practice to always look for images, with or without a camera. Whenever you have a moment, riding on a subway, waiting for a meeting, or out on a walk, try to find the images in that environment.

It can help to "frame" with your hands making two "Ls" on top of each other or touching your thumbs together, and look through them with only one eye, to simulate what a camera would see with a single lens. Simply find images that are interesting to you. Why not use a camera to do this? Because we're working on training your eye, freed from the camera or any equipment, just you and the scene. Think of it as a workout for your eye.

I often will walk into an environment and just know there is an image there, and like a game of hide and seek, will look for it until I find it!

## LOOK FOR ART ALL AROUND YOU

It is also easy to translate this drill to other art forms: For a writer you carry on this same practice of observing visually, perhaps the way someone gestures, or the motion of trees as the wind bends them back on a ridgeline, the smell of dew on grass in the morning air. The same for dialogue by listening and

noting how people talk, what they say and the words and phrases they use. You then transform your observations into words to convey what you saw and felt, passing it along to your readers.

> "IF THERE IS A MAGIC IN STORY WRITING, AND I AM CONVINCED THAT THERE IS, NO ONE HAS EVER BEEN ABLE TO REDUCE IT TO A RECIPE THAT CAN BE PASSED FROM ONE PERSON TO ANOTHER. THE FORMULA SEEMS TO LIE SOLELY IN THE ACHING URGE OF THE WRITER TO CONVEY SOMETHING HE FEELS IMPORTANT TO THE READER."
>
> —JOHN STEINBECK

The magic in writing (or in any art form) is conveying your message, what you feel is important to the reader. What strikes me when I read Steinbeck is how observant he was of details in his subjects and their environment. This paragraph from Cannery Row is an example of his power of observation. His ability to take in the whole environment, telling us what he considered important so vividly that he takes us directly into what he saw and felt:

> "The Carmel is a lovely little river. It isn't very long but in its course it has everything a river should have. It rises in the mountains, and tumbles down a while, runs through shallows, is damned to make a lake, spills over the dam, crackles among round boulders, wanders lazily under sycamores, spills into pools where trout live, drops in against banks where crayfish live. In the winter it becomes a torrent, a mean little fierce river and in the summer it is a place for children to wade in and for fishermen to wander in. Frogs blink from its banks and the deep ferns grow beside it. Deer and foxes come to drink from it, secretly in the morning and evening, and now and then a mountain lion crouched flat laps its water. The farms of the rich little valley back up to the river and take its water for the orchards and the vegetables. The quail call beside it and the wild doves come whistling in at dusk. Raccoons pace its edges looking for frogs. It's everything a river should be."

A songwriter might take a page from Eminem who gathers lyrics and phrases from the world around him, then pushes them back out in his gritty raps. You may not like his music, but it's undeniable that he can tell a story.

## DIAL IN TO ALL YOUR SENSES

After taking a break from writing one evening for an exercise class, I took the long way home on my Vespa, slowly winding along the coastline of Carmel. Fall had fully moved in and kicked summer out. The crisp air funneled into my helmet, and mixed with the pungent smell of pine smoke. Turning left onto Scenic Drive, I looked down at the beach, with only the faintest remains of sunset, kids playing by a lone beach fire, sending up sparks and its orange glow into the misty air. Looking at the kids, I reached back into my own childhood on this very beach.

The aesthetics of seeing this life-as-art drew me in me like gravity, begging me to pull over and drink the scene in fully. Slowing the Vespa to a stop, I took off my helmet. I had an intense rush of senses: the smell of sea air mixed with smoke, the flickering fire, a sailboat with a tall lighted mast bobbing gracefully to the swell in the bay. Then seeing a second fire south on the beach with another group laughing and reveling in the magic of a warm fire, holding off the damp coolness of fall. Summer had faded, but was trying hard to hold on with an ever-slackening grip.

Pausing to take this all in, I marveled at the display of art all around me. I collected moments that I knew I would write about, picking out the pieces and savoring them, moment by moment.

Practice opening your senses by being mindful and very attentive to any scene that sparks emotion in you.

## Summarizing

1. How can you place art in your life?

2. How can you be a receptacle for emotions and art?

3. Can you remember a time you were inspired by life like Picasso was with his fish?

4. How can you develop the skill of looking deeply?

5. How can you look for or listen for art to put in your life?

6. Describe some examples of finding art in your life.

## Application

☐ 1. Read Picasso's quote again.

☐ 2. Be a receptacle for emotions and find at least five examples of art around you and note or draw what you found.

     a.

     b.

☐ 3. During your next walk, do the drill of using your hands to find and frame images. Note what you find.

☐ 4. On your next walk mindfully and very attentively observe a scene that sparks emotion with at least five senses. Write your observations.

☐ 5. Write down how you can use what you have found in this exercise to enhance your art.

# CREATIVE CONVERSATION WITH SUSIE COELHO

» **Susie at launch of her newest endeavor 'House of Sussex' Art & Fashion**

Susie Coelho has an extraordinary array of talents: a former Ford model, actress, TV personality, lifestyle guru, restaurateur and a serial entrepreneur.

*The New York Times* described her as "the effervescent cable television design guru who takes an infectious gung-ho approach...the effect is frolicsome rather than egotistical." She hosted two series on HGTV, was a frequent contributor and style expert for ABC's *The View* and was previously a regular contributor to NBC's *Today* show.

She built her brand by providing straightforward tips on home style, gardening, entertaining, and cooking in a fun and easy-to-follow way. With a busy career and two children, Susie knows firsthand how difficult it can be to find time for creative activities.

Susie is a bestselling author of four lifestyle books. One of them, *Secrets of a Style Diva: A Get-Inspired Guide to Your Creative Side.*

Susie once again is expanding into new endeavors. This time she is turning her entrepreneurial savvy and fashion sense to the House of Sussex, which will marry together Susie's lifelong fascination with fashion and art.

I wanted to include Susie's advice on creativity since she's become a guru providing tips that are easy to follow for adding creativity to life.

\*\*\*

***What have been your successful actions for bringing creativity and style into your life?***

One of the most important things for me is not to worry about whether I know how to do something before I start. It's a "creativity killer"! If I have to wait to learn something first and the learning curve is too long I move on to something else. Generally I just decide I want to create something and just start. I have done it this way with all of my endeavors, from the restaurants to my store on Melrose and my lifestyle company. Trying to know it all and do it perfectly will stop me dead in my tracks. It just seems too hard and too serious! I think creativity has to have a spirit of play and excitement and joy. Not be a drudgery.

I suggest people just flow with their ideas and they will find their way. There is no failure. It's all part of the creative process. The most successful people hit road blocks but they are tenacious to get around them, as they are not going to give up!

Tenacity is key along with drive and passion. What if you are not passionate? Well look for something else that you are passionate about, that you dream about...that you wake up excited about...that gnaws at you. Then figure out the resources you have to get it done. When I opened my store on Melrose, A Star is Worn, which sold celebrity designer duds and collectibles, I had the idea after I had a private garage sale with all these clothes that I had accumulated. It was very successful. I thought now here is a business and I just did the pilot program for it. So I tried it once more with a few of my celebrity friends and of

course it was a hit. So I found a location and opened the boutique even though I had never run a store. I was passionate about the idea. No one had done it and I coined "Clothes aid" and donated a portion of every sale to charity. That was a creative idea that turned into a reality.

For me, I try and not censor myself before I even get started. There are always so many reasons not to do something. At first you have to just let the ideas flow and not edit them. Don't stifle your creativity before you even get started. Sometimes it takes diving in and finding your way even if you zig and zag a bit along the way. Creativity is never a straight line! It's a freedom that you are looking for. You will feel it I assure you.

*Are there any common misconceptions about being creative you'd like to dispel?*

Creativity is a word that people can be afraid of and many feel that they were born without the "creative gene." I don't think there's truth to that because everybody has an aesthetic side. Everyone can create, whether it be home décor, fashion, food or a business. It's all a creative process.

People all love the aesthetics as it lifts their spirits. Whether it be music or art, fashion or design. Beauty is inspiring and you don't have to compare yourselves to the masters of anything. It's how you feel when you create something that will fuel you!

*Did you have to overcome any barriers, emotions, hardships or whatever to get where you are now?*

I've had so many different careers and there are always barriers, nothing comes that easily but that is part of what fuels me. I want to overcome those barriers, turn a negative into a positive, do something that someone else has not done, etc. I want to always be creating...but sometimes there are hardships. Once, my ex-husband Sonny Bono, sold a TV series with the two of us to one of the networks. I had never acted before and I was terrible and they replaced me. I thought I would never act again but I picked myself up and started taking classes to learn that craft.

Another time, I had my successful boutique on Melrose and got married, pregnant, and found out that the baby was coming early and had to lie down for five months during my pregnancy. Literally on bed rest. I had to sell the stores.

I was not supposed to get out of bed. There went those years of creating the stores but I learned a lot.

So I spent the time enjoying motherhood and learning about that. I didn't work for quite a few years and once my son was at school, I was bored to death just waiting for him to come home. That's when I decided I had to go back to work but then I thought...doing what?

I came up with the idea to survey my friends and asked them "If you thought of me as a brand, what would you consider my brand attributes to be? What do you see as my strengths?" Many came back with similar descriptions...but all came back with "style" being a big strength, whether it be fashion or home décor. They felt I had a confidence about my sense of style regardless of the area. Well I thought...that's something I can market!

So I did. I decided to launch into the lifestyle arena as I saw it as a growing area and there were few people in it and no one with an ethnic background. I saw a spot for me. Martha Stewart was the most known lifestyle expert at the time but she was not even a household name then, before she went public with her company. If you are starting a business it's always good to choose a field where you can win and maybe be the first or second or do something unique. There is more of a chance you'll succeed.

So, now how was I going to enter this lifestyle arena?

This was all part of the creative process and it fueled me every day. I had nowhere to go but up! I set up a desk in a little alcove and put up an empty calendar on the wall. I went to the stationary store for supplies to create a little office.

Now I had a place to work from. Now I needed a name. I thought Susie Coelho Enterprises, Inc. Had a nice ring to it! I would have lots of enterprises. Television, publishing, endorsements, licensing, and personal appearances.

Since I wasn't known as a lifestyle expert yet, I really couldn't do any of these except maybe television and it meant getting an agent and then a TV show. It was my best resource since I had lots of experience in television.

It wasn't easy, in fact I couldn't even get an agent. I had been out of the business too long I guess. I finally got some junior agent on the phone and took her to lunch and told her what I wanted to do and she said she'd keep her eye out and call if anything came up. Sure enough, two weeks later, she called with an audition for a garden makeover show on HGTV. I said HG what? (Home & Garden.) I had never heard of the network as it was a very new cable network in its third year.

I was determined to get the job and if I didn't I had no launching pad. So I got it. That launched my whole platform and from there I was able to build the rest, with books and personal appearances, endorsements with Fortune 100 companies, and licensing deals with major retailers. It was hard work, time consuming but so much fun. Lots of challenges and barriers to overcome but every day was a new day to create and that is the way I approached every day. The company blossomed and those words on that piece of paper became a reality! So don't sit around and think about all of the things that might pass you by. Just start creating. That is the joy of life! Taking an idea and seeing it come to fruition by your efforts. That is creation.

***What advice do you have for someone who wants to bring art and style into their whole life?***

I would say to everyone to start by trying to live life in a more artful/creative way, every day, by just taking baby steps. Get an idea about what you want to create and start small and then do it. Don't worry about it. Just figure out a way to get it done. Then pick the next thing. Don't start out writing a book if you want to be a writer. Start out with a poem, a page of thoughts, and build from there as you get your confidence. Don't set out to redecorate your entire home. Start with a room or a part of the room.

Also, depending on what you are creating, you'll need to find a place to do it. I created that little office in a hallway alcove, then later as the business grew converted the garage into my studio with a staff of five. If you want to paint then find a place to put your easel. Don't let space be the barrier. You can always find a spot to create.

Also, some of your best creative ideas will often come to you when you are doing other things rather than sitting at your desk, like walking or cooking, or for me, it's in the sauna or bath, when I'm quiet and have time to be alone with my thoughts. Then the ideas flow. The idea for my new company House of Sussex came to me in the sauna and I wrote the business plan right then and there just random notes on a piece of paper but it was clear as day.

These are the most exciting moments for me. Creating. Having an idea and then making it a reality. It's the joy of creation that I love, the process, the doing. Often when I get there, I'm not as excited as the creation is done. Creating is constant. You don't create and then stop. Either you continue to create something or expand it or start the next creation! For me that has been my path as new creative ideas and a new passion will drive me. I'm tenacious and often relentless about reaching the goal I set out for myself. The journey is what is fun for me. The constant process every day of creating. That is the joy of life for me!

# LIGHTEN UP! THE ROLE OF HUMOR FOR A CREATIVE

"IF YOU GO WITH YOUR INSTINCTS AND KEEP YOUR HUMOR, CREATIVITY FOLLOWS. WITH LUCK, SUCCESS COMES, TOO."

—JIMMY BUFFETT

Humor can be a mighty powerful tool for anyone who wants to live a happier life, and swing the doors of creativity open wide. We could all stand to lighten up and melt some of the seriousness. I want to explore the subject of humor and how it fits into your creative toolbox. I asked my friend Jim Meskimen, to help us unpack some of its many features and uses of this versatile tool.

# CREATIVE CONVERSATION WITH JIM MESKIMEN

» **Jim Meskimen dancing to his own beat**

Jim is one of the most multi-talented people I know, and of course one of his talents is helping people laugh. As a professional actor/ impressionist for thirty-plus years, he has appeared in such films as *Apollo 13, The Grinch, Frost/Nixon, The Punisher, Not Forgotten, There Will Be Blood* and many others. Some of his TV credits include recurring roles on *Parks & Recreation, The Marvelous Mrs. Maisel, This is Us, Friends, Whose Line is it, Anyway?, NCIS,* and The *Big Bang Theory.*

Here's what Jim and I discussed.

\*\*\*

*What are your successful actions with humor?*

I'm like you, or like anybody, I'm trying to get along with people and humor is traditionally a way of doing that. Life is tough. It's really difficult. There are constant challenges and even when things are going well they can all come crashing down and so we have to get along with one another. In my case, growing up was sometimes a happy childhood and sometimes not a happy household. My father used to drink a lot. I think I developed a lot of my habits about empathy with people by observing there were times when my father was very difficult to get along with. Humor would be something that I could use to warm him up again a little bit, or get through to him.

Making friends at school and breaking the tension and the boredom of school, I remember just laughing and having a great time sometimes when it was completely inappropriate. And that's a secret to humor too, sometimes in the most serious of circumstances. Like when my mother's mother passed away, I was a little kid and my sister was small and my mom was a single mom and her mother had died. We're in the limousine coming back from the graveyard and it had been a gut-wrenching kind of sadness. And then my mother made some kind of funny remark and the floodgates just opened and we laughed and giggled and laughed. It was just the expression of relief. I'll never forget that—I didn't see it coming. As a little kid, you're like, "No, no, funerals are sad." That's it. End of story. Well, no. Now I always look for it at every memorial. There's a moment when people like to get together and laugh and release and talk about the bereaved since that's about the most serious situation there is.

Laughter has this great therapeutic value. In my studies of life and experience I've come to recognize that humor comes about from a recognition of something that just isn't logical or just doesn't make sense or just doesn't follow. It's non-sequitur, which means doesn't follow. And a non-sequitur remark is either judged as being insane or really super funny.

For my money, humor and comedy are different from telling jokes. Jokes are a whole other facet of humor. They are like a recipe. I like to be really loose. I like

to be in the moment with who I have right then. A joke is very static to me. It's very set in concrete.

Humor can be part of your brand, if you will; it's definitely part of my brand. There's nothing I can do about it now, even if I say nothing, people don't believe me and they think I'm kidding.

Did you ever play Mad Libs? Well, Mad Libs is a wonderful exercise. They are little stories in a pad of paper, little written things that have omissions where you fill in an adjective, a noun, or a verb. And you just do them randomly with your friends. You'd say okay, "Now we need an adjective. Okay, now we need a noun, now we need another noun, now we need a compound word," and you'd fill it all in. And since it was completely out of context, these choices you were making, when you read it out loud, were hilariously funny often because it would be completely inappropriate: "The president made the elephant fly like a goose," whatever it was. I remember just being delighted by that and also tickled by the fact of how easy it was.

### Are there any myths about humor you'd like to dispel?

One thing I used to hear a lot, I don't hear so much anymore and maybe it's dying out, but among Hollywood writers and comedians, they'd say, "Well, you know, you're funny or you're not, you're either born funny if you got it or you don't." It's almost like it's genetic or something, which is obviously BS. And Mad Libs showed me that no, do you have a ballpoint pen? You can be funny.

» **Jim Meskimen making friends, photo by Ray Kachatorian**

### How does humor bring value?

Promotion and advertising have embraced humor since their earliest days and the reason is because it gets across to people. It warms them up a little bit in that it's considered to be friendly if it's not abusive. So in my dealings with other people in my promotion, my self-promotion as an actor, I'm in a very difficult and competitive field and it's getting more difficult and competitive all the time for various reasons. So I use humor as many people do, to make friends and get people to listen to what you have to say or get people to listen to your demo and look at your headshot and read your letter and whatever. You can't just send stuff out willy nilly and expect anybody to pay any attention to it these days. You've got to bring some value.

Humor and comedy bring value if they're done skillfully and if they're done with reality. I like something that's funny and pleasant. So again, it has to do with empathy. You have to use a little self-awareness and ask, "What do I like?" I like comedies, I like pleasant statements, I like things that are amusing and so I try to deliver that when there's an opportunity. I think comedians look for opportunities to amuse people. They look for gigs, they look for script ideas, and they look for concepts.

### How can you find inspiration for humor?

When I go around my neighborhood, my eyes are always open to a couple things. I look for visually beautiful things and I look for funny things. We're in a world full of visually beautiful things and we're in a world full of funny things. My theory is that if it's here on planet Earth or here in the universe at all, there's something holding it in place; there's got to be a lie involved somewhere. There are these dichotomies that kind of keep things suspended in space down to the molecular level. I've looked around and I've seen that there's so much stuff that's just based on nonsense and silly things, you've just got to open your eyes.

I was walking down the street just now. There's this building that's for lease on one of the corners on Ventura Boulevard, a major thoroughfare down here in my town and it says "Emergency Center." It looks like a place where you should go if you're really in trouble. On the second floor though, the windows are all blown out and there's this plastic tarp floating in the breeze. Do I go

there because I have an emergency or because I want to buy one? There are things everywhere. There are just little things that don't belong.

So much of comedy and humor is a recognition of something that just doesn't follow or just doesn't belong: the wrong emotion, a wrong object. Something which I've described recently as a *pivot*, is what creates a lot of humor. You suddenly go off, you change your opinion completely, or someone changes on a dime and they're pissed off at you, and then they're really super friendly. If you watch *Friends*, this is a great example. That TV show is just brilliant and it almost always a hundred percent involves a rapid change of emotion or viewpoint.

» **Jazz Legends Herbie Hancock and Chick Corea having a good laugh,**
**Marc Silber**

You'll see the character go, "I'm so glad to see you—get outta here!" You know, they'll pivot continually and they're geniuses at it, the actors and the writers. They create that great thing. You can use that, it takes a little practice, but you can just go, okay, "How do I feel? What do I want to say? What's the opposite of that? And can that be integrated into the communication at all?"

### What's the connection between creativity and humor?

Creativity is taking something or using your resources, and making something out of it. It's sometimes springing something from your imagination, but it's also looking around and combining things in interesting ways. I think humor is a byproduct of a lot of creativity. I'm thinking now of the artist Banksy who creates political statements, takes a lot of found images and combines them in different ways and puts them in a different environment in a location that you wouldn't expect and it communicates. It's also humorous and interesting.

I get ideas all the time and if I really am interested and involved in that idea, I'll chase it in my mind. I'll take a pen and paper to it. I don't know where it's going to go maybe, but there's a little something there. A little door opens up or a little balloon goes up or whatever you want to call it and you think, *That's something in there.* It's almost like when you go to Pier One and there's a little decorative box from Istanbul and I look in that box, I've just got to open it up. When you've got an idea and you chase it down, you open it up, you look at it and you start to monkey with it. It's very artistic and sometimes it's funny, sometimes it's not. But that's part of creativity.

### Any advice to others for adding creativity and humor to their lives?

The simple thing is to just look around and spot things in your environment that are amusing. It could be something that's an accident about to happen. Something that's ironic or silly or just unfinished. Something amusing and something that just isn't quite appropriate in its environment. It's all about awareness; creativity has a lot to do with being aware. You're aware of things on the outside, aware of things on the inside too.

People could make a list of things that make them smile when they remember them. Things that they treasure and have kept as a funny thing when they ask, "What's a funny thing you've seen in your life?"

So much of it is just being alert and aware, like being a good photographer. It consists to some large degree of *turn your eyes on* and look because you will see stuff. And the job of an artist, a photographer, a painter, a writer, is to find something that nobody's looking at and go, "Hey, check this out. You know, when I come really close to it or when I take the color out of it or when I light

it like this, pretty cool, huh?" And people say, "How, how did you...? I walked by that every day. I never saw it that way." Or a guy writes a poem about it, you know Shakespeare's work is all this stuff he's observing that has been part of human nature forever and he just happened to set it to a delicious meter and organize it.

I'm always looking for something that'll tickle people. And the best barometer I have for that is, does it tickle me, and does it interest me? And if something makes me laugh, then I know that a good percentage of other people will also enjoy it. So I try to find those things and again, that awareness. I look around for things that make me laugh. When I watch a movie, or watch a play, sometimes I find myself laughing at things that nobody else is laughing at and I think it's because I'm looking at it on a lot of different levels and I can find things about it that are rejectable.

If people feel like they're not funny inherently themselves and they lack that, they may feel, *Well, what's the point? I can't do it. He does it so much better...* But just as with this Mad Libs thing, it can be a kind of a mechanical exercise. You can create humor quite mechanically. And I think we've all learned that with our iPhones and with autocorrect where the wrong word is automatically substituted and it's really pretty funny sometimes.

Humor has a lot of value; people need the release of humor. So much of our entertainment is valuable because it makes people laugh or makes them feel some amusement in some way.

### Any advice for sparking or rekindling creativity?

People have been trained out of creativity to some degree. They're being more and more squeezed out of it. It's all being produced for them. One doesn't need to do anything themselves. It's all been produced and you just need to consume. That's pretty much the message of this really disrespectful culture that we're in.

So, I always encourage finding some way to make something on your own. And whether that's a rhyming couplet (two lines that rhyme or that have rhyming words at the end) or a little song or a little drawing or anything, make

something just for you. You don't need to show it to anybody, but just as an exercise to try it out.

Some art form that you say, "I don't think 'I screwed that up.' I think I could do that okay." Maybe pick up where you left off and you go, "Wow, I haven't made anything since fifth grade in Mrs. Tomashoff's class. All right, what was I making then? Well we were making these corrugated cardboard fish." Good. Go back. Make that fish, pick it up from there.

I've done that a lot of times, I'll go back to where I last was doing well or where I last kinda screwed up with an art project and say, "I better pick that up again." A lot of people put down the guitar or the bagpipe at a certain point when they get married maybe, and go back to that, pick it up again, and get that flow going. Creativity's a flow, but you have to start it. It's like a trickle of water that eventually will bore a groove in a piece of granite. But at the beginning it's just a drip and you have to get that flow going again. And when you do, amazing things happen, ideas start to come. But if you don't get the flow going, you'll never get those ideas. You'll never have that kind of relationship with the creativity.

 Summarizing

1.  What are three ways you could use humor to improve how you get along with others?

    a.

    b.

    c.

2.  What are some ways you can use humor in your creativity?

3.  How can you incorporate humor into your brand?

4.  What are ways you can look for and find humor?

5.  How can you find an area of past creativity and get back into the flow of it?

 Application

☐  1.  Find someone you'd like to improve how you get along with.

☐   2.   Send them something humorous (not abrasive) and see what happens.

☐   3.   Using self-awareness, write down what you like as far as comedy and communication in general.

☐   4.   On your next walk look for something amusing, silly, or unfinished. Write down what you found.

☐   5.   Write down three funny things you've seen in your life.

      a.

      b.

      c.

☐   6.   Write down three dreams you've had about creativity that you should chase.

      a.

      b.

      c.

### Bonus Steps

☐   1.   Write down three areas of past creativity where you may have been doing well with it.

      a.

      b.

      c.

☐   2.   Pick the easiest on to jump back in on and do so.

☐   3.   Note what happened.

☐   4.   Go to Amazon or a toy store and buy a copy of *Mad Libs*

☐   5.   Arrange to play it with family or friends soon.

☐   6.   Do so, and note what happens.

# ADDITIONAL TOOLS TO HELP YOU LIVE A CREATIVE LIFE

» NOLS River Crossing, Wind River Range, WY, Marc Silber

"IF YOU WANT TO TEACH PEOPLE A NEW WAY OF THINKING, DON'T BOTHER TRYING TO TEACH THEM. INSTEAD, GIVE THEM A TOOL, THE USE OF WHICH WILL LEAD TO NEW WAYS OF THINKING."

—BUCKMINSTER FULLER, ARCHITECT, AUTHOR

On your journey to a more creative life, you need to be armed with some additional survival tools.

Just like in mountaineering, you have to be prepared for anything that could go wrong. I trained as a NOLS[8] instructor to be able to handle anything from broken bones, hypothermia, to the sheer panic of being lost in the woods. By knowing how to handle any possible scenario, we were able to achieve the goal of the school's founder, which was to enjoy a high level of comfort while being in the mountains.

I remember a talk he gave us about how most extreme "survival" situations could have been avoided with proper training and preparation. Rather than throwing us into these extreme worse-case scenarios to prove that we could endure them (I had already been through Outward Bound training and had proved to myself I could endure it)—his attitude was, if you know what you're doing you shouldn't have to endure the wrath of nature. More than just wishful words, I found this to be empirically true in my approach to the mountains. And of course the principle of being prepared for any eventuality holds true in all areas of life, particularly creative ones.

So let's roll out these tools and get them firmly in your hands so you can easily use them to exist at a high level as a creative.

> "WHATEVER YOU DO, YOU NEED COURAGE. WHATEVER COURSE YOU DECIDE UPON, THERE IS ALWAYS SOMEONE TO TELL YOU YOU ARE WRONG. THERE ARE ALWAYS DIFFICULTIES ARISING WHICH TEMPT YOU TO BELIEVE THAT YOUR CRITICS ARE RIGHT. TO MAP OUT A COURSE OF ACTION AND FOLLOW IT TO AN END, REQUIRES SOME OF THE SAME COURAGE WHICH A SOLDIER NEEDS. PEACE HAS ITS VICTORIES, BUT IT TAKES BRAVE MEN TO WIN THEM."
>
> —ATTRIBUTED TO RALPH WALDO EMERSON

---

8 National Outdoor Leadership School, the foremost wilderness education school. It was founded by Paul Petzoldt who had previously been part of the founding Outward Bound team.

 As an artist, you should be aware that there are "vampires" out there; meaning people who try to rob you of your life and what you have created. They may sometimes act like your best friend, with "creative criticism," but if this results in your slowing down or being discouraged, recognize what you have encountered! You can ignore the naysayers and keep them away from you, and you and your art will be better off for it (there's much more to this, which I'm happy to discuss—email me).

Emerson might well have written his advice for today's world of critics and haters. This is so powerful that I want to fully unpack it to reveal all of its strength and inner workings.

Yes, it takes courage to put your art out in today's world of trolls and haters. They can easily hide behind the anonymity of the internet. There have always been viscous critics, but the internet provides a soft oozy place for the trolls to easily hide under dank bridges or in swamps. I've come to realize that their comments are slung at any creative activity: since vampires can't create, and they can only draw life from those who do, the best course is to brace up and flatly ignore them. Stay the course to get your work out into the world. And heed Emerson: don't be tempted to believe they are right.

If you ever run into a vampire and have gotten "slimed"[9], take a page from Frank Sinatra's book, "The best revenge is massive success." Don't pull back, push forward and achieve "massive success." As you've read in our creative conversations, there are always obstacles and barriers to overcome toward success. Have courage, ignore the trolls, haters, vampires, and double-down to win your victories.

And before we leave this point, most importantly of all, seek out those who are the antithesis of vampires: people of good will who support you. The *enablers*, who help you, who connect you with the right people, and who give you good, sound advice. These are the people who you'll feel better for having been in

---

9 Like when the evil ghosts left slime all over in *Ghostbusters* (the movie).

their company, who have no hidden agenda, but who genuinely are your supporters.

## STRENGTHEN WHAT IS WORKING FOR YOU

Success breed success. In our creative conversations , you've seen that we always touch upon what has been successful for each person. These are like beacons leading you up the mountain to the top, where your goals live. They are your golden highway that you definitely don't want to wander off from.

You want to strengthen and nourish whatever actions have been successful for you: put a tab in your notebook marked "Success." On these pages keep an ongoing list of your own successful actions. My books form a collection of what I have found to be truly workable that I have passed along to you. Of these, two sources of my success stand out as the most basic and powerful, I'm sure they are true for you too.

1. Expand your skills daily by reading and studying your craft. This is the central point for success: be obsessed with learning. And this is not just for the latest developments, far from it. Study the works of the masters in your genre. I do this first thing every morning; I find it's a much healthier diet than beginning each day with a dose of (bad) news.

2. But my daily study goes deeper than study of my craft: I am passionate about the study of knowledge and philosophy, but I take it to the next level by teaching and practicing it in my life and helping others with it. My quest is to understand how people operate, and how they can improve mentally, emotionally, physically, and spiritually. I believe that creativity is the keystone that supports all these.

3. The study of art and creativity have been intrinsically connected to philosophy for millennia. For me, it's vital to know why I am creating. Opening my awareness mentally and spiritually allows me to answer that question.

4. Talk to those who have mastered your art form. I built my YouTube channel by interviewing outstanding photographers in a wide variety of genres. By doing this I was able to get an inside look at their world, under the hood. I learned not only about their techniques and approach to their craft, but about them as well and how they approached life and what worked for them.

5. I did the same with this book, discovering and gaining valuable insight from a wide spectrum of creatives.

6. I recommend that you carry on this same mission, and record what you find in your notebook.

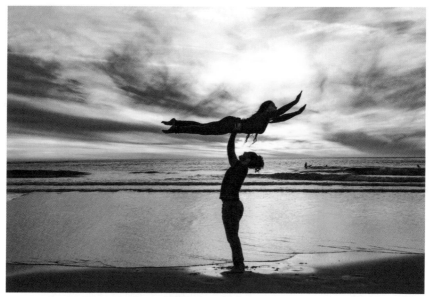

» **Learning to fly, Carmel CA, Marc Silber**

## DO WHAT YOU CANNOT DO

> "I AM ALWAYS DOING WHAT I CAN'T DO
> YET IN ORDER TO LEARN HOW TO DO IT."
>
> —VINCENT VAN GOGH

You may have many comfortable ways to create, to add art into your life. While I've said you should cherish those, on the flip side you should always look for new ways to express yourself: do what you cannot do.

As just one example, with photography you can hit a plateau by making images that are easy or comfortable for you—I know, I've done it thousands of times. Some examples of cliché images are taking landscapes with pat framing through the trees, or a certain pose you've used over and over—you probably have your own list.

If you find yourself going after a cliché image (even if only a personal cliché), break out by following professional photographer Chase Jarvis' advice of "... trying to do something that is unusual. How can I put a little twist on it, or as we say when we're on set, 'How can we turn this one on its head?' I look for ways to make it different, those are the little things that separate it from making it an interesting photograph to a great photograph."

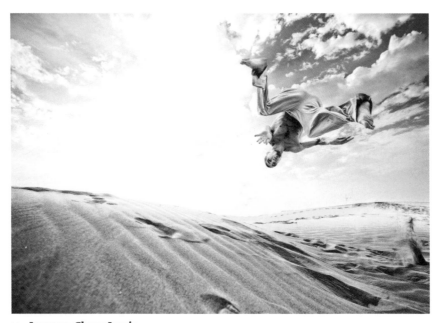

» **Jumper, Chase Jarvis**

But how? By pushing yourself to try new approaches and look for new angles, different lighting, a different way of visualizing. For example, every time you see a beautiful sunset, you shoot into it, capturing the glow of the sun going down (which gets you a string of "likes," encouraging you to keep shooting them). But instead, turn the other way and capture that gorgeous glow hitting an object or a person. The obvious can be so tempting that it's hard to let it go. Okay then, capture it that way, but then go on to "turn it on its head." Then look at your results, and learn how to do it better, as van Gogh said.

The same follows for any art form you're working in. Push yourself to try new ways of expressing yourself and using your two obsessive learning skills I mentioned and you will be constantly advancing.

## INVENT & EXPERIMENT

"CREATIVITY IS INVENTING, EXPERIMENTING, GROWING, TAKING RISKS, BREAKING RULES, MAKING MISTAKES, AND HAVING FUN."

—MARY LOU COOK, ACTOR

» **Test Flight, Peninsula School, Menlo Park, CA, Marc Silber**

Follow this advice in your art form. Be willing to take risks and break the rules and be on the cutting edge. All new art forms or new applications of art were developed from one person's experimenting or breaking rules. When they catch on and gather momentum they enter the mainstream, cutting a wide swath into our culture.

The Beatles appearing on the scene had this effect: many musicians remark about seeing them live on *The Ed Sullivan Show* in early 1964 as the point they decided to make rock and roll their life. In fact 73 million viewers tuned in that night. Their "mop" hair sans brill cream, Edwardian suits, pointed boots, their polished delivery, and catchy humor swept over all of us and ignited a tidal wave of newly inspired musicians.

Tom Petty expressed this moment for many of us: "I think the whole world was watching that night. It certainly felt that way. You just knew it, sitting in your living room that everything around you was changing. It was like going from black-and-white to color."

Thus an avalanche of teens decided to invent themselves as musicians, braving the risks, making mistakes, experimenting and having fun.

##  REVITALIZE YOURSELF

Another tool you'll want to have handy is how to prop yourself back up and revitalize yourself when you've hit a point of failure, fatigue, or feeling you should quit.

First remedy: never give up.

> ## "I'VE MISSED MORE THAN NINE THOUSAND SHOTS IN MY CAREER. I'VE LOST ALMOST THREE HUNDRED GAMES. TWENTY-SIX TIMES, I'VE BEEN TRUSTED TO TAKE THE GAME-WINNING SHOT AND MISSED. I'VE FAILED OVER AND OVER AND OVER AGAIN IN MY LIFE. AND THAT IS WHY I SUCCEED."
>
> ### —MICHAEL JORDAN

Next: Write your daily goals, as bestselling author Grant Cardone advises:

> "Want to stay motivated? Want to wake up motivated? Write your goals down, first thing every day...if you don't have goals, and if you're not focused on those goals every day, you're going to spend your whole life making somebody else's goals and dreams a reality. That's not what you want."

We began by writing your goals and I asked you to refine them at various points. Make this a daily ritual as Cardone advices. Even if you write the same goal over and over, do it newly as though it's fresh and alive for the first time.

Do this any time you start to run out of gas, or run into any trouble.

Another remedy, the flip side of goals, which will carry you forward into the future, is to write down your accomplishments. It's important to take stock and inventory your progress and achievements. Realize the actions you've taken. Write these in your notebook.

And remember your remedy of going out for a walk. Use it liberally. Don't seek a substance "cure"—it doesn't work, even if there is a momentary buzz, the downside will take you lower.

These are tools to use to revitalize yourself which are much better than desperately seeking someone else's answers: their goals are not yours. You are beautifully unique and gifted with your skills, dreams, and abilities. One of them is the ability to self-recharge by using these powerful remedies.

## Summarizing

1. Can you remember a tool that prepared you for something that could go wrong? How did it work for you?

2. How can you detect a vampire?

3. How can you respond if you run into a vampire and "get slimed"?

4. Who are some examples of people who have supported you?

5. What are some ways to revitalize yourself?

### Bonus Questions

6. What are some passions you can have to help you succeed?

7. How do you think you can avoid hitting a plateau in your art?

8. What are some ways you can invent and experiment with your art or creativity?

## Application

☐ 1. Note down any vampires you've encountered.

    a. What happened?
    b. Are you still in touch with any?

☐ 2. Using the advice from Emerson and Sinatra, note three steps you can take to get "un-slimed."

    a.
    b.
    c.

☐ 3. Take them and note how you feel.

☐ 4. Write a list of works that you want to study first thing every morning.

☐ 5. Implement this in your schedule and write it in on page 166.

☐ 6. Start keeping pages in your notebook for your successful actions. Fill them in now and keep this up to date at least weekly.

☐ 7.  Note down one thing that you would like to do with your art that you cannot now do.

☐ 8.  Write down your goals in your notebook right after you complete your daily study.

☐ 9.  Start a page for accomplishments, fill it in now and keep it up to date weekly.

# CREATIVE CONVERSATION WITH NANCY CARTWRIGHT

As an Emmy & Annie Award-winning actress, Nancy is best known as the voice of Bart Simpson, but also gives voice to Ralph Wiggum, Nelson Muntz, Rod Flanders, Maggie Simpson, DataBase and Kearney in the town of Springfield on Fox's twenty-eight-year-old iconic hit, *The Simpsons*. It is the longest running scripted TV series in history. In her thirty-six-year career at the microphone, Nancy has lent her voice to hundreds of other award-winning animated series, including *Rugrats* (Chuckie); *Kim Possible* (Rufus the Naked Mole Rat); *Richie Rich* (Gloria); Animaniacs (Mindy); *The Replacements* (Todd) as well as *Pinky and the Brain*; *The Critic*; *God, The Devil and Bob*; *Mike, Lu & Og*; and Chuck Jones' final work, *Timberwolf*.

Nancy is known in the non-profit world as a generous and active philanthropist who gives of her time, energy, and resources equally. She loves what she does on *The Simpsons*, however she sees it mainly as a means that fortunately allows her to support many non-profit organizations, particularly those that help children.

I've known Nancy for some years, having had the fun of participating with her on educational and humanitarian programs. I wanted to find her secrets for exuding humor and creativity in everything she does.

\*\*\*

*What are your secrets for putting creativity into your life?*

The number one thing is that I do what I love. I don't think about monetary remuneration, If I'm doing what I love, it's on my purpose line, which is the second thing. I have goals for myself and I have purposes. It makes life so easy when I have those because if you don't, you're just dispersed all over the place. However, if you have goals in your life, it's very easy to make decisions. For example, if someone approaches you and asks you to participate in something or they want to hire you to do something, if it's not along your goals and purposes, you just say, "Thanks, but no thanks," and it makes things super easy.

Another one is to "surround yourself with people who support your dreams." It's very easy as an artist to get people around you who just say yes to everything that you want to do, especially if you're paying them. They're called, "Yes Men." They have no integrity of their own. They cannot create on their own and they're there to get a paycheck from you. So they're afraid to speak up even if what you're doing could possibly be harmful, but they don't want to jeopardize their job slash income by speaking up.

Even if I have family members or best friends that just say yes to me, I would appreciate getting somebody else's opinion, even if it's not concurring with mine. Because if I listen to that opinion, it might make more sense than what it is that I've decided to do.

A couple more things: be professional in everything, especially in your art, in your business—you have to be a professional. You have to treat people with respect. If you have to correct someone, do it privately, don't do it in front of other people. It's quite humiliating otherwise. Another part of being a professional is don't just show up on time, show up a bit early.

Another successful actions for me is I always want to find out what's needed and wanted when I'm hired because as an artist there's such a vast spectrum of

what can be delivered. And I always want to make sure that the person who's hiring me is getting what he or she wants. I may have a great idea, but if it's not what they really want, you've got to put your ego aside and make sure you deliver the product.

But, if you do have another idea, speak up. Most of the time they don't know what they want—that's why they hired you—you bring your brilliance and if you have more than one idea, definitely give them options.

"Hitch your wagon to a winner." You can find a mentor if you find somebody who knows more than you do. Find somebody who is an opinion leader in your arena who you can establish a connection with. That's going to take some doing. But I have found it to be successful when I look to others who are setting a better example than me.

*Are there any common misconceptions about being a creative or adding creativity to your life that you'd like to dispel?*

We all have so many abilities. There is a common belief that you should just focus on this one thing. I suppose if you're trying to make a living doing something, it would be a good idea to be able to focus in on that one aspect that you're trying to do, but I would never ever, ever limit myself to not experiencing other forms of art, because I can. As an artist, we have infinite abilities to create and to try something new. The world is your playground and you could just try things out.

Another one is other people have said this: "Oh, I'm not going to get it because I'm a woman or I'm too old or I'm too young, or I'm too fat or I'm too ugly, or whatever." These are just their own ideas. You have to just shut off those and

then you just keep on going anyway. I don't know if it's possible for anybody to turn off all those negative comments, but you just have to recognize that is not you, that's some voice in your imagination. Shut it up and carry on and do your passion.

***What were some of the big barriers that you've had to overcome to really get the kind of life you have?***

I was very career oriented, very artistically motivated and I put my attention on that growing up. I was one of six kids in my family and my mom and dad were awesome because they were very supportive of our dreams. When I was in high school, I had this ability to use my voice, so I trusted it and I did what I loved. I sought other opportunities to fulfill my dreams and I had so much fun. I made people laugh. I made people happy. So why not continue? This was in Kettering, Ohio and that's not where they do cartoons. That didn't stop me. I connected up with Daws Butler a voice pioneer who was Huckleberry Hound and Yogi Bear and Quick Draw McGraw. He did dozens of voices for Hanna Barbera. We hooked up and he became my long-distance mentor.

So I transferred to UCLA, but two weeks before I was to make that move my mother fell ill and she passed away. All of a sudden the rug was pulled out from under me and I was in such grief for the loss of my mother. My family asked me: what are you going to do? And I couldn't imagine staying home and not carrying on with my dream. So I went ahead and came out here to LA and I didn't share it with anybody that my mom had just died. And it started to affect me and I remember getting migraine headaches really bad. Mourning the loss of my mother was something that I had to overcome, that was tough and it was very, very personal.

The way I overcame it was that I just immersed myself in my work. I auditioned for some plays at UCLA and I got cast in something and just started to create as an artist and it saved me! It was very self-validating. It was amazing.

And then a couple years after that I got cast as the lead in a sitcom. Everything happened so fast for me. And then I got a phone call from my dad and he told me that my brother had just died of a drug-related incident. My career was just starting and now I was sort of torn. What am I going to do? I looked at it and I

said, "Dad, I just can't come back." And through my tears I said, "I hope you understand." And he actually did. "I don't want you to think that I don't miss Steve. I really miss him, but I don't think it's a good idea for me to come home at this time. I just got the lead in this television show. Plus, Steve would want me to do good." So, as easy as it is telling this story, it was a decision that was really hard to do.

**Switching gears now, is there any secret for improving humor?**

First of all, there's a difference between humor and just telling a joke. I feel like I naturally have a very good sense of humor—I said "naturally" and yet I have found that as my communication skills have improved over the years and my willingness to listen to somebody else has improved, I can see where they're coming from, I can come back with something very funny, a comment that's very funny and it's organic.

**So how do you add creativity to other parts of your life?**

Come to my house sometime and just look around! I live in "Nancyland"! I love it. It just pops out in a way that I use my creativity to make my space very aesthetic. I tend to go for not just aesthetics but also whimsy. It's my sense of humor. I have found that I have ability in decorating that I really, really love and a keen eye for aesthetics.

**Any final advice for somebody who wants to bring art and creativity into their life?**

You don't have to be an artist, quote, unquote, to have art in your life. Everybody has a viewpoint even if you don't paint and you're not a dancer and you're not a singer and you're not an actor, or a voiceover person... Say you run a printing company, you can still be creative with your business. By being a professional and setting up your space so there's a place for everything and everything is in its place makes it very conducive to creating. It's very clean and that is a quality that your customers would step into and just go, "Oh, I love this."

I find I am shocked at how many of these small business owners don't go that extra length in order to make the space aesthetic. It doesn't take much to do that. I think that's the thing that we all have that ability to do that and you don't have to be an artist to live your life as an artist.

***I have one last question for Bart: I'd like to get his thoughts about creativity?***

He'd probably say, "Well, I didn't do it. Nobody saw me do it. You can't prove anything."

Bart has mastered the art of being recalcitrant!

# ENVOI: TRAVELING ON FROM HERE

» **Matterhorn, Zermatt, Switzerland, Marc Silber**

"DON'T LOAF AND INVITE INSPIRATION; LIGHT OUT AFTER IT WITH
A CLUB, AND IF YOU DON'T GET IT YOU WILL NONETHELESS GET
SOMETHING THAT LOOKS REMARKABLY LIKE IT... AND WORK. SPELL
IT IN CAPITAL LETTERS, WORK. WORK ALL THE TIME. FIND OUT
ABOUT THIS EARTH, THIS UNIVERSE; THIS FORCE AND MATTER AND
THE SPIRIT THAT GLIMMERS UP THROUGH FORCE AND MATTER
FROM MAGGOT TO GODHEAD."

—JACK LONDON[10]

London wrote this powerful advice at the conclusion of his essay, *Getting into Print*. Like one of our creative conversations, he was mentoring new authors, telling them his secrets for success. It is very fitting to leave you with these words. They should ring clearly for you, equipped with many tools to help you accomplish your goals.

The creatives we heard from echoed his advice: go after your inspiration and dreams and work your craft no matter the obstacles. Ignore the negative

---

10 It's fitting to end with this quote, as I am completing this book I am already into my next project: a screenplay adaptation of *The Star Rover*, Jack London's remarkable novel. In the story, London explores past lives and the struggle of the immortal spirit inhabiting mortal flesh. Stay tuned...

voices whether internal or external. Experience the sheer joy of bringing into being what you have envisioned and share it broadly with others. Never stop exploring life and this universe—especially "the spirit that glimmers up."

Make this a way of life, your art of living and creating.

My recommendation at this point is to re-read this book to pick up additional understanding. Review your responses to summarizing questions and application steps, refining them or taking them further.

My wish is that this book is the beginning of newly energized creativity for you across all areas of life. I am constantly struck by how much there is to know about making life an art form: how to follow your own dreams while helping and cooperating with others in the pursuit of theirs.

But it's not always so rosy, so your creative life must embrace those difficult moments of emotional flare up, defeat, burnout, and all the other negativity we can encounter. My passion is to improve my understanding of people and of life as a whole. Don't hesitate to reach out to me for recommended study that I have followed.Continue to broaden your scope of application to include a wide a swath as possible: How can you apply these tools to yourself—physically, mentally, spiritually? To your relationships with those you love, familiarly, and children? To your career and business goals? And to our world as a whole? And I leave it to you where you take it from there.

## STAY IN TOUCH

Remember to keep adding to your notebook every day. I'd love to see any pages you'd like to share, simply hashtag #createbook along with images or videos of your work.

I'll soon be offering online training to augment this book, so be sure to stay connected through SilberStudios.com You'll also be able to email me from there.

# ACKNOWLEDGEMENTS

"GRATITUDE IS A MIRACLE OF ITS OWN RECOGNITION.
IT BRINGS OUT A SENSE OF APPRECIATION
AND SINCERITY OF A BEING."

—OSCAR AULIQ-ICE, AUTHOR AND PHILANTHROPIST

Writing a book was like a mountaineering adventure where one person might plant the flag on the summit, but it takes numerous people to support him or her in achieving that success. I want to mention those who were my key supporters but there are countless others, too numerous to mention, that I deeply appreciate as well.

I want to acknowledge all those creative folks who are dedicated to their craft and who helped tremendously with my research and writing of *Create*. First, to those who generously gave us their time and shared their wisdom in our creative conversations that you discovered as you read the book. I hope you will also search for them on and offline to find out much more about these seriously talented people: Chris Burkard, Keith Code, Jim Meskimen, Chris MacAskill, Mark Isham, Marsie Sweetland, Camille Seaman, David Campbell, Susie Coelho, Aaron Kyro, Joanna Vargas, and Nancy Cartwright.

Thank you to the team at Mango Publishing for looking over my shoulder and helping my words and images flow more smoothly to you, my reader. I appreciate your continuous support, especially Chris McKenney, Hugo Villabona, Yaddyra Peralta, and Elina Diaz

I want to thank my early readers who gave me their notes, especially Cathy Weaver and EmilyAnn Pillari, who passed along very important feedback that greatly improved the book. Thanks again to Pete Hoffman for his magic with Photoshop. Thanks to David Brier for guidance and wisdom throughout. Thank you to my followers on YouTube and social media for your support and encouragement over the years.

And a special huge thanks to my wife, Janice, for her bright ideas and boundless support in millions of ways.

And finally, to you, my reader, for reaching for a more creative life and for improvements that I know you will make. Like a ripple in a pond from a single stone, your creativity has far reaching effects.

# ABOUT THE AUTHOR

>> **Photo by Bear Silber**

Marc Silber is the author of the number-one bestselling books *Advancing Your Photography* and *The Secrets to Creating Amazing Photos,* an award-winning professional video producer, photographer, and educator who has been successfully working in the creative field for decades. Marc combines his passion for art with his love of life.

He began studying art, writing, and photography at the legendary Peninsula School in Menlo Park, CA in the '60s, and moved on to hone his skills to professional standards at the famed San Francisco Art Institute, one of the oldest and most prestigious schools of higher education in art and photography in the United States.

Since then, Marc has been a dedicated educator; he began his teaching career at the age of nineteen at the National Outdoor Leadership School, teaching mountaineering. When teaching a

life-or-death subject such as mountaineering, one learns how to make sure the students understand the material; when Marc moved into teaching photography in workshops all over the country, he became renowned as an engaging and helpful speaker and coach, as his greatest joy comes from helping others.

Marc has embraced the digital age with a highly popular YouTube show also named *Advancing Your Photography*, which has won several Telly Awards and other recognition for his work. On his show he has interviewed scores of

seriously talented artists, which forms the foundation for his books. He loves to talk with those who have mastered their craft to get an inside look at what has been successful for them—and to pass along their wisdom to you.

He lives with his wife, Janice, and their beautiful Golden Retriever in Carmel-by-the-Sea, where they hike, explore and surf on the beautiful coast.